N 66 .W32

OTHER PUBLICATIONS OF PAUL WEISS

BOOKS

The Nature of Systems

Reality

Nature and Man

Man's Freedom

Modes of Being

Our Public Life

The World of Art

WITH OTHERS

American Philosophy Today and Tomorrow

Science, Philosophy, and Religion

Moral Principles of Action

American Philosophers at Work

Dimensions of Mind etc.

EDITOR, with Charles Hartshorne

Collected Papers of Charles Sanders Peirce
(six volumes)

NINE BASIC ARTS

Paul Weiss

SOUTHERN ILLINOIS UNIVERSITY PRESS

CARBONDALE AND EDWARDSVILLE

FEFFER & SIMONS, INC.

LONDON AND AMSTERDAM

ARCT
URUS
BOOKS ®

Copyright © 1961 by Southern Illinois University Press
First Arcturus Books Edition, February 1966
Second printing, November 1970
Third printing, July 1974
This edition printed by offset lithography
 in the United States of America
International Standard Book Number 0–8093–0199–7

TO THE CONTRIBUTORS

TO

EXPERIENCE, EXISTENCE,

AND THE GOOD

PREFACE

THIS work and a previous one, *The World of Art,* were originally planned as a single book. The generosity of Mr. Harold Feldman and Mr. John F. Molloy enabled me to send a draft to various friends for criticism. As a result of the suggestions of several readers they now appear as independent though related volumes.

Both are in good part the product of an interest in the arts long ago awakened by Eliseo Vivas, and encouraged, nourished, and enriched by Neil Welliver. It has been sustained by conversations with George Howe, King Lui Wu, Paul Rudolph, Peter Millard, Arthur Drexler, Erwin Hauer, Robert Engman, James Brooks, Charlotte Park, C. Marca-Relli, K. R. C. Greene, Howard Boatwright, Richard Sewall, Harry Berger, Cleanth Brooks, Janice Rule, Curt Conway, Kim Stanley, Lee Strasberg, Uta Hagen, Alfred Ryder, John Gassner, Eliot Elisofon, Jonathan Weiss, Robert Thom, David Slavitt, and Scott Sullivan.

A draft of this work was criticized in detail by Ellen Haring, Iredell Jenkins, K. R. C. Greene, Jonathan Weiss, and Richard Sewall. In addition it has had the benefit of comments from John Gassner, Louis Z. Hammer, Dorothy Walsh, Robert Herbert, Vincent Scully, Philip Johnson, Paul Rudolph, Peter Millard, James Brooks, I. C. Lieb, V. C. Chappell, Richard Bernstein, Scott Sullivan, David Slavitt, Theodore Weiss, Henri Peyre, Merce Cunningham, John Cage, and Robert Lowell. I am most grateful to them; they have made it possible to improve the book immeasurably.

I have tried to follow the lead of the criticisms which I have received. Divergent vocabularies, outlooks, and stresses, however, have often proved to be great obstacles in the way of a clear and common understanding. None of the foregoing critics should be held accountable for any of the blunders or blurs the work contains.

I am glad that this book is being published by Southern Illinois University Press. It is a source of great satisfaction to me that Mr. Vernon Sternberg and his excellent staff have made it the object of their usual thoughtful, sensitive concern.

P. W.

New Haven, Connecticut
May, 1960

CONTENTS

NINE BASIC ARTS

INTRODUCTION

EVERY experience has an aesthetic, qualitative side. The leaf I hold in my hand is smooth and green. These features were first encountered (though not actually known) without the mediation of words or ideas. I then kept apace with them, or suffered them. What I first faced and still continue to face is a purely present, entirely immediate, intuited content. The leaf is of course more than this. It has latent powers and energy, and a career which began in the past and continues into the future. I grasp something of this side of it too, but not in the same way in which I grasp its qualitative, sensuous features. Part of the leaf is not yet manifested, not yet open to an *aesthetic experience.*

There are men who deny that there is anything more to the leaf (or any other object) than what it is immediately, i.e. aesthetically, experienced; some say that what is immediately confronted is merely a sensation or a floating sense datum rather than qualities resident in things. Still others think that what is experienced is wholly our product or creature, something not at all real, in no sense objective or intelligible. But all of them, with the rest of us, acknowledge that part of what is experienced has different lilts and colors at different moments, that it is encountered apart from all mediation by ideas, and independently of any determination as to whether or not it is real or objective, or whether or not anything else exists. The most heroic attempt at scepticism must begin by accepting the aesthetically experienced; otherwise there would be nothing for it to question, deny, or subjectivize.

When we attend to the purely aesthetic, to the merely qualitative, we have an aesthetic experience. The qualities we then encounter are seen to differ from one another in tonality, vividness, stress, and

rhythm. The experience need not be restricted to what is made by us; it may be had apart from any works of art. Nor need it be an experience of objects, substances, occurrences. We have aesthetic experiences of silence and emptiness, of the monotonous and repetitive. Sometimes these are recognized to be qualitatively complex. For one thing, because of our habits, memories, expectations, and appetites, parts of them encountered later have a different weight and role than similar parts encountered earlier. Also, the environing world demands that any stretch of experience, simple and uniform or complex and varied, have different stresses in different places.

We all have aesthetic experiences. But few of us have aesthetic experiences as subtle, as variegated, as complex as they could be. We are too practical, too immersed in the affairs of the world to be willing to spend much time in savoring to the full what is available to us all. We focus on a feature here and there, ignoring the wealth of content which could be enjoyed. We hurry on to give the feature a role in our daily life. And so far as we do attend to it aesthetically, we face it as merely an accented part of a larger but rather thin aesthetic experience. We are content to attend only to what will help us move more readily to what else there might be. Were we willing to open ourselves fully to aesthetic experience we would have excitements, pleasures, and revelations we never imagined possible. To look and enjoy the "empty" space between trees from multiple sides is to feel something of the excitement undergone by the mountaineer when he looks around him on the mountain top. This, at least, is what happened to me not very long ago when for the first time I noticed how "empty" space, powerful and positive, changed in tonality, nuance, and weight as I shifted my position in relation to it.

An aesthetic experience is ours when and while we are conscious. At different moments it has different qualities, stresses, and significance. As a rule, though, it is rather flat and uninteresting. If we wish to enrich it we must, while remaining on the surface of things, make ourselves more attentive, more receptive than we had been. We will not, in this way, get the values we can obtain when we concern ourselves with *aesthetic objects*. These are objective, judged, substantial, distant beings, not termini, not just surfaces, more than sensuous con-

tents immediately experienced. To obtain an aesthetic object we must enter into the common-sense world, with its robust and vital activities, and there, through an act of concentration detach a portion of it from the rest. The act of bounding is produced by a change in attitude. Instead of being concerned with the world of common sense, as spread out over a large area of space and time and organized by convention, tradition, and social demands, we must so attend to a portion of it that it is torn out of its context, freed from its social role, and infused with our emotions, interests, and values.

An aesthetic object is a dislocated common-sense object. It is a bounded region, a fragment of the common-sense world which we fixate in an attitude of concentrated concern. It usually has an arresting qualitative side. In fact, one of the reasons men attend to aesthetic objects is to enable them to have new aesthetic experiences. Dadaism, the use by artists of "found" objects, the introduction of ordinary things, colors, sounds, and shapes into works of art yield new and fresh aesthetic experiences of ordinary things. If a common tool were exhibited as though it were a work of sculpture, if pigments of various thicknesses and hues are set down on canvas without regard for one another, if sounds coming over the radio or escaping from the street are incorporated in a musical performance, we will be led to attend aesthetically to what we otherwise would overlook. The public and some critics are inclined to treat such a separation of objects from their conventional settings as being without value; experimental artists and avant garde students tend to speak of the dislocated objects as works of art. Both sides exaggerate, the one ignoring the aesthetic dimensions which are being made available, the other forgetting that without an element of creative making there can be no work of art.

Works of Art, "art objects," unlike aesthetic experiences or aesthetic objects, are produced by working over recalcitrant material in the light of more or less vaguely apprehended meanings. Ideally, the meanings permeate the material of an art object. When they do the result is a beautiful, self-sufficient, dramatized, substantial whole with which we can live for a while. But we find it hard to understand or to communicate what we then discern. Each work presents itself as a

product worthy of man's utmost devotion. Each is unique. No one can take account of it unless he immerses himself in it.

Works of art are to be lived with as unduplicable, irreducible, self-sufficient realities. By means of them, we complete ourselves and come to know about ourselves, improve the daily world, and grasp the import, texture and nature of reality in a way no other enterprise permits. Despite their uniqueness, they have features in common. If they did not, there would be little warrant for treating them all as instances of one single, distinctive enterprise.

In modern times, works of art have been approached from three different positions. Intellectuals are accustomed to saying that works of art not only have their origin in the mind or spirit of man, but ideally could be perfected there. Had a man a fully determinate image of what he might produce, he would, on this view, have no real need to make or externalize the image, except for the purpose of communicating what he had in mind. Though this view finds favor with philosophers and pedagogues—concerned as they are with ideas and their communication—it, because of its comparative neglect of art products and art production, never has satisfied either spectators or artists.

At the opposite extreme from the intellectuals are the spectators. They are concerned primarily with works of art as finished products. It is these to which they attend, it is these which they buy, it is these which they admire. The idea that the artist may have in mind does not interest them, except so far as it might provide a clue to the enjoyment of his works. Since spectators pay practically no attention to the process of producing a work of art, their understanding of art usually omits a consideration of the nature of artistic activity. The works which spectators like could conceivably have been made by abnormal beings or by strange accidents. That is why spectators are able to entertain a high opinion of art and curiosity about the biographies of artists and yet show no or little interest in the production of art or in the ideas of the artists responsible for it.

The position of artists is almost midway between the positions taken by philosophers and spectators. Artists are primarily concerned with the process of creation. Under the guidance of attractive ideals, they

adventure, experiment, improvise in one unending search for the an-
swer to a perennial, half-noted question as to just what the world im-
ports for them, and what they ought to do. They need that answer if
they are to do full justice to their powers and are to find their proper
place in the world. The ideas they have in mind are not matters of
major importance to them; their ideas function merely as plans,
suggestions, guides, to be modified and even discarded in the course
of the process of creation. Nor is the finally produced work of art
at the centre of an artist's concern. An artist takes his work to be a
residuum of the creative process, a momentary rest in an unending
quest, a testimony to the degree of success so far attained in his effort
to be as complete as he can be. In his reports of himself, he is inclined
to do less than justice to his own preparations and achievements.
For him the problems and demands of creativity are primary. Were
one to follow his lead, it would be hard to understand why he decided
to aim at one thing rather than another, or to discover why anyone
should be interested in what he produced.

Art cannot, I think, be properly understood without taking into ac-
count ideas, the process of creation, and the work created. Ideas are
made determinate in the process of creation and are fully expressed
only in the resulting work. The creative act is no mere unending
process; it is fractionated by the ideas and brought to a proper close
by the work. An art object gives a sensuous, material locus for ideas
and epitomizes the process by which it was achieved. But it would not,
I think, be correct to put the object, the creativity, and the ideas on
a footing. The emphases of spectators and artists on objects and
creativity are more appropriate to art than is the intellectuals' stress
on ideas. The objects and creativity are about of equal value. Both are
more important than the ideas or plans initially entertained.

All the arts are guided by ideas, involve distinctive acts of creation,
and yield works which have a self-sufficient excellence. The work of art
with which the artist finally ends realizes his ideas and epitomizes his
creativity. All three—idea, creativity, and work must therefore be
understood if one is to do justice to what is in fact essential to art.
The artist's activity and his works, though of primary importance,
can never be adequately understood if one ignores entirely the ideas

which are in fact presupposed and inescapably embodied in them. Those ideas, however, are overrun with features and tensions which can be known only by those who take account of his experience, his past training, and his power of imagination. His act of creativity breaks new ground and in new ways. No ideas are ever adequate to its freshness, novelty, power and uniqueness; no work ever makes fully evident the adventures, the trials and errors, the struggle that went on to achieve it. Conversely, no knowledge of an artist's ideas or creative acts will be adequate to the work which is finally produced, for neither tells us about the nature of the medium or the beauty which finally characterizes the successful work.

A work of art is sensuous, concrete, embedded in a medium. There is no substitute for the experience of it. Every discussion of a work of art, because inevitably framed in general terms, will fail to capture its distinctive flavor and substantial being. But since all artistic creativity and its products have the same ultimate origin and motivation, belong to the same kind of enterprise, offer the same type of solution to man's problems, questions, doubts and inadequacies, one can intelligently deal with art in general. If we attend to the features to be found in them all, we can more readily understand the enterprise of art in relation to such other vital disciplines as mathematics, philosophy, and religion. We can also more effectively attend to the problems which face all artists, and can consequently become clearer regarding the nature of artistic creation and beauty, the role of the emotions, the place of representationalism, the kind of being works have, and the task of critics than we otherwise could. These and similar matters were topics of the preceding work, *The World of Art*. The present is occupied primarily with the arts as belonging to different classes or types. It comes closer therefore than *The World of Art* to the concerns of those who seek primarily to make, appreciate, or understand particular arts.

Works of art are produced when men make use of their existent powers to create something excellent. If they succeed they capture the texture of an essential dimension of existence and portray the emotionally significant meaning which existence has for man. Since the essential dimensions of existence are space, time, and becoming, it

is reasonable to distinguish the arts on the basis of their primary interest in one or the other of these dimensions. Architecture, sculpture, and painting are arts which create a space iconic of existent space. Musical compositions, stories, and poetry create a time having the texture and meaning of existing time. Becoming is creatively presented in musical performances, in the theatre, and in the dance. Each triad has its own kind of units. The units of the spatial arts have primary reference to the size of man, that of the temporal arts to the span of his attention, and the dynamic arts to his life pulse. Each triad too has its own kind of "negative space." The first takes account of empty places, the second of unaccented beats, and the third of rests.

There is a correspondence among members of the different triads. Architecture, musical compositions, and musical performances enclose a created dimension of existence; sculpture, story, and the theatre occupy a created dimension; painting, poetry, and the dance are the very dimension which they create. The recognition that there are three distinct types of art and three distinct positions in each type makes it easy to see that each of the nine basic arts has distinctive problems, tasks, and results. No one of them is superior to the others; all portray and reveal existence in distinct but equally important ways. Each has the same value, is faced with similar hazards, demands the same degree of devotion, and is to be pursued and enjoyed for the same reasons.

Art makes its demands on the whole man. It requires an integrated use of mind, body, emotion, and will. These enable him to lay hold of common-sense items or facets of them in distinctive ways and with distinctive results. A man's thought, action, response and decisions are parts of a single adventure in self-completion whose success is measured by what he creates. Works of art are measures of the degree of completion men achieve through the creation of a world in the shape of complete, excellent substances. These sustances are realities in which men and the world—the one as emotional, the other as a texture—are harmoniously united.

Each artist is the outcome of a long tradition, artistic and conventional. His work echoes with his memories, hopes, and fears, some quite subterranean. His every achievement is the result of a struggle in

which his tradition, ideas, and attitudes are altered. He ends with a product greater than himself since it is the outcome of a host of trials. It is also less than he is, for he is alive, still in the making, while it is finished, done with. He is best known through his followers and those who copy them. These make use of a filtered-down version of the common tradition, exploit surface feelings, work in approved ways, and accentuate the familiar or readily acceptable sides of experience. The artist's offspring make an appeal he rarely does. If we are to understand what it is that he produces, we must not only keep our attention focussed on him and his activity, rather than on his disciples or their work, but must know what it is that he can and does create.

The present book has as its task the examination of the kind of adventure and product which is characteristic of some long-established particular arts. It, together with the previous work, should make possible an understanding of the nature of art as a vital, indispensable, irreducible, and splendid civilized adventure in a cosmos at once threatening and benign. Neither individually nor together do the books make possible a more sensitive appreciation or help a man improve his capacity to make works of art. But they should help one understand what art is. If sustained by a genuine direct participation in art, they should help a man become more alert and to increase his tolerance for arts not yet recognized. And they should help him get a better grasp of the unique life and world in which an artist lives. Progress towards these goals will be accelerated by a consideration of some of the main kinds of spaces, times, and ongoings there are, by a classification of the arts, and by an awareness of what some leading artists take art to do and be. The remaining chapters of this part of the book are devoted to these topics.

PART I: THE REALM OF ART

I. VARIETIES OF EXTENSION

THE common-sense world in which we daily live is crisscrossed by ritual and convention, and overlaid with meanings which tell us more about our inherited beliefs, the lessons of experience, and the demands of practice than they do about the essence and native promise which objects actually have. It is the world of nature transmuted by the interests, needs, and values prevalent in our society. Trees in our common-sense world have features, values, and roles which Eskimos have not even surmised, whereas snow, cold, and distance have natures for them which are not discerned by us.

We come to know what objects in nature are really like by ridding common-sense objects of multiple accretions. This is best done by abstracting various strands from them, dealing with each strand systematically, and then understanding how all the strands can be together. Perception, science, action, and evaluation are four basic modes of apprehension which abstract strands from the common-sense world. Each frees features of common-sense objects from conventional accretions. As a consequence each enables us to see what those features are like, apart from the conditioning imposed by our societies. Each mode of apprehension, however, imposes conditions of its own. A feature dealt with by one has a character and role distinct from what it has when dealt with by another.

Common-sense space is a most irregular space, qualitatively different from place to place. It bumps and slides and twists in unexpected ways, depending in good part on what is in it and how this relates to society's practices and interests. It has many shifting and distinctive focal points. It embraces a plurality of privileged positions. Each of these answers to the fact that each man, ritual, institution, task, and cherished object is a centre towards which many things converge and from which many others radiate. It has a fairly clear up and down,

back and front, right and left, oriented with respect to ourselves or favored objects. We live within that space, moving and acting at different rates and with different stresses at different times, thereby imposing tensions and changing the quality of different regions around us. Common-sense space is a highly complex space. We grasp it only partly by means of our concepts, language, emotions, evaluations, and decisions. Nor do we do it full justice when we catch it within the mesh of our perceptions, science, actions or values. But in these latter ways we are able to abstract from, manipulate, and systematically organize it, and thereby have elements by means of which we can understand the space of nature.

What is red here is related, through the sense of sight, to what is blue there; what is warm here is related, through the sense of touch, to what is cold there; but we have no sense which relates the red or the blue to the hot or the cold. The seen is related to the touched not by a sense but by perception. The sensed world is a world without volume, without objects, without powers, peopled by nothing more than what is then and there the terminus of a sense. It is not the perceptual world. The termini of the different senses occupy different planes of a perceptual world, a world that can be known only if we judge as well as sense.

Perceptual space is a voluminous space. Within it observable objects are related and isolated as contrastive and supplementary contemporaries. Since previous acquaintance with regions of perceptual space makes a difference to them, perceptual space, in its parts and as a whole, necessarily has a changing nature.

The space of science is just a geometry. It has no volume, no roominess. As John Wild, following Merleau-Ponty and Heidegger, observes, it has no privileged centre, no directions which are measured by care or eliminated by approach, no horizon, no definite directions, no right and left. It is abstract and conceived, not perceived, not encountered, not sensed, not observed. Its nature is exhaustively expressed in universal, impersonal, objective terms, by means of variables, functions, numbers, algebraic formulae, and the like. It is not open to a traversal by any object.

We blunder when we speak of Venus as so many millions of miles

away from us, if by "millions of miles" we intend to refer to some multiple of the miles dealt with in common sense. A common-sense mile has an extension, and over it one can walk in a common-sense way. A scientifically defined mile is an abstraction from this, a set of numbers having no extension and allowing for no movement. If we want to go to Venus we must travel, not in a scientifically defined space, but in the space of common sense, or the more refined space of known natural substances. If we do the former we will move as common-sense men; if the latter, we will move as natural ones.

A space ship cannot travel along a mathematically defined path. That path has no thickness, no volume, no location with respect to us who are supposed to launch it and perhaps travel in it. A space ship can travel only in a time appropriate to substances from which one can abstract a perceived time, an eventful time, an urgent time, and a scientific time. When we, at last, set out in a space ship, our time will be primarily urgent; those traveling in the ship will be aware of lived time; when they land, they will look about in a perceived time. Throughout there will be charts prepared, changes made, observations recorded in the frame of a scientific time. That time will be no more but also no less real than the others. It will be real time dealt with under limitative conditions so as to make possible its readier manipulation or articulation. Not illusory, it still is not final, not as real as the time of nature or the time of existence.

The yellow ball we feel pressing down on us from the sky at midday is not the sun with which science deals. That sun is neither hot nor cold: it has only temperature. It is neither yellow nor red. It has no color, though it vibrates. Nor has it a shape. It is to be seen neither over our heads nor at the horizon. It is not visible at all, being without perceptual qualities and having no relation to a perceiver. It does not exist today or yesterday; it has no position in our daily world, but only in an abstract conceptual domain of related abstractions. It is a pattern of mathematically defined terms, strung out without extension and without efficacy. The scientifically known sun is a structure, the parts of which are so described and arranged as to make them into instances and termini of formal, abstractly expressed, intelligible laws.

The space of action, of *events,* is a space of constantly altering tensions. Each event has a sharply demarcated temporal beginning and ending, and within that span a space comes to be. That space is related to the spaces of other events to constitute a single region of eventful space. This eventful space is constantly being made and un-made, coming to be and passing away, since it is the product of vectors which overlap and separate in the course of the development of their sustaining events. Both the space of the events and the space between the events are abstractions from the events and their interplay. In neither space can one move or place anything, since each space is ex-hausted by the events and their vectoral interconnections. Some White-headians, however, have argued as though events were ultimate realities and all objects were derivatives from these. Were they right, there would be nothing which could act, and nothing which could be said to be the product of the action. A world of events is a world of happenings in which nothing is done and nothing is produced, a world of abstract occurrences which is disconnected from the worlds of com-mon-sense and nature.

The space of values, *evaluational* space, is a space of positive and negative affiliations, of oppositions and frustrations, adoptions and rejections, of subjugations and enrichments. If "dimension" is under-stood mathematically as a distinct direction to be expressed by an independent set of terms, evaluational space will evidently have an indefinite plurality of dimensions. That space is not perceived, not conceived, not acted in or through; it is a space which is appreciated, affectively responded to. Objects in it are distanced one from the other in multiple hierarchies of excellence. As our valuation system changes, the objects in evaluational space shift in position with respect to one another; this is the only kind of movement or change possible in that space.

Common sense has a characteristic time as well as a characteristic space. Its time has a private and a public side. The private time is a time of interests, feelings, sentiments, attention; the public time is a common time of interaction and interplay, of conditions imposed and submitted to. When we are impatient, angry, bored, irritated, our private time has a pace and quality conspicuously different from that

which it has for us when we are relaxed, pleased, or friendly. The public time is measured by common-sense occurrences, which vary in beat and color in different circumstances. In a battle one short moment follows hard on the heels of another; in a different situation the public moments are longer and slower in coming.

Public and private time are rarely kept apart; our irritation floods our apprehension of public time to make us annoyed with the pace of the public occurrences, and prompting us to take them to be faster or slower than they are. The public time in turn intrudes on our private time, accelerating and slowing it in various degrees. Both by themselves and together the two times change in speed, rate, and quality according to the kind of content through which they pass. Both have many nows within them, each oriented in objects of interest, in distinct individuals, and in distinct situations. Neither stretches out endlessly towards the past or future; neither flows equably; both measure rest as well as motion, silence as well as sound. In each there are many divergent lines of passage, separating and converging, overlaying one another in unanticipatable ways. We live through and in both of these times, constantly adjusting the one to the other. Our daily time is a most complex time.

The time ingredient in what we perceive, like public time, is extended. Were it not, it would be gone before we could attend to it. Since we do not perceive what is past or what is future (for the past is gone and the future is not yet), what we perceive is evidently present, and the time ingredient in it is necessarily a present time. Psychologists sometimes misleadingly speak of this perceived time as a "specious" present. Some seem to suppose that it is not real, not objective, but something produced by men who somehow convert an actually unextended present into an apparently extended one. But one has no right to say that the perceived present is specious, unless he can show that time is only a succession of unextended presents, or that all perception is inescapably illusory. Time is not specious unless we in fact instantaneously encounter unextended contents, and then somehow combine these to make something fictitiously extended. William James popularized the term, but apparently intended to reject the associations which usually accompany the term "specious."

". . . we are constantly conscious of a certain duration—the *specious* present—varying in length from a few seconds to probably not more than a minute . . ." "The practically cognized present is no knife-edge, but a saddle-back, with a certain breadth of its own on which we sit perched, and from which we look in two directions into time. The unit of composition of our perception of time is a *duration*, with a bow and a stern, as it were—a rearward and a forward looking end."

Perceptual content is always spread out, sometimes spatially and always temporally. It carries within it the effect of the immediate and sometimes of the remote past on us. We confront it not as an isolated item but as charged with memories and habits, and thus as affected by our impressions of what we had encountered in the past. We do not passively look at a green circle, passively listen to a high pitched cry, or passively feel the razor's edge. Each of these is perceived as already involving us, because we had been involved in similar or related experiences before. During our perception of them, they and our emotional tones alter, for the past out of which we are issuing is, through the intrusion of our habits and memories here and now, making a difference to us and what we confront.

No perception encompasses a simple uniform content: none is simply present. What we perceptually encounter is a directed present stretch of content under the primary governance of what has been. The past is now present in what we perceive through the agency of a vital recall, conscious and habitual. The future is also now awaiting in it, and can even be said to be present in it by virtue of our anticipations, habitual and conscious. What we perceive is perceived as that which will continue or change, or will be followed by some other content. Our content leans over into the world to be under the pressure of what we experienced and what we anticipate.

If we separate the effective past and future out of our perceptual content, the residuum will be like what Locke, Berkeley, and Hume took to be the original data of experience. But they surely followed an odd procedure, telling us that the way for us to find out what is in fact experienced is to replace what we know is experienced by something which we find only by analysis. It is conceivable that a datum

completely purged of all past or future elements is more real than one which has these as integral parts. But one thing such a datum is not: it is not experienced, not perceived. Our perceptual data are ordered, quickened, and qualified by an intrusive past and future.

The physiological theory of perception, which is in the main accepted by most contemporary philosophers and psychologists, avoids denuding the world of experience to the degree that the English empiricists did. According to this view we perceive the antecedent of a whole series of occurrences in the air, and in our organs, nerves, and brain. But in this way we turn the evident facts upside down, for we then deny that we perceive the past in what is present, and hold, instead, that while in the present we perceive only what is past. On this view we would have to say that we are always peering back into a world that no longer is, and have no acquaintance with what is now contemporary with us. If we are to take perception seriously we must take the perceived as it presents itself—sensuous, complex, exterior, present, durational, and observed.

The time that concerns science is distinct from that known in perception. Scientific time is totally sundered from all sensuous content, as both Galileo and Descartes made abundantly clear. Following their lead it is today described as a set of world lines, a structure of mathematically ordered, law-connected "dates" or numbers. Among contemporary philosophers, Donald Williams seems almost alone in his awareness that there is no passage in it. His message was missed because he spoke as though scientific time were the time of experience or existence. Scientific time is a time in which nothing acts, nothing happens, no thing in fact exists. Like perceptual time, it is real time under a distinctive limiting condition.

Neither the whole nor the parts of scientific time are in a temporal relation to us, or to the things with which we interact. Its present is just the boundary between two unlimited arrays of numbers, one with positive, the other with negative signs. One should not, strictly speaking, say of it that it embraces a past or a future, and one cannot therefore, strictly speaking, say of it that it contains a present, if by "present," one means something at once extended, perceivable and encounterable. The dates in scientific time are merely numbers. Putting

plus and minus signs before those numbers does not make them into future and past times joined by a present.

The fact that the "present," "past," and "future" of scientific time are merely numbers need cause no embarrassment. More is needed only where genuine passage occurs, where time in fact passes. But scientific time does not pass; there is nothing from which, to which, over which it could go. It is a static array, unperceived and uneventful. Still, it is right to speak of it as a time, for it has a direction, and is extended in the sense that one portion can be said to be more distant from a given "present" than another.

Eventful time is distinct from both perceptual and scientific time. It embraces a set of unit occurrences, turbulent ongoings in an extended present, atoms, each with its own beginning and ending. The units have no effective pasts or futures, though one can distinguish within them a portion which is before and another which is after. The being of an event consists in its coming to be. Once it has come to be it necessarily perishes, as Whitehead insisted. But also, an event is no less tenuous, abstract, distant from the real time of acting substances than is the time of perception or science. When substances by their interplay constitute an event, those substances continue to remain outside it, with their own particular times.

There are short-range events and long ones. The Rockies are slowly crumbling to dust. Their story occupies one long event. The movement of an aspen leaf is short termed; there are fewer distinguishable elements within it. The movement of the aspen is finished long before the Rockies cover a fraction of their span. Were events the final stuff of the universe we could not say this unless we were to take a stand outside both events, or were to use the leaf's movement to measure the length of a present moment. In either case we would have abandoned the event which is the Rockies. That event is one single present, not a sequence of presents, each just large enough to span an aspen's flutter. We do not grasp the full nature of that present because we do not get inside it. We do not live in its present but in the presents of smaller events, such as the steps of a mountain climb, which provide units by means of which we can subdivide and measure the larger.

Inside the one event of the Rockies, there are distinguishable stages

marking the Rockies' growth and decline. All are part of a single, indivisible present event. That event is not coordinate with, and cannot be related to other events. Because each event is self-confined, each with its own present time, it cannot be correct to say that events together can by themselves constitute a universe.

The future, for a present event, is nonexistent. The past of the event is dead. Like the future, it too is without efficacy in the present of the event. He who can accept a theory in which an exterior past operates on the present of an event will be a sufficiently powerful cosmic jumper to make it possible for him to leap from present to past, from present to future, and from future to present. And since a two-fold impossibility is no more difficult than a single one, there ought to be no difficulty in his jumping over the present entirely, and getting from past to future and from future to past in one move. A past effectively operates in perceptual time, and a future effectively operates in important, in urgent time; neither operates in scientific or in eventful time.

Events are singular universes containing within themselves times which are wholly present. That present is not the present of perception, but like it, is extended, ordered, and objective, though abstract. A so called preceding or succeeding event is an event with its own present, unrelated to the event which is to come or which had gone before. For it, what had been is no longer, and what is to be is not yet. He who lives inside one of these events knows nothing of what had been, what will be, or what is alongside. His philosophy is essentially Hume's, though one relating not to sense data but to events in the experience of man.

Events are not fictions, but, also, they are not the real. If we treat a musical piece as an event, we will therefore not make it illusory. But we will also fall short of grasping it in its entirety. We will see it as a single piece, all in a present, disconnected from any other present. We will then in effect have "musicalized" ourselves, made ourselves part of the musical event. We will then live through and in the musical piece—which is what we seek to do when we read it. That there should be a time perceived outside the piece only shows that there is more than one kind of time, and that these have considerable independence.

A hall is hired for three hours, and the janitor begins to complain. He lives in one event and carries a watch by which he can measure the length of the concert. That he is bored is just as true as that the audience is excited, and that, from the position of a common-sense clock, both of them have been inside the hall for three hours. The janitor's event is not longer, the audience's event is not shorter than three hours. By the clock they are equally long; apart from the clock they are incommensurable.

In urgent time, the time of *importance*, the future is operative in somewhat the same way as the past is operative in perception. Much neglected by philosophers, it is a time that has been of great concern to religious men, politicians, and historians. The ancient Hebrews lived in the light of the coming of the Messiah. Christianity lives under the aegis of a day of last judgment. Both are sensitive to the idea of world which is governed providentially, in which the future casts its shadow on the present and thereby makes many things, thought bright and valuable, flat and dull—and conversely. The time of importance is a present restructured, directed, redefined, over-whelmed by a future now operative in it. A precipitating, effective future is now doing its work, making what now occurs the locus of a movement from the end to the beginning. That future alters the meaning of what has occurred, forcing us to write our history anew every time we freshly grasp what that future is; it assesses us and therefore determines whether or not and to what degree we have been good or bad, properly responsive.

Important time is not a time in which we daily live. It is surely not a time which we perceive or for which we can give a scientific account. It is like the time of an event, except that there is no ongoing, no becoming in it. Still it is not an eternity, for there is sequence in it and even change, though the change is a change in status and not in nature or place.

The future that is working in important time directs and assesses, thereby making value present, and defining what is past. It is a time in which one works to produce the beautiful. Musical compositions are written primarily in that time. The composition is of course begun at

a certain moment marked by a clock event; it is open to perception and to scientific study. But it has accents and rhythms and a tonality which are brought about only by going through a time of importance where future desirable prospects govern what is to be.

Perceived time, scientific time, eventful time, and the time of evaluations differ markedly. And all of them are distinct from daily common-sense time, as well as from the time characteristic of nature. Daily time is these different times inchoately together and qualified by social conditions. The time of nature is these times intelligibly together and then as outside all social conditioning. Both common-sense and natural time are qualitative, formal, transitional, and value laden. Their component times divide these characters amongst themselves.

The common-sense world is spatial and temporal; it is also dynamic, insistent, transformative, embracing a sequence of becomings and passings away, each of which has a rhythm, span, nature, and extension of its own. In it there are processes of the most diverse kind, each grounded in a distinctive object. It is a world in which things serve as origins, termini, loci, and grounds for a continuum of short-ranged, efficacious happenings. That world has an impersonal and a personal component, the one encompassing the currents pertinent to institutions, the other relating to ourselves, to the activities in which we engage, and to the objects in which we interest ourselves. All of us come to be and pass away in a corner of society which is held over against a more extensive process of the whole society and its institutions. The personal and the impersonal are both subdivisions of a common-sense world of becoming, the several parts of which interplay with one another in unpredictable ways. Our daily world is, consequently, a pulsating one, with many foci, boundaries, centres, causes, and effects. Only an occasional repetitive mechanical pattern can be discerned in it. Its objects, human and animal, inanimate as well as animate, are both purposive and free.

Perception offers one way of isolating a single manageable strand within the dynamic, complex, irregular, unstable common-sense world. Each perception encompasses diverse kinds of sense data. The different sense data occupy distinctive fields and have distinctive rationales.

Since each sense datum has its own tempo, a perceptual object necessarily encompasses a plurality of ongoings qualitatively and effectively different from one another.

We are assaulted, our attention is compelled by what we confront. Our perceptual objects are seen to be insistent and resistant; there is, as Peirce remarked, a *hic et nunc,* brute side to them. We seem to be passive when we perceive what is dynamic, but we are not so in fact. We have merely been overwhelmed, dominated by what we confront. Sense data, and the perceived unities of these, are realities. When derived from the dynamic side of the common-sense world, they have features which they do not have as purely spatial or temporal. Both are abstractions from a richer, more substantial common-sense world, abstractions which are more coherent and more readily identified and systematized than that from which they were derived. And what is true of perception is true of the scientific formulations which constitute the scientific world.

There is no activity in the scientific world. There are no depths, no potentialities, no entities in it which are capable of action. When we speak in science of forces and energies, of actions and reactions, and of causation, we speak only of abstract structures and their rationally ordered parts. The laws of science express only what the scientist is able to abstract, purify, universalize, and connect.

Neither severally nor together do science and perception present us with something which is intrinsically dynamic. Percepts pulsate and scientific hypotheses implicate. To find that which is vital, effective, sheer ongoing throughout, one must attend to events. Events are happenings, transitions, processes. Each is a realm of sheer creativity in which there are neither compulsions nor laws. But for all their vitality events are only abstractions. He who says that one event is preceded or followed by others, must go outside the given event. The flux of Heraclitus, the Will of Schopenhauer, and the *élan vital* of Bergson are the result of their expanding an event to cosmic proportions, supported by the supposition that the outcome is ultimately real.

For action to occur there must be substantial beings. They must have an inherent vitality, not entirely sunderable from a rational structure and perceptual qualities. A philosophy which stops short of

the acknowledgment of substances cannot ground an ethics, a politics, a history, or a philosophy of art, for all these refer to beings which do not merely come to be and pass away, but which make and act. There is no making or acting in a world where there is only process. Action and making presuppose the existence of persistent beings with powers that they can express over a period of time. Only such beings can accept, begin, sustain, and complete a task. Whatever has its being exhausted in its becoming has no energy left over for any other work but that of perishing.

Men have always recognized a fourth strand, the strand of import-ance, in addition to the perceptual, scientific, and eventful. They have always spoken seriously of fortune and fate as having a power which affects the value of themselves and their cherished possessions. The ex-cellencies, the desirability of things are recognized by them to be sub-ject to hazards having nothing to do with the logic of perception, science or events. Everything is constantly and unpredictably sub-jected to realignments. A cherished object, quiescent and unmolested, may suddenly have its status radically altered. Without any evident warrant, it may usurp the place another had long occupied. The dice roll well for the thief and poorly for the man he robbed; there is love at first sight, a love which ignores the most obvious faults, virtues, defects, and merits.

From the standpoint of perception the process of re-evaluation is capricious or blind; from the standpoint of science it is irrational or illusory; from the standpoint of events it is effete or supernatural. But it is no more abstract, no less real, no more or less mysterious than themselves. It exhibits the outcome of the operation of final causes, stemming from the ideal.

The fact that fortune smiles provides no evidence that those it favors have an excellence denied to others. Jack Horner drew the wrong conclusion. No one has a warrant for thinking that the process of evaluation expresses the intent of some external real power. It is an error to give the process a human form, to suppose it attentive to human acts and hopes, or to think that it has a special bias towards specific individuals. Good fortune does not testify to the presence of virtue in men. It is but a testimony to the impersonal operation of the

ideal, to be isolated in a strand of importance, running through the entire common-sense world.

A common-sense object is a substance in which perceptual, scientific, eventful, and important elements merge imperceptibly into one another. Sometimes one of these elements is dominant, sometimes another. That is one reason why common-sense objects are so difficult to keep in clear focus, why those objects are so lopsided, so irregular, so hard to understand. The abstractions we derive from those objects are freed from the accretions society imposes. When we unite those abstractions, we forge an intelligible unity of them. They then become integral parts of known substantial natural things. An object in nature is a common-sense object purged of its societal components; it is known when we combine the perceptual, scientific, eventful and valuational elements that we had abstracted from the common-sense world.

The space, time, and becoming of nature are apprehended in partial and qualified ways in perception, science, action, and value. To know them we must synthesize the different guises which they exhibit in the different strands. The synthesis results in a concept reporting essential features of nature. Known nature is a conceived unity of distinguished, purged aspects of the common-sense world, an intelligible abstracted unity of strands. This does not mean that there is nothing apart from us, independent of our societies, our modes of apprehension, and our syntheses. Not only is conceived nature more objective than the common-sense world, but it is rooted in an irreducible reality, the domain of existence.

To learn what existence is we must either speculate or create. If we do the former, we will know something of its nature, but will not grasp its texture or be aware of its import for us. We turn to art to know about a reality more coherent than common sense, more concrete than what can be caught in perception, science, action or evaluation, richer and more fundamental than known nature, and more directly and emotionally felt than is possible in philosophy. Each work of art is a creation which, because it makes use of the existence in and about ourselves, enables us not only to reproduce the texture of a real space, time, or dynamics, but to portray it in significant, sensuous terms.

2 . A CLASSIFICATION OF THE ARTS

IF ACCOUNT is taken of the fact that artists have been active in almost every land, and apparently as long as man has resembled what passes for a human today, it is evident that there have been more works of art than anyone has had an opportunity to know. The arts with which we already have some acquaintance differ considerably in material, structure, content, and method; the rest undoubtedly differ even more. No one could possibly deal with even the small segment that has found its way into the histories, galleries, and museums unless he is guided, at least implicitly, by general pertinent principles. Such a guide makes it possible to deal systematically and steadily with what otherwise would be an unmanageable miscellany. At its best, it also points up the important affiliations and divergences which exist among the arts, makes us attend to the areas where further study would be desirable, and throws light on art's tasks and achievements. There is, of course, considerable danger in the use of any guide. The more successful it is, the more surely is one tempted to turn its principles into absolute canons, thereby making it difficult to recognize as arts what is not clearly warranted by those canons. The gain in control and understanding which a generally applicable principle provides is counterbalanced by a tendency to use the principle to blind and rigidify. The best way of avoiding these undesirable results is not, however, by refusing to make use of any principles. In that way we will but place ourselves in the position of having to make only arbitrary connections among the arts. It is better to make the needed principles explicit while remaining alert to the dangers which accompany their successful use.

There are many ways of dealing with the arts systematically and intelligently. The most common is perhaps one which makes reference to the milieu of the artists or to the time in which they flourished; arts

are usually grouped according to place and date. Such classification rests on the supposition that the arts reflect the world in which they were produced. This they surely do. The arts of a given society and historic period have much in common with one another, with the prevailing mythology, religion, and philosophy, and with the dominant structure, the characteristic adventures, and the typical activities of the culture and day. None of these may have been consciously noted by the artist; he might even have set himself resolutely to oppose all of them. Yet the prevailing patterns make their presence inescapably felt in the language, the routine life, the omnipresent customs, rules, and habits which characterize him no less than it does the other members of the culture and period. Still, a work of art is much more than a function of a given time and place. The differences to be found among the works produced in a given place and time obviously cannot be explained solely by making a reference to a common culture. If it be true that the main difference between Indian and French poetry of the nineteenth century is that one fits inside Indian and the other inside French culture, it is also true that both are poetry. They are certainly at least as closely affiliated with one another as poetry as they are to the architectures that were produced in the same areas at that time.

At the very best, an historical or cultural ordering of works of art cannot be of much use except with respect to the arts of the past. Also, new discoveries in archaeology and new interpretations of history will force one to revise one's conclusions every few years. More important, no historical or cultural approach to works of art will enable one to know the difference between a trivial and a bad work, an important and a good one. Nor will it enable one to tell what difference there is, say, between a poem and a dance. Indeed such knowledge is presupposed by all those who deal with art from an historical or cultural standpoint.

No one is so much a positivist that he refuses to distinguish between important and minor works, or good and bad ones. Not every shard a shovel turns up finds or ought to find a place in a museum. And no one is so much a contextualist that he refuses to distinguish between different types of art, not merely in terms of what the culture

recognizes to be distinct, but in terms of a more comprehensive under-standing of the essential features of the different arts. Though a culture may have no word enabling one to distinguish a poem from a dance, it would be folly to forget that the one makes use of words and silences and the other of movements and rests, which we, with our larger vocabulary, ought to remark.

A better approach to the ordering of works of art than that pro-vided by an historical or cultural approach is one which signatures offer. What we now usually take to be a signature is the *mark* placed by an artist on his work, to testify to his having made it. But this is perhaps the least common of six types of signature and is of import-ance primarily only for ready cataloguing and identification. A more common signature is one which reflects the techniques of a place or time. It is to this we refer when we remark on the *style* of a work. Although it is sometimes deliberately produced, as a rule the style is not even known by the artist or the contemporary spectator. A third, somewhat related signature, is one expressed in the *manner* of compo-sition by means of which an individual or his group, usually without deliberation, organizes or structures a work in a characteristic way. One manner may embrace many styles; one style allows for many manners. A fourth type of signature is evident only to those who have considerable historical knowledge and analytic powers. This enables them to break down works of art into parts and relations each having a distinctive *symbolic* import not necessarily intended or noted by the artist. A fifth type of signature is inevitably and unknowingly pro-duced by the artist, because he is a creature of habit and training who always leaves *evidences* of himself in whatever he does. No matter how self-consciously and deliberately a man may set himself to walk, he will inevitably exhibit a characteristic and long habituated way of holding his body, hands, and neck. Similarly, no matter how resolute an artist is in trying to escape his own habits, he will inevitably ex-press some of them in a characteristic form. Finally, every artist has a distinctive *outlook*; he takes a characteristic stance and allows this to dominate his choices of pitch or color, movement or incident, and the way these are to interplay.

Signature stops where spontaneity, freshness, genuine novelty enter

in. But a work of art is these together; it marries habit and originality, stability and exuberance. An ordering of works by signatures will therefore miss an essential ingredient of the works. Also, an artist can leave the same sixfold signature in a number of different arts. Picasso's sculptures have the same signature as his drawings and paintings, particularly in his cubistic period. An ordering of the arts by signatures will, then, not always enable us to distinguish different types of art.

A better and almost as long-established a way of ordering the arts, takes one art to serve as a model and arranges the others on the basis of a judgment as to how closely they approximate to it. Cellini thought that sculpture was eight times as great a subject as drawing and painting because, said he, a statue has eight views which had to be good. Leonardo da Vinci thought painting was superior to sculpture because it was more intellectual. But each art has its own problems, the solutions to which are as difficult to obtain and as revelatory of the world as any other. All arts are of equal value. They ought not to be placed in a hierarchy of better and worse. A hierarchy of better and worse properly relates to the success achieved by an artist in some work or other; it is not pertinent to the arts as such. There are, of course, long-established arts and new ones, simple arts and compound ones, arts which are favored by a multitude and others which interest but a few. But as arts, they are all on a level; no one can take the place of another; each is complete in itself, offering a final excellence and a perspective; each in its own way exhibits equally well the features which mark off the arts from all other enterprises. Cellini was surely wrong in thinking that a statue has eight sides and that a drawing has only one. A statue has an endless number of sides, and a drawing can be seen from an endless number of angles, distances, and points of orientation. But even if it were true that a sculpture had eight sides and a drawing only one, it is also true that both arts are irreducible, and when successful equally exhibit beauty and tell us equally well something of the nature of reality.

The positions—that some art is superior to another or that, as here maintained, they are all on a footing—are either arbitrarily assumed, or presuppose the use of principles in terms of which all arts can be

justly evaluated. Both of these alternatives attend to what is essential to an art, regardless of why or how it was produced. Either offers a better approach to the arts than is provided by an ordering of arts according to date, place, or signature. An inquiry into the kind of principles that can be used for classifying the arts will, though, I think, lead one to recognize the superiority of the second alternative.

There are at least five distinct principles—formal, transcendental, motivating, psychological, or ontological—to which one might have recourse in an attempt to classify the various arts. Each principle provides criteria in terms of which all the arts can be assessed, interrelated, and understood. Each is rooted in a distinctive theory of the nature of art; each requires a distinctive ordering of the arts.

A *formal* principle is the object of man's reason. It may be newly produced or extracted from mathematics or science. Those who invoke such a principle often tend to treat the arts as illusions produced by passionately adding obscurities to what otherwise would be clear and distinct. They tend to belittle the values ingredient in art, to overlook its rationale, and to miss what it reveals. It would be better to view formal principles not as obscured, but as carried out by works of art. Yet if one supposes that arts merely exemplify formal principles one will ignore not only the concrete, sensuous vital contours of art, but the roles which the emotions play in creation and enjoyment.

A *transcendental* principle is not as abstract or detached as a formal one. It refers us to a God, to Platonic forms, or some similar reality whose virtues or powers the arts are supposed to exhibit at some remove. The principle can be thought of as self-manifesting or as being elicited by the artist. In either case, it is usually held that the transcendental principle is muted when it enters into the arts, with the result that it becomes indistinguishable from a purely formal principle. This result can be avoided. Just as one can, with Berkeley, view the world as God's language, God's intent made directly manifest, so one can treat a work of art as an expression of a transcendental principle. Such an approach will make it possible to deal with all the arts from a single position. But it will also lead one far from the arts themselves, will tend to make one neglect the role of the artist, and will

fail to take account of the activity of creation. We need principles which are as widely applicable as the transcendental ones. But unlike these, they should ride on the back of the driving forces that govern men's activities.

A *motivating* principle is one which takes art to be grounded in efforts to bring about some end. When one says that architecture arose from the need to worship, sculpture from the need to commemorate, painting from a desire to record appearances, and so on, use is being made of a principle of this kind. This is also the case when artists are said to be creatures of a patron, society, or political force. Insufficient attention is then paid to the fact that the work of art is revelatory of reality, and that the artist sometimes ignores and even defies the prevailing social or political powers.

Most psychologists know that man is not a mere avenue for the expression of impersonal forces. They therefore try to account for his art by attending to some peculiarly personal facet or power. In the light of the pluralization of psychology in recent times, their *psychological* explanations of art take many forms. They treat it as an expression of an unconscious, of a will, of emotion, or of some drive.* Such accounts fail to show what it is that the unconscious, the will, the emotions, the drives must obtain, and why it is that art can provide this. If it is said that the unconscious, the will, and so on, seek pleasure or satisfaction, it still must be shown why it is art that gives this pleasure or satisfaction.

Men are organic, unified beings who are concerned with many things in addition to art. They are motivated by a deeply rooted and constant need to become complete. And they can become complete by mastering what is other than themselves. Art offers men one of a number of possible ways in which this completion can be achieved. Men do not deliberately engage in art to achieve this completion; the completion is rarely consciously sought. Nor is it necessary that it be

* One of Plato's accounts of art belongs here. According to him, art originates in a private, inchoate emotional drive which produces a distortion of truth and a disruption of political stability. Art therefore deserves to be criticized by anyone who takes truth and politics seriously. But it is questionable whether art distorts rather than presents truth, and it is questionable whether one ought to take politics so seriously that whatever conflicts with it must be censored or rejected.

sought through the agency of art. The drive behind man's interest in art is below the level not only of consciousness but of the unconscious. It is *ontological* in nature, to be satisfied by something which is or represents the real. Art can provide a deep satisfaction to men because it both presents them with and reveals a reality which they must master in order to grasp who they are and what the universe promises them.

Man is concerned with mastering existence, that all-encompassing region of space-time-energy of which he is a finite part. He can master it to some degree in direct encounters, through technological devices, and through the agency of thought. But in none of these ways does he deal with the whole of it in its concreteness. Encounters and technology put him in direct touch with only parts of it; speculations tell him about the whole but only in abstract terms. Art alone enables man to be aware of existence as one, concrete, and ultimate.

Existence manifests itself through man. His basic activities, interests, and disciplines exhibit existence in many distinct and independent guises. The powers he uses in his art are existential powers, by means of which he conveys the meaning of the whole of existence. Art is his device for coming to effective grips with existence by portraying its space, time, and energy in appropriate ways. The principles in terms of which we deal with art should be ontological, for it is these which enable us to show most effectively that art creatively relates us to an existing space, time, and energy.

Space has a distinctive structure, defining the occurrences in it to be contemporaneous. It offers time a place through which to pass and allows energy to be expressed in a field of tensions and contrasts. Treated as a synthesis of the others, space is that which enables time to have endurance, and energy extensionality. From the perspective of the others, however, space is just a rigidification of them, the dead ashes of their vital play.

Time offers a perspective on all else. Space, in its perspective, is but the outcome of reciprocal temporal references, and energy is but a sustaining power, the locus of time's expression. Time also offers a synthesis of space and energy, a unity by virtue of which energy can come to occupy space and space can function as the locus of resistances and insistencies. Time is the route over which energy expresses itself

in space, and space sustains energy. Time also can be treated as an attenuated form of the others; it is space deprived of its concreteness and made one-directional, energy denied power and volume.

From the perspective of energy, space and time are but expressions; it dictates their rhythms and breaks, their contours and dimensions. Energy also offers a synthesis of space and time, a way in which the two are welded into one. Space here is the concurrence, time the sequential aspect of a unitary dynamics. Energy is also subordinate to the other two; it is the inside for which time is the outside and space the synthesis. Energy finally is space made manifest and time reduced to movements, with a consequent double loss of vitality.

Since existence has three dimensions, there are three types of art—spatial, temporal, and dynamic. Each type is occupied with the conquest of its appropriate dimension through the creation of works in which that dimension is reproduced in a controlled and experienceable form. Since each dimension can be treated as subordinate to two others, each type of art can be subordinated to two other types of art. But since each dimension viewed in its own terms is also irreducible, each must be recognized as distinctive and on a footing with the others.

All the works of a single type create an appropriate dimension—a space, a time or a becoming. The arts divide within a type depending on whether they bound, occupy or exhaust the dimension. Architecture bounds, sculpture occupies, and painting exhausts space; musicry bounds, story occupies, and poetry exhausts time; music bounds, the theatre occupies, and the dance exhausts energy. ("Musicry" refers, among other things, to the composition of music—"music" to its performance—see Chapter 7.)

Each of the spatial arts profits from a knowledge of what is accomplished in the other spatial arts. A painter looks about with an architect's eye and treats all spaces as regions with boundaries. Even the oriental painter with his desire to allow for no well-defined limits, either to the world or to his work, does this. The painter also treats objects as sculptural unities when he views the spaces between them as having a power to keep them apart.

The sculptor works within an architecturally defined environment

and enjoys his own work as an element in a single self-contained whole. Similarly, the architect is alert to the sculptural and painterly aspects of nature and art. Instead of attending exclusively to the nature of a region which he is to stabilize through the use of rigid materials, he notes the sculptural components within that region as well as the sculptural significance of the region itself. Within that region divisions are made which harmonize with one another as well as with the whole. The architect's materials both fill up and divide spaces. The work with which he is occupied is always part of a larger spatial whole, and in that larger whole his own accomplishment serves as a sculptural unit separated from other similar units by a spatial interval. He also sees his demarcated regions merging with others. For him, subdivisions are so many surfaces sliding into one another, intersecting and supplementing, to be solidified into a self-sufficient whole with integrated subordinate regions.

Painting, sculpture and architecture also find a place for both time and energy. In the spaces of Pollock and Van Gogh a time and an energy are used which, while not repeating, elicit and evoke the rhythms exploited in other arts. Moore's sculpture attempts to capture or at least evoke the dynamic rhythms of existence; Calder's mobiles try to catch the time intervals. Energy is reflected in modern buildings and bridges, when these expose the musculature of the beams; time is to be found in the way in which movement slows and accelerates in going forward and backward, upward and downward, in the course of a reorganization of various spatial blocks. More evidently, when architecture embraces city planning, time is provided for in the traversals of the architectural space.

The temporal arts of musicry, story and poetry are irreducible. Each also provides a perspective and a synthesis for the others, and can be treated as a component in or as a residuum of them. Musicry creates an encompassing time, a time in which subdivisions can be made and through which beings can live. From its perspective, story is a specialized art indicating the way in which certain effects are produced in time, while poetry, by using words in a more specialized way than story, is seen to exhaust whatever time musicry made possible. Story accentuates the rhythms of time, pointing up the meaning of

a world beyond discourse; poetry fills up the time which musicry bounds, and vivifies what story has created.

Musicry offers a synthesis of poetry and story, balancing the one by the other. It is, in turn, a component of a synthesis expressed in story and of a synthesis expressed in poetry. Story supplements it with poetry; poetry supplements it with story. It is also a residual phenomenon. We begin by using language dramatically to express our vital concerns, and only when its vital edges have been worn away through use or inattention do we have the broad gauged rhythms of musicry. Our initial use of language reflects our emotional grasp of the world; in the effort to communicate we tone down the stresses, eliminate the private nuances and connections in it and thereby move towards the more universal patterns exploited in musicry.

Story—which includes short stories, novels, and scripts for plays— offers a primary perspective on the other arts. From its position musicry flattens out the tensions of daily life and imagination, and does not answer to the vital involvements of men. Story sees poetry as being too self-contained, as having too small a canvas, as too oriented towards the poet, and thus as not allowing vital interchange between men and the world. For story, poetry is overpersonalized, a part of a total situation which the story exhibits. In contrast to story, poetry verges on being the language of only one man, and musicry tends to be the language of an anonymous group.

Story offers a synthesis of poetry and musicry. Musicry provides it with a daily time in which we make contact and communicate with others, while poetry gives it a vitality and dimensionality, nuance and intensity. Story is at once individual and common, answering to the nature of men and the vital experiences they undergo. Offering a language which appeals both to an individual and to all men, it is also, as we saw, a component in the syntheses offered by musicry and by poetry.

Poetry unites musicry and story, filling out the rhythms of the one with the tensions of the other, subduing referential elements by means of more universal, self-contained rhythms. It is more personal than musicry, and less involved in human affairs than story. It is, as we saw, an element in, and a residuum of the other two as well.

No one of these temporal arts is purely temporal. All take up and exploit space; all use and exhibit the nature of energy. Lewis Carroll and Guillaume Appolinaire bring out the spatial components of poetry; e. e. cummings brings out its vitality. Stories are envisaged as taking place in a space and involving vital interplay; musicry is concerned with prospective voluminous tones requiring different expenditures of energy.

The performing arts of music, theatre, and dance have spatial components. Music fills the hall; actors are on the stage; dancing creates a sequence of spatial regions. All three also have temporal components. Indeed so obtrusive are the latter that these arts are often taken to be merely temporal arts. But they are all more than spatial or temporal: they are dynamic, energetic, creating new modes of becoming.

Each performing art can be treated as offering a perspective on, or as a unity of the two other performing arts; it can also be viewed as a component in each of the other two and as a kind of residuum left behind by each. Since they have these roles for reasons analogous to those relevant to the spatial and temporal arts, there is perhaps no need to spell them out. It is, in fact, more important to recognize the signal contribution made by each type of art and its subdivisions than it is to recognize the fact that each contains something of the values, virtues or interests of the others. A painting, e.g., makes space visible. The architectural and sculptural aspects of that space are incidental and subordinate. Even more obviously, the painting cannot do justice to time or becoming. Indeed, it has no real concern with either.

All men seek to create existence in the form of a domain, a claim, or an epitomizing being. The arts of architecture, musicry, and music provide them with an answer to the need to create an extended region. Sculpture, story, and theatre satisfy the need to create a claim to a space, time, or process of becoming. Painting, poetry, and dance are arts which create beings epitomizing the whole of space, time or becoming. Because each art stresses one of the dimensions of existence more than others and deals with it in a distinctive way, it is desirable to deal with each art as though it attended to just one dimension of existence and then only in one of a number of possible ways. One can then also make evident why it is not possible to combine all arts to

obtain an all-inclusive art. By combining a number of arts, one obtains a new unity of the dimensions of existence; while this may illuminate what separate arts left dark, it will not be adequate to what they individually master.

Every one of these arts can have a relaxed form. Painting relaxes into "doodling," sculpture into decoration, architecture into engineering; poetry relaxes into punning, stories into tall tales, and musicry into metrics; dancing relaxes into gesture, theatre into conversation, and music into melody. The relaxed forms lack the concern, discipline, and revelation characteristic of a genuine art.

Other arts serve sometimes as sources of materials for the more basic arts. Thus, textiles offer architecture coverings, walls and textures; cloths and clothing are material for sculpture; they may also provide painting with the stuff for montages. The matching of perfumes, cooking and the like can be viewed as relaxed forms of art. But like those which produce materials, they are more properly taken to be subordinate or minor arts; they lack the tension, the vitality, in any case, the self-sufficiency of the major arts.

We are now, I think, in a position to make a detailed examination of each of the nine basic arts. But a great deal of benefit can be derived if we first attend to some of the observations made about them by some distinguished practitioners.

3. SOME OPINIONS ON ART

PHILOSOPHERS tend to provide accounts of art primarily from the position of spectators, and in terms of a theory of knowledge forged to deal mainly with issues raised in common experience and in science. Artists, on the other hand, think primarily in terms of the activity of production itself; untrained and undisciplined in the use of abstractions, their discourse is often cryptic, overly dogmatic, and unorganized. Students of the arts—historians, connoisseurs, iconographers, collectors, dealers—tend to side with the philosophers in assuming the position of spectators, but balance this with a preferential use of aesthetic categories. Unfortunately, they rarely have a way of so expressing themselves that they do justice to what they sensitively discern.

As a consequence of these three limitations, there is no clear account available about the nature of art from the position of both the creator and the spectator. In the attempt to overcome these limitations, I have culled some arresting comments on art from various sources and have appended to them brief remarks of my own. This is a device peculiarly suited to art and to mystical experience. In a book on ethics there is no need to call attention to what good men have said about virtue and obligation. In politics one might, with Machiavelli, report the actions of successful men of practice, but will have no need to quote their comments on compromise, law, and justice. In these fields the opinions of experts and laymen are about of equal value; all seem to have had relevant experiences in these areas. And much of what is not already known by laymen can apparently be learned through reading and reflection. But art and mystical experience seem so out of the way to most men, and what one does not directly learn from experience seems so beyond the reach of imagination, that all tend to look for guidance to those who are masters in the

field. It is not true, though, that most men are entirely cut off from artistic creation and mystic experience. Nor is it true that speculation will not help one to move over the plains of ignorance and inexperience to a knowledge of the structure, meaning, and value of art and mystic experience. But it is true that outstanding practitioners in these subjects have again and again called attention to factors which ordinary men tend to neglect or deny. The following quotations and comments, arranged according to the scheme of classification presented in the previous chapter and followed through the rest of the book, should help us attend to some major issues relating to the artistic process, its results, and the way these are to be appreciated. The appended comments are not so much elaborations or justifications as resonances which the quotations invoked in me. The present work, I think, supports and extends both the aperçus of most of these artists and the appended comments.

L. Eidlitz: "An architect . . . who consents to . . . permit a layman decide the merit of his work, to gauge it, correct it, accept or refuse it—has already given up his position as a professional man." An artist must be dictated to only by his art; this has its own requirements which he is pledged to meet. When he attends to what this art might mean to one uninterested in it as art, he gives up his role as artist to become a craftsman, a teacher, a businessman, a politician, anything but a "professional" artist. But this does not mean that he has a right to ignore the others entirely. A client who asks for a Protestant church must not be given a mosque or a factory; a spectator should not be faced with a work which blocks or diminishes others.

Le Corbusier: "Architecture is the masterly, correct and magnificent play of the forms of light." Architecture is a business, a craft, and an art. As the last, it is concerned with making reality visible in the guise of environed volumes.

R. Bradbury: "Architectural theory . . . is a branch of philosophy, and exists purely for the sake of knowledge and not as a guide to practice." Those interested in immersing themselves in a work of art will find a theory about art to be too general, too detachable from the particular work, too conceptual to be of much interest. Theory

is needed, not in order to practice an art, but to understand how its achievements are related to other achievements, to man, and to the world beyond.

R. Bradbury: "Architecture is the abstract embodiment of the philosophy, aims, and ideals of the social organization of the period which calls it into being." Strictly speaking, no work of art is called into being by a period; it is produced by men in creative acts, sometimes in defiance of the prevailing outlook and values. But no one can entirely escape being influenced by the society in which he lives; the work of art always embodies something of the myth dominant in the artist's society.

R. A. Cram: "Architecture alone seems to be the art that is greatest at the outset, probably because it is, after all, a communal art." By "outset," Greece presumably is meant. But sculpture, drama, and poetry, not to speak of philosophy and history, also achieved an incomparable excellence in Greece. The "communal" part of these arts has little to do with their excellence; that excellence is usually the achievement of one man. More important, the excellence brought forth in other periods is distinct from, but not inferior to what was achieved by the Greeks.

G. Scott: "The architect models in space as the sculptor in clay. He designs his space as a work of art . . ." An architect uses the three dimensions of ordinary space to make a new space having new tensions, new interrelations, and a distinctive scale. The fact that one can move in this space shows only that one can sometimes move in a created space at the very same time that one can move in a common-sense space.

L. Mises van der Rohe: "Less is more." Adornments often help make a work of art more conspicuous, attractive, or acceptable. But they also tend to obscure its nature, blur its value, prevent the work of art from being recognized as a single, organically unified whole. A work without ornaments is more likely to be a more fully unified work than one with them.

N. Nowicki: "Just as proportion established relations among divisions of space, so scale establishes relations between man and space." Each work of art has its own measures, governing the interrelation-

ship of its various parts. It also has measures defined by the attitudes, needs, activities, and positions of possible users and spectators. Neither measure can be known through the help of any instrument. To know them, a man must deal with the work as that which can represent existence and thereby complete him.

A. Rodin: "Molding from nature is copying of the most exact kind, and yet it has neither movement nor eloquence." Nature, taken as a set of substances, has vital elements. But it still lacks the dynamic, pulsative, "eloquent" movement of existence. To achieve "movement or eloquence," one must turn away from nature and create an icon of a more ultimate, vital, insistent dimension of reality.

E. Falconet: "Nature, alive, breathing, and passionate—this is what the sculptor must express in stone or marble . . ." Even a static work of art should express the vitality which is at the root of all being. Sculpture, like every other art, captures something of the texture and reports something of the nature of existence, spatial, temporal, and dynamic.

G. L. Bernini: "Sometimes in order to imitate the original one must put into a marble portrait something that is not in the original." An "imitation" of an object must take account of the demands and limitations of the medium in which the imitation is to be embedded. The work can convey what the original did only if it is unlike the original, only if it subtracts from, adds to, and transforms what was initially discerned.

A. Canova: "Sculpture is but a language among the various languages whereby the eloquence of the arts expresses nature." Sculpture offers one of a number of possible ways of expressing the nature of existence. It is a language whose terms are lights and shadows, hollows and protuberances, planes and solids, whose grammar is given by the established techniques, and whose message is expressed in a created, beautiful work.

A. Maillol: "I pursue form in order to attain that which is without form." Art is pursued under restrictions; there is not only a technique which must be mastered, but a structure which must be achieved. But this structure is achieved in order to enable us to grasp that which underlies all structure, what is at the root of all forms.

L. daVinci: "The air is full of an infinite number of radiating straight lines which cross and weave together without ever coinciding; it is these which represent the true form of every object's essence." The spatial structure of existence is complex; it is a vast matrix beyond the reach of any formal geometry. For the sculptor this is the very stuff of reality. When he portrays an object he congeals the meaning of spatial existence within a narrow compass so as to make himself confronted with an icon of that existence.

H. Lauren: "Essentially sculpture means taking possession of space." Sculpture is a spatial art, an art which presents the texture and reveals the nature of the space of ultimate reality by means of a newly created, occupied space. It possesses the space it makes by structuring and tensing that entire region, whether this be "empty" or not.

N. Gabo and A. Pevsner: "Space can be as little measured by a volume as a liquid by a linear measure. . . . Depth is the unique form by which space can be expressed." A sculpture is voluminous. But it is not only voluminous. It lays hold of, possesses space. To deal with as a mere volume is to overlook the manner in which the space which it creates is, even in its "empty" portions, occupied by the sculpture.

O. Redon: ". . . placing the logic of the visible at the service of the invisible." There are two kinds of visible—and appropriate logics: the visible of common perception and that which the artist makes. The first is put at the service of invisible existence, by being transformed, transcended, and utilized. It functions as a means by which an art work can be produced. The second is put at the service of invisible existence by serving as its icon, telling us what it is like, without involving us in a direct interplay with it.

G. Poussin: "Painting is nothing but an image of incorporeal things despite the fact that it exhibits bodies." What is exhibited in a painting is the nature of existing space. That space offers an "incorporeal" locus for bodies. Any body portrayed in a work of art over-specializes that incorporeal region which the body is thought to occupy.

F. Goya: "Color does not exist in nature any more than line . . .

only advancing and receding planes exist." Whatever the artist draws or paints are his creations. His colors and shapes present real space as at once tensional, vibrant, vigorous, and ultimate. Strictly speaking, what is true of his colors and shapes is true of his planes and volumes. None of them exists in nature; but all enable him to communicate what nature, and the reality beyond this, are like.

V. van Gogh: "Color in itself expresses something; never mind the object." The painter works with colors; he molds with them and draws with them. They are the material out of which he creates a world. If he understands their power he can dispense with a reference to the role they might have in ordinary life, for this offers only a partial expression of the power they actually have.

J. Bazaine: ". . . there is a kind of inescapable logic in the way shapes and colors develop . . . an inner obligation from which I cannot escape, and it is often against all my inclinations, against my mood, my taste and my considered opinion. As Braque says, 'the canvas must kill the idea.' " The immersion in the logic of the work requires some denial of oneself. The canvas must not only kill the idea, but the inclinations, moods, taste, and individuality of the artist as well, so far as these make demands in opposition to those made by the work.

G. Severini: "The sensation produced in us by a reality which we recognize as being square in shape and red in color may be expressed plastically by its complementary shapes and colors, in other words by rounded shapes and shades of blue." ". . . out of the dancer and the aeroplane is engendered the sea." The objects we recognize, which is to say the substances of common experience, are ultimate reality transformed by being subjected to special conditions. If the artist is to recapture that ultimate reality, he must subject the recognized objects to new transformations. In expressing square as round the artist but returns to the reality of which the square is a transformation. Round is not, of course, the necessary form which the reality has. It is a round which is also blue that portrays the reality underlying the recognized red square.

G. van Haardt: ". . . colors are neither warm nor cold, but simply different, as colors. The painter is not an optician. This is why it is

useless to invoke the laws of complementary colors from a discipline which has nothing to do with painting. Red can be married as effectively with green, brown, grey or red as with any other color. The luminosity of color in painting remains a myth." The artist uses colors or sounds, shapes or movements to create a new entity. No one of these elements has an absolute value; no one of them makes an absolute demand for just one companion, support, or contrast. If it did, there would be very little room left for innovation, experiment, improvisation. The organic whole which is the work of art is not subject to the rules that govern other types of whole. The artist is free to forge new relations, make new organic unities.

R. Chastel: "My practical objective is to attain complete abstraction, rejecting preconceived technical solutions. As the work progresses, the original visual emotion, whether objective or subjective, suggests new relationships between colors and shapes which become more and more abstract as they take their place within the pattern of an inward illumination." A work of art is produced, not in accordance with any set of rules or technical devices, but in terms of ideas which continually require new acts and constant alterations. The terms are related "abstractly" in the sense that they are not made to conform to the nature of some external object. Art is nonrepresentational to the degree that it is allowed to develop according to its own requirements, in abstraction from those which are to be found in the external world of common objects.

P. Klee: "Art does not reproduce the visible but makes visible." A painter is not a reporter. He offers no reproduction of what he sees, but makes something to be seen. Similarly in the other arts: none of them merely reproduces what is experienced; all of them produce something worth experiencing.

A. Lanskoy: "Painting is always abstract, but one did not notice it. When one no longer looks for apples, trees or young girls in a picture, the word 'abstract' will become redundant." There is no radical difference between classical and modern art. El Greco is a classical painter, but his work is nonrepresentational. Every art in fact works under limitations; it has its own media, materials, limits, and cannot therefore re-present any object in nature. He who looks for apples

or trees or girls imposes on the work conditions which are not germane to it. One can find apples, trees or girls there only by tearing pieces out of the painting and viewing these as though they were substances rather than focal points in a creation of an icon of existence. No art is ever simply representational; all are also nonrepresentational, which is to say, "abstract."

P. Picasso: ". . . the white I thought of, the green I thought of, are in the picture, but not in the place foreseen nor in the expected quantity." More accurately, they are not even the white and green thought of, but rather are a new white and green made under the guidance of a white and green remembered. Where they are to be placed, just what intensity, magnitude, relationship they are to have cannot be determined except in the act of producing the work.

P. Picasso: "I get an indigestion of greenness. I must empty this sensation in a picture." In an aesthetic experience we isolate qualities, free them from their involvement in the hurly-burly of this contingent world. We are enriched thereby. But there is a limit to this richness. Beyond a certain point, the experience of green becomes cloying, satiating, tiring. He who makes creative use of green frees himself from this limitation, gives it a new locus, being, and function. He thereby purges himself, frees himself from the indigestion of unsifted emotion, with the result that he has a more appropriate attitude towards experienceable green thereafter. The world is too much for the artist, both because it is shot through with contingency and because aesthetic experience soon comes to a limit. He creates to achieve a way of dealing with the world more penetratingly, while retaining his distance.

P. Mondrian: "To create unity, art has to follow not nature's aspect, but what nature really is." Nature's aspects are the strands we distinguish for various limited purposes. The substances we discern are the grounds for these strands, loci of a number of them, all intertwined. Art's task is to reveal, not the strands or the substances, but what lies beneath both of them.

P. Klee: "The purer the artist's work, the less well equipped he is for the realistic rendering of visible things." The "visible" here is what is perceived. An artist is primarily concerned, not with this, but

with existence. His work is pure just so far as it is cosmic, metaphysical, occupied with what is outside the reach of common sense.

M. Seuphor: "A painting is to be called abstract when it is impossible to recognize in it the slightest trace of that objective reality which makes up the normal background of our every day experience . . . no aspect of the real world, even if it is a point of departure, should remain recognizable." It is impossible to remove every trace of the "objective reality which makes up the normal background of our every day experience." A work of art is not bound by the contingent structure and connections characteristic of daily experience. But one cannot entirely avoid connecting one's work with that experience. And if by "objective reality" one means the irreducible modes of being behind experienced substantial individuals and events, it is precisely this which should be portrayed and recognized in every art, abstract or concrete.

U. Boccioni: "We must assert that the sidewalk can find its way on to the dining room table, that your hand can cross the road all by itself . . ." The connections between things in this world are largely a matter of happenstance. They do not bind the artist. To focus on what is fundamentally real the artist makes things function in relation to one another; he makes evident their potentialities, only some of which are utilized in our everyday world. The sidewalk in daily life has a definite place and a limited function; the artist deals with it as freed from these restrictions.

G. Severini: "The whole universe must be contained within the work of art. Objects no longer exist." Art is a self-sufficient domain; extended and pulsating, it is a substitute for, a replacement of the domain of existence. In providing an icon of existence the artist transcends any objects he might have initially distinguished, and which help him divide, order, and communicate his work.

H. Matisse: "The work of art has its own absolute significance implicit within itself and should convey this directly to the beholder before he stops to wonder what the picture represents." A work of art is a unity. It should be appreciated as a single whole before there is an attempt to understand its themes and developments and the various foci which make it possible for it to refer to ordinary things. A work

of art should be accepted as self-sufficient, complete in its own terms even before there is an attempt to reflect on the nature of the ultimate reality it iconically presents. Ultimate reality is in fact portrayed in the art, and need not be sought beyond it, except by one who is not content with merely enjoying art, and would understand it.

H. Wadsworth: ". . . the painter does not paint what he sees but what he knows *is*. A reality must be evoked—not an illusion." Art does not present us with illusions. Instead, it portrays existence in its bearing on man, at the same time that it exhibits existence's spatial, temporal or dynamic texture.

H. Matisse: "Exactitude is not truth." Exactitude is not truth in at least two ways. If it re-presents the familiar, it fails to make the selections and additions which are needed in order to convey the real. If it conforms to rules and techniques, it hides what a free creation reveals—a real, pertinent, objective existence.

R. Dufy: "Nature is only an hypothesis." Nature in the guise of a scientifically apprehended strand is the real under a special condition. Today men wrongly accept the hypothesis that the real world is like that which science portrays. More plausible would be the hypothesis that real substances are like those we come to know through the synthesis of strands within the body of some given one. It is no hypothesis that the world is existentially what the artist portrays.

P. Gauguin: "It is better to paint from memory, for thus your work will be your own . . . When you want to count the hairs on a donkey, discover how many he has on each ear and determine the place of each, you go to the stable." It is not the function of art to provide duplications or reports of what particular things are. Men who are primarily concerned with observing those particular things and making reports of what they have noticed are not artists, but practical men. Creation demands that one ignore the commands of daily life and penetrate the guises common objects present.

Yun Shou-p'ing: "If one is able to realize how the ancients applied their minds to the absence of brush and ink, one is not far from reaching the divine quality in painting." "Negative" space, the intervals between focussed items, is as positive and as important as the rest of a work of art. But since men are keyed to attend to things and to

emphasize the separateness of one from another, it requires a great effort to do justice to this essential side. The real, as at once "positive and negative," is cosmic in nature, closer to the being of the divine than any particular and merely "positive" item could be.

T. Gainsborough: "I don't think it would be more ridiculous for a person to put his nose close to the canvas and say the colors smell offensive than to say how rough the paint lies . . ." The smell of the colors is a fact in nature or society; the roughness of a painted surface is a fact about the way the paint is used. The two are not on a par. Still, attention to the paint is attention paid not to the work of art, but to the manner in which it is produced. It ignores the artistic side of a creation to attend to the result of a subordinate work of craftsmanship.

P. Gauguin: "Do not finish your work too much." There is a closure point to every work of art dictated in part by the nature of the work and the artist's limitations. He who ignores the demands of closure prepares to add irrelevancies to the work. In the effort to make it seem finished and complete, he makes it into a combination of two or more works, neither of which is allowed to function on its own.

P. Picasso: "I put all the things I like into my pictures. The things —so much the worse for them; they just have to put up with it." What one likes to put in a work is in part determined by what will be or what is already there. What is put in acquires a distinctive role and function by virtue of the fact that it is an integral part of a single newly created whole.

W. Kandinsky: "I see no essential difference between a line one calls 'abstract' and a fish. . . . This isolated line and the isolated fish alike are living beings with forces peculiar to them, though latent . . . the environment of the line and the fish brings about a miracle; the latent forces awaken, the expression becomes radiant, the impression profound. Instead of a low voice one hears a choir. The latent forces have become dynamic . . . the fish can swim, eat, and be eaten . . . These capacities of the fish are necessary extras for the fish itself and for the kitchen, but not for the painting. And so, not being necessary, they are superfluous. That is why I like the line better than the fish— at least in my painting." All things gain determinations from their

context. The determinations accreted by natural objects have, how-
ever, to do with their roles in nature. The determinations which a
line achieves in a painting are of a different sort, having to do with
what makes the line support and be supported by the rest in a single
beautiful totality.

P. Klee: "Color has taken hold of me forever . . . Color and I are
one. I am a painter." The painter cannot distinguish himself alto-
gether from his work; the behavior of his color is himself exteriorized
and functioning as a locus for beauty. That color is not the color
known to optics. It is a color with quite different properties, reflecting
the fact that it is an item in an emotionally sustained creation,
affiliated with other colors, and with the various shapes and spaces
which were produced by the painter.

J. Constable: "I am anxious that the world should be inclined to
look to painters for information on painting." It would be good to
turn to painters for information on painting, were they able to ex-
press themselves properly, and could they free themselves from com-
monly accepted presuppositions and categories regarding the nature
of existence, the validity of science, and the relation of one art to
another. In the meantime it is necessary also to listen to philosophers.

J. Haydn: "Art is free, and must not be confined by technical fetters
. . . I feel myself as authorized as anybody else to make up the rules."
Art has rules, but it is not subject to rules. Its rules are the residua
which technique and habit leave behind in a work that has been crea-
tively produced.

G. Verdi: "It may be a good thing to copy reality; but to invent
reality is much, much better." Copying is essentially a servile act; it
subjugates one to conditions which prevent the exercise of vital
powers. The "invention" of reality calls upon man as at his best, and
ends with something he could never have obtained by copying—an icon
of existence having something of that existence's texture.

P. Mendelssohn: "The thoughts which are expressed to me by music
that I love are not too indefinite to be put into words, but on the
contrary, too definite." The communication of a work of art is direct
and concrete; it leaves over no margin for elaboration or exegesis. If
we are to speak of it, it must be at a distance and in general terms;

these cannot claim to reproduce it but only to explain it, put it in a setting, make it available for discourse and understanding.

F. Chopin: "Nothing is more odious than music without hidden meaning." An art without meaning would be indistinguishable from decoration or ornament. An art without hidden meaning would be too intellectual, too formal. The meaning of the work is revealed in the course of the enjoyment of the work as a self-sufficient, sensuous, excellent whole.

F. Chopin: "Creation is not a thing one can learn." Creation is an expression of freedom, of the power to act with initiative, spontaneity, exuberance and control, to turn an open partly indeterminate future into a definite determinate result. There are no principles which can exhaust its nature, there is no training which can guarantee it. It has a nature only when and as it takes place. Rules and habits can tell us where its boundaries are, but it spreads to those boundaries on its own.

V. Williams: "The great men of music close periods; they do not inaugurate them. The pioneer work, the finding of new paths, is left to smaller men." Innovators open up new aesthetic dimensions; the masters give these an excellence which closes an epoch. The excellence achieved by masters precludes anything but copying; the greater the achievement, the more necessary it is to begin from another perspective.

C. Debussy: ". . . music is a very young art, from the point of technique as well as of knowledge." Every art is a young art; we are always learning more about it, both as individuals and as a group. In every age there are experimenters who are breaking new ground that is as difficult to occupy as was the ground which was occupied yesterday for the first time.

I. Stravinsky: "Dissonance is no more an agent of disorder than consonance is a guarantee of stability." Dissonance emphasizes the tension, consonance the accord holding among various parts of a work. A tensed whole may be stable, particularly in relation to others, while an untensed one may have little order, with the items in it merely together.

W. Pater: "All art constantly aspires towards the condition of music." Each art has its own integrity and its own aspirations. None

aspires towards the condition of any other. Music, though, has been more aware of its value and rights for a longer period than most of the other arts. It is less tempted than others to become didactic, reportorial or useful. All ought to aspire to its self-confidence. The great works of music follow out their own logic and are appreciated because they do. Every art in its own way ought to try to have the same independence, boldness, self-development, complexity, immediate appeal that music so often has.

H. Miller: "Writing, like life itself, is a voyage of discovery. The adventure is a metaphysical one; it is a way of approaching life indirectly, of acquiring a total rather than a partial view of the universe. The writer lives between the upper and lower worlds; he takes the path in order eventually to become that path itself." Writing, like any other artistic activity, tells about reality itself. It is an adventure, a fresh and creative process. The more one concentrates on carrying out that process, the more one becomes identical with a process of exposing the secret of the universe.

G. Stein: "When a man says, 'I am a novelist,' he is simply a literary shoemaker." The genuine artist does not stand apart from his work. He immerses himself in it. The craftsman, on the other hand, has a role, and thus is one who is different in rhythm from what he is working on.

H. Miller: "Art is only a means to life, to the life more abundant. It is not in itself the life more abundant. It merely points the way, something which is overlooked not only by the public, but very often by the artist himself. In becoming an end it defeats itself." Art enriches man, but it is less than he really is. To be content with it alone is to be content with what is only a simulacrum of the real, what is iconic of it, but never identical with it.

H. Melville: ". . . though in many of its aspects the visible world was formed in love, the invisible spheres were formed in fright." The world of every day has its well-marked boundaries, its recognizable limits, its points of departure and return. Behind this is the uncharted world, the counterpart of ourselves as unprobed and unknown. It is in good part overwhelming and threatening, an object to be feared.

Through our art we make it visible, with foci and boundaries which are recognizable and enjoyable because made by us.

The roots of art are at the roots of man. And art has its own requirements to which the individual artist must yield. There is a rationale to the unconscious which art exhibits and the artist inescapably follows. The truth in this observation should not be allowed to obscure the fact that the artist is an individual making individual decisions; that he evaluates and reorganizes; that it is he who makes the work of art. The artist can be said to "allow" an art to take place, if "allow" means, "an activity of continual supervision and modification." Were there no such activity there would be nothing like individual idiosyncracies, personal involvement, exhaustion, etc.

G. Stein: ". . . a blame is what arises and cautions each one to be calm and an ocean and a masterpiece." A work of art has an importance of its own, demanding in the end that one retreat into oneself so as to enable it to be on its own. It is an ocean, in which every thing finds its place, and which defines even the islands and continents, the dry land of every day, to be but focal and terminal points. When the artist falls short of achieving a masterpiece he feels within him the guilt of having failed to do what alone justifies his having left the common world and its tasks behind.

P. Baudelaire: "Great poetry is essentially *stupid;* it *believes*, and that's what makes its glory and force. Do not ever confuse the phantoms of reason with the phantoms of imagination: the former are equations, the latter are beings and memories." Reason, at the service of science and mathematics, forms hypotheses, combines possibilities; it does not affirm or believe. It is too cautious, too critical, too intelligent. Art believes, affirms, imagines: it is dogmatic, uncritical because it represents an irreducible reality which subtends all that we encounter, and which is also to be found at our core. In our innermost selves we echo the nature of an existence outside. By bringing ourselves to expression in ways other than through reason, we make be that which, alone of all man's achievements, is at once glorious, particular, and possessed of cosmic significance.

S. Coleridge: "A poem of any length neither can be, nor ought to

be, all poetry." An art object is an organism; it requires articulation, diversification, contrasts. The prosaic offers a set of relative stops and silences for it. These are part of the work. Without stops and silences we have only artistic elements, crises at which we neither arrive nor depart, and thus no genuine well-integrated artistic wholes.

Ezra Pound: "Poetry ought to be as well-written as prose." Prose has a function: it seeks to communicate in common terms. To enable it to function properly it must be well written. The task of poetry is to present something which cannot be presented in prose. Its use of metaphor and rhythm, alliteration and assonance enable it to create a time which iconizes the nature of existential time. This task ought not to obscure the poet's need to use words with the craftsmanship employed in the effective use of prose. Poetry ought to communicate, and its counters, though not used in conventional ways, should nevertheless be familiar.

W. Wordsworth: ". . . poetry is the spontaneous overflow of powerful feelings; it takes its origin from emotion recollected in tranquility; the emotion is contemplated till, by a species of reaction, the tranquility gradually disappears, and an emotion, kindred to that which was before the subject of contemplation, is gradually produced, and does itself actually exist in the mind." The emotions expressed in the course of a creative act are not deliberately elicited. Nor are they to be identified with the emotions elicited in the course of ordinary experience. They are new emotions which arise only so far as one has separated himself off from the world. The separation requires the subjugation of ordinary emotions by the tranquility of detachment; the production of the work of art requires one to vitalize oneself in ways and with results similar to but not identical with those produced by ordinary events.

T. S. Eliot: ". . . poetry . . . excellent words in excellent arrangement and excellent metre. That is what is called the technique of verse . . . a poem in some sense, has its own life; . . . the feeling, or emotion, or vision, resulting from the poem is something different from the feeling, or emotion, or vision in the mind of the poet." At best, verse is only the product of a technique, of craftsmanship; a poem is more than verse—it is something created. It adds to, alters,

qualifies, subjects to new conditions, whatever might originally have been in the mind of the poet.

W. B. Yeats: "We make out of the quarrel with others, rhetoric, but of the quarrel with ourselves, poetry. . . . we sing amid uncertainty; and, smitten even in the presence of the most high beauty by the knowledge of our solitude, our rhythm shudders. I think, too, that no fine poet, no matter how disordered his life, has ever, even in his mere life, had pleasure for his end." Poetry is produced from within by men who face a dimly apprehended world beneath the world of common sense at the same time that they strive to give a sensuous body to an ideal. The poem must be forged in the face of the attempt to do justice to reality and the ideal. So far as it is successful its value outdistances that of mere pleasure.

W. B. Yeats: ". . . poets are good liars . . ." A work of art qualifies, distorts, reshapes and in this sense misrepresents what the artist otherwise knows or allows. If one were to attend to an artist's explicit beliefs and acceptances one would have to term the results of his activity "good lies."

A. E. Housman: "Experience has taught me, when I am shaving of a morning, to keep watch over my thoughts, because, if a line of poetry strays into my memory, my skin bristles so that the razor ceases to act." Poetry affects a man deeply; the disturbance it causes at the roots of one's being has its repercussions in one's responses, routine habits, the body and mind.

P. Valery: ". . . I did not *want to say* but *wanted to make*, . . . it was the intention of *making* which *wanted* what I *said* . . ." The artist's primary concern is with creation. The creativity makes demands on him, dictates in fact what it is that will be said, portrayed, conveyed. In making the work be, he makes it possible to express himself most deeply and effectively.

W. B. Yeats: "The winds that awakened the stars/Are blowing through my blood." The artist calls on his most hidden powers and makes them to come to expression in a context he has provided. The very forces that move the world move him.

P. Shelley: "Poetry defeats the curse which binds us to be subjected to the accident of surrounding impressions . . . It creates anew the

universe, after it has been annihilated in our minds by the recurrence of impressions blunted by reiteration." We must first escape the tiresome and routine, the monotonous and uninteresting, the merely contingent and adventitious before we can create. We must turn away from them, erase their traces; only then will we be able to replace that world with another which, because freed from the blunting barrenness of a law-abiding world, will do justice to the real.

E. Fenollosa: "The moment we use the copula, poetry evaporates." "Is," the copula, is used in prose to make statements claiming to be true. It is needed to relate abstract subjects and predicates in an assertion and also in something apart from the assertion. Poetry, in contrast, directly unites words to constitute single terms which portray the unifying reality from which the subject and predicate were derived.

M. Arnold: "Without poetry our science will appear incomplete." Science tells us what is the case under special conditions. But there are other special conditions in terms of which reality has other guises. And outside all special conditions there is reality itself; this is completely what the conditioned items are incompletely. The truths that science provides are partial expressions of the truth that art expresses.

C. E. Ives: "When a new or familiar work is accepted as beautiful on its first hearing, its fundamental quality is one that tends to put the mind to sleep." We are inclined not to explore, analyze, or understand that which is quickly accepted as being beautiful. We become aware of the richness, nuances, textures, and structures only of those beautiful works in which we fully participate, and such participation often demands that we attend to the works again and again.

V. Thompson: "No element of musical execution is more variable from one interpreter to another than tempo. . . . Many musical authors, beginning with Beethoven, have indicated in time units per minute their desires in this matter. And yet interpreters do not hesitate to alter these indications when conviction, based on reasoning or feeling or on executional circumstances, impels them to do so." "The truth of the matter is that very few pieces require to be played at a given speed in order to make sense." A musical composition and

a musical performance are distinct works of art. A musical composition is, for the musical performer, a script or set of general instructions which the performer is to use as a guide in the course of his creation of a work of art. That work may deviate from the set instructions which the composer set down to govern the performance. No one art has a right to dictate to any other.

H. Berlioz: "I feel grateful to the happy chance which forced me to compose freely and in silence, and has thus delivered me from the tyranny of the fingers, so dangerous to thought, and from the fascination which the ordinary sonorities always exercise on a composer, more or less." Though a composition is intended to be played, it must itself be produced in independence of the demands of a performance. A composition has a rationale and makes a general reference to the sounds that may be produced. But he who allows sounds to dictate to the composition subordinates the art of creating an inaudible time to the demands of a different art, concerned with creating an audible becoming.

R. Sessions: ". . . factors which make all the difference, indeed, between a good performance and a bad one, cannot conceivably be indicated in any score." "What composers have always tried to indicate in the clearest possible manner are the essential contours of the music, and the means required of the performer in order to make these clear." ". . . one plays . . . not so much notes as motifs, phrases, periods, sections, the rhythmic groups or the impulses of which the music is composed." The performance has its own rationale which must be lived through in order to be known. No one can specify it in advance without turning the performance into a mechanical translation of a composition. The performer gives the composition a new sensuous embodiment, thereby altering the meaning of its themes, sections, etc.

P. Hindemith: ". . . no difference can be detected between tones produced by the adept touch of a great artist's hand and those stemming from the manipulation with an umbrella. . . . The tones released by the keyboard receive musical value only if brought into temporal and spatial relations with each other." Musical instruments provide ways by which certain sounds can be produced. Those instru-

ments could conceivably be manipulated by machines. But a musical performance is more than an aesthetic object or an interrelation of such objects; it creatively interconnects sounds to constitute a new dynamic excellent whole.

C. P. E. Bach: "Good performance can, in fact, improve and gain praise for even an average composition." A composition which was not a distinguished work of art might be given a distinguished performance. Though that performance cannot make up for a poverty of the composition, it can vitalize and subtletize it. It would be wrong to praise the composer for the achievement of the performer.

C. P. E. Bach: "Certain purposeful violations of the beat are often exceptionally beautiful." Every artist flats his notes occasionally, delays his recurrences, forestalls his climax, in order to heighten the interest, sharpen contrasts, and thereby bring about a more important resolution than is otherwise possible.

J. J. Rousseau: ". . . noise can produce the effect of silence, and silence the effect of noise . . ." There are no fixed positive and "negative" spaces in a work of art; all have something to contribute; all are tensional in nature; each demands its own closure. The kind of closure of a sound may be such as to make one aware of the silence to follow; the closure of a silence may reveal the fact that it is bounded by noise. Also, what is noise in one context may function as a silence in another, and conversely.

M. Reger: ". . . the art of expression begins at the point where one reads 'between the lines,' where the 'unexpressed' is brought to light." A composition offers general guides for the production of a work which has a meaning and value of its own. The performer produces stresses and values which never were before, precisely because they are produced for a performance and not for a composition.

E. Satie: "As for the perennially cited nightingale, his musical knowledge makes his most ignorant auditors shrug. Not only is his voice not placed, but he has absolutely no knowledge of clefs, tonality, modality or measure. Perhaps he is gifted? Possibly, most certainly. But it can be stated flatly that his artistic culture does not equal his natural gifts, and that the voice of which he is so inordinately proud, is nothing but an inferior, useless instrument." No animal can compete

with an artist. It has no creative ability, no controls or objectives, no understanding of how to use its powers to produce a self-sufficient excellence. He who tries to imitate a nightingale denies himself the use of the very capacities which mark him off as a man; he does not, as he should, use the nightingale's notes in new, creative ways, to produce something beautiful.

P. Hindemith: ". . . play . . . fuges from Bach's Wohl-temperiertes Klavier, as string trio or string quartet pieces. You will have a queer and rather disagreeable sensation; compositions which you knew as being great, heavy, and as emanating an impressive spiritual strength, have turned into pleasant miniatures." Musical composition and performance are distinct arts. Still, the nature of a composition does require a certain type of performance; so far as this is true, one can spoil a work of art not merely by performing it badly, but by performing it with inappropriate instruments.

H. Irving: "The essence of acting is its apparent spontaneity. Perfect illusion is attained when every effort seems to be an accident." No art is pure improvisation; all rest on the mastery of a medium, a disciplined use of materials, and a recognition of what must be done to achieve an excellent outcome. Each step in a production might be deliberately taken, but it must then be allowed to fall away from the area of will and thought where the deliberation takes place, to find its niche in the organic whole.

Lope de Vega: "Always trick expectancy." Expectations are grounded in past experience; they reflect the habitual temper of conventional daily life. To live up to these expectancies is to be caught in the realm of work, technique, stabilized patterns. A work of art is produced when the demands of these is transcended, and a new world created. That world is peopled with fresh creations beyond the reach of expectancy.

B. Coquelin: "The actor is his own material." In art a world is made which portrays what is outside the artist. To make that world he must make use of powers beneath the dividing and specializing channels through which he usually expresses himself. In creating a work, he expresses the aboriginal powers in new ways, thereby reorganizing himself. He remakes himself when and as he makes a new

world. The actor, no less than the sculptor, the poet, or the singer, makes himself over, creatively recreates himself while creating a work of art.

G. Arliss: "One can never be really, truly, 'natural' on the stage. Acting is a bag of tricks. The thing to learn is how to be unnatural, and just how unnatural." A building site, a canvas, an orchestra, a stage are artifacts within whose limits a work of art is to be produced. The acceptance of them makes the work contrast with what "naturally" occurs in common experience. One must learn how to live inside the boundaries characteristic of a given art—this knowledge is embodied in one's "bag of tricks." But an art is more than a mastery of a medium; it produces a result which answers to a world beyond. The product of "unnatural" acts, it does more justice to the real than any "natural" act can.

A. Pinero: ". . . dramatic talent . . . the power to project characters and to cause them to tell an interesting story through the medium of dialogue. . . . Dramatic talent must be developed into theatrical talent by hard study and generally by long practice. For theatrical talent consists in the power of making your characters, not only tell a story by means of dialogue, but tell it in such skillfully-devised form and order as shall, within the limits of an ordinary theatrical representation, give rise to the greatest possible amount of that peculiar kind of emotional effect, the production of which is the only great function of the theatre." The artist in the theatre orders his material with the same independence and freedom as any other artist does, but he attends more to the need to make people share in his achievement than most artists do. He has dramatic talent if he has a talent for writing and producing plays; he has theatrical talent if he has a talent for writing and producing plays which an audience will enjoy.

T. De Banville: "A man of genius will create for his theatre a form which has not existed before him, and which after him will suit no one else." All artists produce distinctive forms; those who do not produce such forms are only craftsmen. If the latter be termed artists, the former must be termed "geniuses." In any case, those who produce distinctive forms do so because these are required by the topic, ma-

terial, and inspiration then utilized; subsequent artists, though taught or inspired by their predecessors, must do their own distinctive jobs.

A. Dumas, fils: ". . . in the theatre . . . there are two kinds of truth; first the absolute truth which always in the end prevails, and secondly, if not the false, at least the superficial truth, which consists of customs, manners, social conventions . . ." Superficial truth concerns the strands and substances which fill our daily world. This is on the surface of a deeper truth with which art is concerned and which remains after the conventions have had their day.

E. Legouve: ". . . a play is made by beginning at the end." All art is involved in a perpetual reconstruction, a modification of what has been done in the light of what is being done. Its creativity presupposes some initial apprehension of the end one is trying to achieve. This prospective end will be modified in the course of a movement towards it. The end from which one takes one's start is constantly altered, until it appears as an end at which one must terminate.

B. Shaw: ". . . resistance of fact and law to human feeling . . . creates drama." All art is dramatic, which is to say, all art achieves its end through a conquest of obstacles. Art is a struggle, and makes this manifest in a grained work shot through with tensions.

W. Archer: "The drama may be called the art of crises." A crisis is a turning point. Every variation is a minor crisis; every crisis is a major variation. All arts are arts of crises, determining when and where major variations in themes are to occur.

D. Humphrey: "The person drawn to dance as a profession is notoriously un-intellectual. He thinks with his muscles, delights in expression with body, not words; finds analysis painful and boring; and is a creature of physical ebullience." Thinking is one form of activity; dancing is another. He who is concerned with the one will pursue paths and engage in efforts which do not interest and are not within the competence of the other. He who is un-intellectual, though, is not necessarily unintelligent.

T. Shawn: ". . . the dance includes every way that men of all races in every period of the world's history have moved rhythmically to express themselves." No restriction ought ever to be placed on the material which an artist may use. Any means for encompassing space

is appropriate to architecture. Story can make use of any incidents and any characters in any ways which enable it to create and occupy time. Similarly, dance can make use of any rests and movements which make possible the creation of a substantial process of becoming.

D. Humphrey: ". . . stage areas will support and enhance various conceptions, or they will negate them. . . . Have a figure walk slowly down center from back to front. When farthest away he is mysterious, with a high dynamic and symbolic potential, much more so than if he were off center. As he advances, the electrically charged center takes over and he increases in stature and in power . . . there are six weak areas and seven strong ones on a stage. . . . No actor has a chance to walk on that magic diagonal." The subdivisions of the stage for the dance are in good part antecedently defined; the subdivisions for the play are primarily functions of the plot. The two stages are different. The one also, but incidentally, subdivides its stage in the process of production; the other also, but incidentally, makes use of preferential positions on its stage, positions which are definable apart from the plot.

M. Marsicano: "The true duration of a dance lies in the time of creating the image, a long gradual realization of which the performance is the final act." Not only is an actual production preceded by long training and discipline, but the particular performance itself is preceded by a series of trial and error adventures, engaged in imaginatively, muscularly, and temperamentally. The work of art terminates and epitomizes, solidifies and completes the process of creation. It is the last step of an activity begun some time before.

I. Duncan: "Pantomime to me has never seemed an art." There is a great temptation on the part of an artist to look at other arts as mere crafts, without any function but to enlighten or amuse. Many a musician wants painters to produce only recognizable portraits, landscapes, and objects; many a poet wants dancers to make unmistakable movements and gestures; many a sculptor objects to novels, poems, and plays which have no recognizable plot. There is a pantomime which functions as a decoration, and a pantomime which is an art. The latter involves as much creative energy and imagination, and can

in fact result in a work that is as significant and revelatory as any dance.

D. Humphrey: "Movement is the arc between two deaths . . . the death of negation, motionless; on the other hand it is the death of destruction, the yielding to unbalance. . . . All movement can be considered to be a deliberate unbalance in order to progress, and a restoration of equilibrium for self-protection." Every art has within it emptinesses, shadows, breaks, holes, which serve to accentuate its crises, turns, and peaks. Without the negation inside the art, there would be only the monotonous. This negation is needed, wanted, pushed towards, and eventually transformed into an affirmative element. Every art is also bounded; beyond it lies what it is not. The act of producing is the act of pushing towards that which it is not, and then cutting the act short in order to keep it inside the accepted boundary. Art is an adventure faced with the possible failure of becoming pulverized into a plurality of diverse elements separated from one another by an unassimilated nothingness, at once inside and outside it.

These quotations and observations all converge on the same point: a work of art is a self-sufficient, substantial reality, creatively produced, and possessing its own rationale.

PART II : NINE ARTS

4. ARCHITECTURE

ARCHITECTURE is the art of bounding, and thereby creating multiple spaces. Like every other art, it exists over against its creator, and over against the things of common sense and nature. It is exterior to the artist and bounded off from everything else that there may be.

In no art are the worlds of common sense and nature ever wholly put aside. Not only does the artist to some extent always live, act, and think as a common-sense and natural man, but his materials, medium, and work are sustained by the worlds of common sense and nature. The stones, metal, paints, and canvas, the beats, incidents, silences and words, the sounds, actions, movements and rests used in his work are subject both to the demands of his art, and to a world outside. The natural and social sides of the material used, however, have no significant role to play in most arts. In architecture they have great importance.

Architecture produces a complex work whose material has the double role of being in and outside what is created. It is an art that makes a space inseparable from one not made. In this respect it is like story, which makes use of conventional grammar and meanings while providing new affiliations for its words, and like the dance, which makes use of musculature, gravity, and distances to govern all movements and rests, even while it creates new values and stresses. Other arts take some account of similar conventional and natural factors, but none does it so conspicuously and insistently as these three. In architecture alone, though, the artistic and nonartistic components are not only held apart as independent, but are accepted as important.

The architect makes the three-dimensional space of daily life into a constituent part of an architectural work. He creates a new space which men can use while also occupying a relevant common-sense space. To share in a story or a dance one must turn away from

(though still presupposing) the forces dominating the world of common sense. We can enter the painter's space or the sculptor's space if we can push back the space of every day. We enter the architect's created space on similar conditions, but the space of his work is also common-sensical. We truly enter his space only if while attending to his created space, we also maintain a grip on daily space.

Architecture not only makes use of property and costly material, but keeps this fact in focus. It exists within a context defined by unskilled labor and such practical activities as excavation, engineering, and plumbing. It must conform to building codes written with little concern for its artistic needs. No other art is so hemmed in by men, tasks, and conditions relating to nonaesthetic matters. To be sure, a work of architecture could conceivably be inexpensive, unobtrusive, and be allowed to develop in considerable freedom. And, on the other hand, such arts as music, theatre, and dance are often expensive, obtrusive, and subject to hobbling conditions. Not only do they, too, have to deal with codes, but they must be produced with the help of unsympathetic stage hands, and must overcome the opposition of insensitive impressarios, dictatorial directors, fickle audiences, and inflexible censors. The uncreated is not, however, an essential part of them. It is for architecture.

Architecture has been said by S. G. Ward to be "a tendency to organization." Le Corbusier remarks that it deals with "the play of forms under light," and in his *Modulor* uses the term to cover even "the art of typography as it is used in the making of newspapers, periodicals, and books." Susanne Langer takes architecture to define an ethnic domain. Because of her concentration on temples, and her unexamined belief that the real is the province of science and not of art, she holds that it gives only a "semblance," "illusion," of perceptual space. None of these views does justice to the richness and reality of an architectural work of art. "A tendency to organization" falls short of an actual organization, and in any case is found in sculpture and painting, story and dance. And sculpture, no less than architecture, can exhibit a "play of forms under light." Both, in addition, involve the production of objects relevant to the sense of touch and movement, and exhibit forces moving in many directions.

Architecture is the art of creating space through the construction of boundaries in common-sense space. One can bound that space through intent alone, but the result will fall short of what architecture creates. A man, for example, might see a clearing in the woods. If he looked at it as a prospective home, he would in effect wrench the clearing from its natural setting and deal with it as an aesthetic ob ject. Thereafter he would look at the clearing largely under the governance of a Fibonaccian series of distances, in which the sum of two consecutive terms supplies the third. If part of the clearing functions as a foreground, the clearing will be seen to have an endless series of fractionally distant and darker backgrounds. As Giedion observed, "In order to grasp the true nature of space, the observer must project himself through it," which is to say he must deal with it as caught within the newly imposed boundaries. The intended dwelling is, though, not yet a work of art, not yet a piece of architecture. A work of art must be *made*, not merely intended. There is no building without the use of muscle acting on resistant material to produce something palpable and substantial. Whoever accepts the clearing as a possible dwelling bounds it off from the rest of the world. But he who makes a dwelling not only bounds it off but produces roof, walls, windows, door, flooring, each of which itself is a newly created, tensed spatial object within a larger tensed space.

Like every other art, architecture proceeds in good part by trial and error, but under the guidance of established habits, acquired techniques, inherited traditions, and desirable ideals. It is an adventure in the use of available materials to make a self-sufficient encompassing space. "Architecture," said Focillon, "creates its own universe." Like every other art, it seeks to make excellence have a sensuous form. More than most it is alert to the prevailing myths and thus attends to those aspects of the ideal which are germane to a people. The organic whole it produces provides shelter, privacy, storage, and protection—or more compendiously, makes it possible for a number of spatial objects to be together in newly created relations. It need not restrict itself to houses, buildings, or temples. Cities, landscapes, pavillions and parks, packaging of all kinds, automobiles, cages, airplanes, and the like, are also products of an art of enclosing space.

Each raises distinctive problems. (The environment of an automobile, for example, is given by a constantly changing road, landscape, and horizons, none of which is in the control of the automobile designer.) But all are architectural works with new created spaces.

Like every other art, architecture seeks to make an excellent work. This at once humanizes reality, and completes man by providing him with an adequate terminus. The final solution of the peculiarly architectural problem is a function of the architect's success in solving four subordinate questions. He must, as was observed before, make relevant to his creation the space of common sense. This means he must resolve *technological* issues raised by the fact of gravity, climate, time, and use. In addition, he must discover the proper *scale* by which he is to subdivide his work, and determine the magnitude of it both as a distinct object and in relation to other works. Thirdly, he must learn how to forge an *articulated space* out of the solid space of his walls, his inside space, and the environment, as well as out of the various subspaces which each of these contains. Finally, he must know how to make an *organically unified work* in which his created, scaled, inside and environing spaces are integrated with his technically mastered, relevant common-sense space. Architecture takes this fourth question to be primary, answering the others in the course of the creation of a work organically conceived and produced. The result is a substance which stands between himself and the common-sense world.

Scale

Through the use of a scale, an architect proportions the parts of a work to the whole of it, in the light of a possible appreciation and use of both the parts and the whole. His scale offers a method for measuring the *relevant* common-sense space, the *solid* space of the walls, grounds, etc., the *inside* space, and the *environmental* space. All these spaces are transformations of a portion of daily space after this has been dislocated from the space used in the course of community and conventional life. *Relevant* space is a technologically conceived space of which the architect takes account in his engineering estimates and which men occupy when engaged in conventional tasks.

The *solid* space of the walls, etc., is daily space intensified by materials and proportioned in the light of the various uses to which they might be put, the places they will occupy, the grain of the material, and above all, the size of man. *Inside* space is daily space creatively articulated so as to accommodate man, the being with a body, mind, emotions, and will organically interconnected. *Environmental* space is that portion of daily space which begins at the boundaries of a work and extends to some outside limit, and which is creatively articulated to accommodate man, the being who is to enter, use, and depart from the bounded world which the architect has created for him.

Strictly speaking, the scale enables a man, as a unity of spiritual, physical, private, and public natures to deal with an architectural work in a four-fold way. As a physical being, he measures the work quantitatively in units which are divisions, multiples, or duplicates of his average size; as a spiritual being, he measures it qualitatively as that which promotes the fulfillment of human promise; as a private being he measures it emotionally as that which does more or less justice to his interests; as a public being he measures it socially for a being engaged in various tasks. The unity of all these measures is himself as a single four-fold scale measuring the excellence of solid boundaries, inside space, environmental space, a relevant common-sense space, and above all, the unity of these.

If we take the use of a four-fold scale to be definitory of architecture at its best, we can say that architecture, ideally viewed, is an art which creatively synthesizes created with common-sense space. The architect might make use only of a spiritual, emotional, or social scale. If he does, he will alter the role that his scale has as part of a single four-fold scale. He will then engage in architecture only in a minimal way. If, instead, the architect attends only to a quantitative scale, he will deal properly only with the result of craftsmanship and technology, i.e., with the relevant common-sense space which is correlative with his created space. Only if all four scales are used together can he produce a work of architecture at once excellent and usable, created and common-sensical.

Buildings which answer primarily to one of man's needs have a different scale from those which answer primarily to another. Thus,

a school building must take account of the physical size and number of the possible students and teachers; but this consideration must be subordinated to that which regards the school as a place of maturation, a place where communication of knowledge and insight are promoted. A business building, a toll station, a factory, though occupied by men with secret passions, fears, desires, and ambitions, ought to be treated primarily as impersonal areas in which quantitative, repetitive work is performed. A home, because dominated by a set of values shared by a family, has a scale that is primarily emotional, though, of course, it has a spiritual, physical, and quasi-social dimension as well. A city hall, courtrooms, railroad terminals, finally, are in intent, if not in fact, public places. They cannot, of course, be made without a use of quantitative measures; they cannot be freed from all reference to what men might be, and to the values which men cherish. But their primary scale is a social one, a measure expressive of the kind of tasks to be done inside and outside the buildings.

A building ought to allow for a number of activities at the same or subsequent times. A scale for it, without losing its definiteness, ought to be flexible enough to permit of the creation of a work which can outlast any present purpose. Also, though the distances from wall to wall in, e.g., a school, a factory, a home, and a courtroom are quite distinct, yet, since it is one and the same man who is in all, they ought not to be entirely alien, unrelated to one another. Whether a scale is flexible or not, whether it is appropriate to different types of buildings or not, it is, as G. Scott observes, affected by light, by the color of the materials used, by our expectations, and by our projects. And it is forever invisible, beyond the reach of any photographs, elevations, plans, mock-ups, and the like. It exists only when vitally measuring a building in relation to interacting men.

The architect often uses a module. This is an explicit observable unit measure usually provided by some part of the work—the size of a mat, a brick, or a column—multiplied and divided throughout. A module is what a scale becomes when identified with a part of a work and then used without regard for men's spiritual needs, values, and social purposes. It is not to be confused with a scale, for a scale is not observable and never repetitively used.

The "International" style, most clearly exemplified in such works as the Lever and Seagram Buildings, tends to stress the module and to have this repeated without alteration. It is not clear whether or not its practitioners think that the qualifications which are in fact produced in any repetition in a work are to be overlooked, or are to be thought of as making unnecessary any deliberate variation of the ac cepted module. Nor is it clear just how seriously its practitioners want to take Mises van der Rohe's slogan, "Less is more." The Lever Building turns over valuable space for walks and flowers; the Seagram Building makes use of fountains. If they had tried for "less" they would have had achieved less, not more.

The "International" style helped moderns break away from the tendency to overlay works with irrelevant ornamentation; its clean lines fitted well with the idea of efficient industry; it took advantage of new materials and made bold use of glass. But its insistence on the use of a module prevented an exploration of some of the potentialities of architecture. Today, architecture seems more ready than ever before to take account of the fact that a single building not only can encompass a plurality of diverse spaces making use of a plurality of distinct but interrelated scales, but that the tensions and divisions in all can be varied in multiple ways without destroying the unity. The module should be used only as a guide or suggestion, not as a unit to be repeated mechanically throughout.

The "International" style was for most of its practitioners one of the outcomes of an insistence on a purely functional work. Functionalism is a theory having the virtue and power of helping men to attend to the grain of the material with which they are working, to become alert to the craftsmanship which architecture ought to incorporate. But it also tends to make men forget the endless possibilities that creativity has before it. Stressing the austere and essentially useful, it overlooks the value of decoration and the joy which the unexpected entails. Since it tends to allow the grain and texture to dictate the form, it is evidently a kind of nominalism in which the form is denied a proper role. It is just not correct to say, with Hegel, that the stones of the architect are more alien to his "idea" than the colors of the painter are to his "idea." Form and grain belong together; each

dictates to the other. To impose a form on what initially was not adapted to that form is a sign of greatness.

Articulated Spaces

Sibyl Maholy-Nagy distinguished six types of space—defensive, living, religious, temporary, storage, and working. Were these in fact types of space they would have characteristic boundaries, magnitudes, grains, textures, and scales. But they are primarily characterizations of space in terms of various functions which it can house. A better division would be between boundaries which cut one off from a space beyond, and boundaries which help enclose a space. The boundary at the limit of an environing space will always cut one off from the unused, irrelevant daily space that lies beyond; a wall helps determine the nature of the environing space, as well as the space inside the building. (Windows and doors are at once double boundaries and passageways; they help cut off and enclose the environmental as well as the building's space, and allow each of these spaces to act on one another.)

An architectural work usually has a created, enclosed inside space, and environs the result by another space. Each part of the building, the space in it, and the space environing it have their own strains and unities, their own subdivisions and sometimes subordinate boundaries. No one of them is produced as a single unit. The architect, like every other artist, works organically, modifying one part in the light of the achievements and demands of others.

One boundary of environing space is given by the limits of the environment, the other by the architectural work. The limits of that space might be at the horizon (as it is in Versailles) to convey the idea of an infinite environment. Usually, though, it is at a short distance from the building, and ends at neighboring buildings, garden walls, streets, and the like. Both the environing limits and the walls, roofs, and bases of the work itself are components of the environment. It is not entirely correct then to say simply, with Wright, that "the room within, the space to be lived in, is the great fact about the building." The environment is also an essential part of an architectural work.

Every building affects and is affected by what is outside itself. The

limits of that outside can be given by natural objects. The Greek temple, as Vincent Scully has stressed, took advantage of this fact. It was set on a hill and oriented towards a distant peak which acted as a limit for the temple's environing space. Such a limit can also be deliberately made by an architect. This is done by means of landscaping, with hedges, walls, and similar devices.

Both those who speak of producing works in defiance of, and those who speak of producing them in consonance with nature, intend to speak of the way their works are related to their environments. When it is said that Wright worked in sympathy with nature, what in effect is meant is that he produced an environing space for his buildings which was not too discontinuous in stress and quality from the mural cage and its inside space. Le Corbusier, for all his insistence on mathematically defined measures, does not really differ from Wright. (In his brilliant Notre-Dame-du-Haut at Ronchamp he seems to have largely disregarded his theory of the module. As he rightly remarked, "the foot-and-inch and metre are numbers," not measures in architecture.) Both he and Wright made works which stand over against nature. His environing space also is consonant with the cage and the space within.

It is difficult to make a distant limit which will completely bound an environing space. Nature insists on intruding itself, presenting us with distant objects which we, through an intent implicit in the acknowledgment of those objects, turn into limits overriding those made by the architect. Even when a building is completely surrounded by hedges, trees, and gardens, it has an environment beyond these. Sunlight and moonlight, rain, wind, and snow show that the environment extends beyond the limits which an architect produced or endorsed, even where the limit is set at the horizon. The architect must always place his environment in a setting whose nature he cannot entirely control, but which he must accept if he is to have an environment that all the rest can acknowledge in intent, work, and appreciation. It is therefore important for him to attend to the kind of limits which are available, and to accept these as conditions which help him to define the extent and character of the environment, and the placement of his walls and other surfaces.

When the idea of the environment is extended to embrace the entire artifactual world in which men live, it becomes evident that it is desirable at times to stress and at other times to minimize the contrast between building and environment. Different types of building need different types of environment. If different types of environment are used without regard for the role the buildings play in the community or what kind of a unity they together make, the buildings will confront us with a mélange of styles. If the community is to be properl dealt with, factories will contrast with their environments, since they are designed to bring about limited ends which will not be pursued outside the confines of the factory. But schools will not make a sharp contrast between themselves and their environments. The work done inside them will be but a concentrated form of what goes on outside. A school prepares students to live in a world beyond; it must hold them apart from that world, but only in order to enable them to fit into it better. Nor will dwellings make a sharp contrast between themselves and the community; the life led inside them is but a private form of what takes place in the public world. A dwelling is occupied by men whose lives are continuous with the lives they live in society. Since inside the dwelling, in the home, they live only quasi-private lives, that inside space is not to be treated in complete disregard of what takes place outside.

The total environment provided by the community imposes conditions on the more limited architectural environment; this in turn imposes conditions on the outside of the building, which in turn conditions the space inside. If what is done in that inside is to be integral to what is done in the other places, in spirit, structure, and meaning, the architect should make the fact evident on the outside and in the environment. A factory should be placed in an environment; a school should be centered by an environment; a dwelling should interplay with its environment.

The space inside a building is partly defined by the outside of the building. A saloon or funeral parlor ought not to have the façade of a cathedral, a school or a bank. The outside raises expectations regarding the inside, and these expectations ought not to be entirely defied. But they cannot be simply met. The inside should satisfy the

demands of the outside in a way no one could have entirely expected, knowing the outside. The expectations which the outside raises are to be answered, dealt with, and developed, not merely yielded to or opposed.

Collegiate Gothic, the Greek porticos of banks and courthouses, and the like, which overwhelmed us suddenly a few decades ago, and which recently have as suddenly been replaced by an odd miscellany of styles, had the virtue of providing outsides that answered to the textures, tensions, themes, and grains of the insides. They looked familiar, stable, conservative, and quieting. They were not the outcome of bold adventuring, but unlike most of the adventuring today, they came to successful terminations. (It is hard to believe that Yale's Gothic was produced no more than some thirty years ago; its architects could have led the way into the future which was just opening up. They failed to do this, but they did not fail to make the result attractive.) The problem for today is to know what a university, a bank, a courthouse, and a church are to be on the inside, and to see that the outside is so made as to allow for the inside needed.

Space should be contoured in different ways, depending on the purposes to which it is put.* This is the truth in functionalism. Because the inside space is to be occupied, it ought to be so organized by the sides as to make occupancy possible. In almost every inside space a number of activities occur. The simplest house should have places for cooking, eating, sleeping, refuse. Susanne Langer is surely mistaken in her supposition that flues, stoves, chimneys have nothing to do with the art of architecture. They are subordinate areas whose presence is demanded by the use to which the room is to be put, and whose placement and structure are partly dictated by the walls, floor, and ceiling of the room.

* Scully rightly says of the Guggenheim Museum by Wright: ". . . once the design was accepted as a museum (a decision of doubtful wisdom), it may be that the authorities would have been well advised to follow Wright's intentions through to the letter. The present solution of projecting the pictures far into the ramp on metal bars, of painting the walls and ceiling around them white, and of installing fluorescent lights in Wright's clerestories and in the ceiling as well, not only does the pictures little good, but severely injures the building itself by substituting a department-store harshness of glare—compressive upon the space—for the naturally changing and expansive light that the ramps demand . . ."

Organic Unity

The inside limits of a room, by virtue of their reference to one another, produce a tensed, unique, inside space. To speak of a house as a machine for living is to tempt one to overlook this fact. A machine is a set of externally related parts intended to function together; a house is a single unitary spatial whole. It closes in and closes out, enabling men to engage in various enterprises free from the intrusions of nature and of other men. Together with the environment, the house presents us with a new real space, a space in which one can live with body and mind, in spirit and in act. Endlessly plastic, capable of being occupied in countless ways, it is an icon revealing to us the texture and meaning of the space of existence.

Just as surely as the outside walls and space of a building make demands on the inside walls and space, so the inside walls and space make demands on the outside walls and space. The outside space, for example, should be oriented towards a source of light and heat not necessarily demanded by the outside alone. A completely enclosed inside space is without light; it is an invisible space. To be used it must be lighted; if lighted from without, it will share an environment with the outside walls, and both must be made with this consideration in mind. The site of a house is then not to be determined solely by what will interplay with its outside walls, but involves consideration of the lights and shadows produced on the inside space by sun, moon, hills, and water. If the building is illuminated from the inside (as it must also be, unless used only at very special times), the lights and shadows must be controlled. The inside space will then mediate the very sides which constitute it, giving them new values, and thereby acquiring new values of its own.

If a building is moved to a new site, its nature is inevitably changed. In modern cities where there is a minimum of planning, buildings are placed without consideration of the space produced by the environing limits that different buildings offer one another. The effect need not be bad. The skyscrapers of New York are placed somewhat haphazardly; Rockefeller Center is designed. Both are successful, perhaps

because the power of the vertical thrusts overpower the horizontal influences.

The failure exhibited by the New York skyscrapers is not the failure to exhibit beauty, but the failure to provide adequate traffic, communication, and transportation facilities. Rockefeller Center has its own failures—it does not fit inside its surrounding. It is internally well organized but lacks a proper environing space. The fault, of course, lies not with the Center's designers, for they had control only over the space of the Center. They knew that the surroundings would be changed in the near future, and perhaps even hoped that this would be done in the light of the boundaries which the Center could provide for them.

Viewed as environing spaces, the interspaces between the New York skyscrapers are most inadequate. But the spaces between them successfully serve as interspaces leading to the space which their towers make with the sky. The John Hancock skyscraper in Boston, due to the fact that it has no neighboring skyscrapers, has no proper interspace with other buildings. Since it is an ugly building—at least when seen close by and from the ground—it would have profited from the presence of other skyscrapers nearby which would make the space between them function as an interspace pointing towards the sky, and somewhat hide from view its outside walls. (Does any area of comparable size have three such ugly buildings as the John Hancock skyscraper, Memorial Hall in Cambridge, and the Jewett art building at Wellesley? The first two seem largely a matter of accident, sheer chance in the selection of architects and projects. The third, though, is evidence of the fact that poor architecture might be the result of too many, rather than too few, ideas. The Jewett building at Wellesley offers a mélange of unintegrated styles, devices, materials, and vistas; Rudolph's later buildings, e.g., his splendid Sarasota High School, are sustained from a single point of view which subordinates the various components more completely to the demands of the whole. No one, I think, has made such stupendous strides in recent years as Rudolph. There is a great distance between Wellesley and Sarasota.)

The theme of the architect is usually a purpose which can be served by some part of the work. This purpose is modulated even in the act

of merely repeating it in the same grained material; it is modulated further when the same material is integrated with different materials, and still further modulated when multiplied and divided at different places in the work. Every boundary and every bounded space has subordinate interspaces; the termini of those subordinate spaces have the role of focal areas. In both interspaces and focal points there are tensions, each with its own magnitude and value. Architecture tends to have clearly defined focal points which subdivide the whole rhythmically in accord with the grain of the material. Resistant, hard, abrasive material demands smaller, whereas soft, smooth material needs larger focal points. Metopes, passageways, windows, protuberances, and recessions serve to space the work and in turn may also function as focal points. None is isolated. There is a bleeding from shadows to light and from light to shadows, from voids to solids and solids to voids, from tensions in the boundaries to tensions between the boundaries, and conversely.

Architects see their buildings as organically connected solids and voids. Some of the parts of their buildings, such as the windows, function as both. Others, such as the doors, sometimes function as the one and sometimes as the other, depending on whether they are closed or open. Both windows and doors can be made part of the limits of an environment, inside of which the building proper is to be placed. When a door is flush with the street and connected by a foyer or vestibule to the inside of a building, it functions not as a part of a building but as part of one of the limits of the environment. The foyer or vestibule in this case is an interspace, part of the environment of the building. If the door is part of the building, we have a building environed by a building, beyond which there is still another environment in the usual sense. The environing building will have its inside limit at the innermost place where the foyer or vestibule ends; the outside limit of that environing building will be given by the door. But beyond this will be a further environing space, with limits at a distance from the environing building.

Architectural works are inescapable. We need not look at sculptures and paintings, listen to stories or music, watch plays or dances, but we cannot escape architecture. The front of a building is usually the

side most often seen. It is the part that most signally intrudes on the passerby. The building, therefore, has the responsibility of having it satisfy the ordinary man's immediate impressions and sensitivities. (Even buildings centered about patios and similar enclosures, unless they merely enclose, intrude on us and must therefore also satisfy immediately.) This does not mean that there are not more subtle and reliable critics than ordinary men, or that architecture must not meet the demands made by disciplined students of the subject, but only that an ordinary man's judgment has rights in architecture it does not have in other arts. That is why architects usually take particular care to make the fronts of their buildings impressive. Occupied with making the front attractive, they unfortunately overemphasize it. The result should harmonize with the rest of the building and the environment.

In the normal case, the front of a building has a climactic entrance sustained by windows. These, spacing and being spaced by the intervening material, constitute a set of tensions on the one hand, and a set of resolutions on the other. As a rule what is shadow is interspace, and what is light is climactic, though this need not always be the case. With the changing of light during the day, the roles of windows and the spaces between them shift. It is in this connection that it is correct to speak of architecture as the study of "the play of forms under light." The architectural work is never properly made if it is not made to be beautiful in sunlight and twilight, in moonlight and under electric light, in summer and in winter, from above, below, forwards, at an angle—in short, from every perspective and under every condition.

Environing space need not be conceived solely as alongside a building. There is an environing space above and often below it. A roof usually has sides, front, rear, top, and bottom. It is not a building; the different parts of it, though they help one to be oriented towards different regions in the environment alongside, are interlocked to make one outward surface which, with the sky, makes an environing upper space. That space is often ignored, except in connection with rather special projects. The Greeks, the Muslims, and the builders of cathedrals, however, have always been aware of it. We today are alert to it usually in relation to skyscrapers. Giedion says that these sky-

scrapers lack dignity, strength, scale, and light, that they are just towers "rising to extreme heights." He thinks that "where the New York skyscraper went astray was in the exaggerated use of the tower, with its intricate mixture of pseudo-historical reminiscences and its ruthless disregard of its surroundings, as well as of the entire structure of the city." He overlooks the fact that the towers are needed in order to provide housing for water, elevators, and heating apparatus, and that the towers make conspicuous the relation of the buildings to the sky.

Roofs are not usually readily seen. But with the development of terraced buildings and the increase in airplane travel, more and more attention will be given to the fact that roofs have a role of their own. Needing a distinctive material, because they usually take the brunt of the changes in weather, they need a different theme and development from that characteristic of the sides. Used as storage places, observation points, and playgrounds, they can be extended into the environing space, somewhat in the way in which a garden extends a house. But whereas the garden usually comes to an end at the gate or not far beyond this in some accepted natural cleavage or obstacle, the space bounded at the roof has no proper limit but the sky. Since one cannot lay hold of the sky, one can do no more with respect to the upper environing space than to acknowledge it to have a distant limit. Looked at from below, however, the sky is not far distant, and the problem of coping with it is not much different from the problem of coping with the limits of a garden or pathway. But, as had already been observed, architecture ideally should be seen to be beautiful from any angle and under any condition, though there is no question that as a rule, preference must be given to daylight and to a perspective from below.

Organically Unified Space

The inside and environing spaces which architecture produces must be harmonized. An emphasis on the first will involve a neglect of the public import of the work; an emphasis on the second will involve a neglect of its private use. These created spaces must be integrated with a common-sense, technologically utilized space. The architect

combines the created and utilized spaces to make a building which is firm as well as beautiful, useful as well as enjoyable. The architect is guided by a myth by means of which his society refers to basic divisions of an ideal, germane to all its members. These divisions express the meaning of a beginning, turning point, or end. One rarely focusses on these with any clarity; we see them usually in the guise of some limited possibility. Those who attend primarily to the basic subdivisions produce monuments; those who attend primarily to the delimited versions of them, work in the light of transient meanings. Together they yield monumental meanings, meanings which while germane to what is then and there of interest, makes men aware of basic values.

A myth, its subdivisions and their delimited forms, are all social ideas which the artists' ideas delimit and personalize. He who attends only to the social ideas produces works of a nationalistic cast; were he to attend solely to his own ideas he would produce works reflecting only an individual interest. The reconciliation of the two yields regionally appropriate buildings, i.e., national ones with locally distinctive styles.

Like every other art, architecture reflects the spirit of the times. Were a Greek temple made today, it would show in its environmental and inside space, in its technological treatment of common-sense space, in its use of various scales, in its relation to the prevailing social ideas and to the individual ideas of the architect, something of the fact that it was made in a quickly moving, twentieth-century urbanized civilization. Still, there is a great difference between the architect who today seeks to make buildings similar to those made at some previous time or in some other civilization, and one who is abreast of our time. It would be unfortunate, though, if an architect were to try to make up his mind as to just what our civilization is like and then set about to create a work which will embody that idea and presumably through it the meaning of the prevailing myth. Architecture not only reflects the spirit of the time, but contributes to it.

We know who we are, in part, by seeing what the architect creates. More generally, the nature of the myth which characterizes our time is in its concreteness formed and displayed by all the different activities, works, concerns, and creations which men today, in some inde-

pendence, together produce. He who makes a work which is intended to catch the prevailing spirit will not only overintellectualize it, but will fail to contribute, as he ought, to its determination.

The architect, like every other artist, must exhibit within a spiritually significant, valuationally important, socially useful, and physically viable space the ideals to which society's myth and his own ideas refer. If he does this, he will present us with an excellent work which reveals not only the nature but the import of the real space in which all of us live and die.

At every stage of its history architecture creates space. This space is self-contained, with its own structures, texture, and tensions. It is a voluminous, empty, bounded space within whose areas other works of art are to be produced, and whose nature can be known only by one who approaches it in terms of an appropriate scale. The spectator no less than the architect must, to see the space which the architect creates, see the whole of it in terms provided by man's body, mind, activities, and spirit.

An adequate study of architecture should deal with the main types of boundary and space that men have created in the past. It will trace architecture's history and indicate where it might experiment and grow. The enterprise would require a study at least as large as this entire work. It would not be amiss, though, to remark that the history of architecture does not seem to have had many great turning points. There seem to be few great adventurers among the architects, perhaps because they are so overwhelmed by judges, critics, clients, and problems relating to engineering, city planning, and scales. What architecture badly needs today are laboratories where students are not only trained and disciplined, as they now are, but are also encouraged to experiment with the bounding of all sorts of space, in all sorts of ways, with all sorts of materials. They should have periods in which they do not care that their work may not interest a client or that no one may ever build it or that it may not fit in with prevailing styles. Not until they take seriously the need to explore the possibilities of bounding spaces in multiple ways will they become alert to architecture as an art, as respectable, revelatory, creative, and at least as difficult as any other.

5. SCULPTURE

As a result of his study of distinguished works in the history of sculpture, Herbert Read observes in his *Art of Sculpture* that "A very real confusion has always existed between the arts of sculpture and painting." The "confusion" has now been dispelled. No one would today, I think, deny that sculpture and painting are distinct arts. But architecture and sculpture are not yet widely recognized to be distinct. Many contemporary sculptors and some contemporary architects, in considerable consonance with tradition, deny that a sharp line can or ought to be drawn between sculpture and architecture. One must show that their denial is unwarranted, or give up the present claim that sculpture is a distinct, basic art on a footing with all the others.

J. M. Richards has observed that Victorian architecture was thought of as large size sculpture—and there is no radical break between the Victorian period and other periods. The fact, though, that at some period of time architecture and sculpture were not distinguished does not provide a good reason for holding that the two are of the same kind. The question to be decided is whether or not they *ought* to have been distinguished.

A. Hildebrand has said that sculpture is a set of paintings around which we walk. In his own way he broke down an essential distinction between painting and sculpture. Granting him his position, his thesis would in effect say that a building, too, is a series of paintings around which we can walk. This would make it all surface, and deny it its three dimensionality, environment, and interior space.

The mock-ups of architects seem to be sculpture, not architectural objects. But is it not absurd to speak of an architect as engaging in a distinct art of sculpture in order to prepare for an architectural work? Would it not be better to say that he is doing sculpture or architecture in both cases, the one in the large, the other in the small? I think not.

An artist can do many things on the way to producing a work of art of a given type. Some of those things will have much in common with other types of art, but they will nevertheless be quite distinct from them. Architects make drawings as well as models. This does not mean that they are painters. The models are not sculptures, the drawings are not paintings. Neither is a work of architecture. They are pieces of craftsmanship, involving no creativity, though they do demand considerable ingenuity.

Sculptures are frequently designed to be parts of architecture. But if they are works of sculpture, they are so far not works or parts of works of architecture. Walls and doors can be made to provide places in which sculpture can be put. The sculpture will then be fitted into an appropriate environment, but it will still be independent of that environment. It cannot therefore be a work of architecture.

Parts of an architectural work can be sculptured. Gargoyles are. That does not make them pieces of sculpture. Gargoyles are spouts, as much parts of a cathedral as are the runways, the facings, and the buttresses. The fact that they are sculptured is an additional fact about them. Like carved doors they have been dealt with aesthetically, without compromising their roles as integrated elements in a single architectural work. Like the carvings on the doors they can be related to other parts of the architectural space over an interval which, with them, can constitute a sculptural work. More generally, any parts of an architectural work can, with the interval between them, constitute a work of sculpture, but only because those parts and often their relations, have first been abstracted from the architectural work. Those who would make the sculptor attend to the needs and desires of the architect are either wrongly asking the sculptor to cease being an artist, or are making the exciting suggestion that the sculptor and the architect should work in some third art in which each listens to the other, and in which each art will have a role distinct from that which it had by itself. Such a third art, of course, does not preclude the independent pursuit of what it treats as subservient.

We can deal with a wall by itself. We can also use it as a canvas or take it to be raw material for a sculpture. The great cathedrals were once painted; murals have a long history. If we make the ornaments or

figures inseparable from a building by hammering them out of a wall, we will introduce a secondary art to supplement a primary one. A wall, whether painted or carved is, as wall, as integral part of an architectural whole; that it may have a secondary function as material for the art of painting or sculpting does not affect its primary role any more than photographing it or using it as something to lean against would.

It is sometimes hard to tell the difference between a piece of sculpture and a work of architecture. The Pyramids and the Sphinx have occasionally been treated as either one or the other. However, though they may have intricate interiors, those interiors are not defined by their exteriors or even by their interior walls. The Statue of Liberty is placed in a fixed site, and is quite clearly hollow. This does not make it a work of architecture. It is just a piece of bad sculpture. Its inside is an unused common-sense area limited, but not encompassed or defined by its walls. In theory, like any other work of sculpture, the statue could be placed anywhere, for it has no environment. A piece of sculpture, of course, needs to be placed somewhere or other. But when we specify the place, we merely sharpen the import of the sculpture as at that place. The Pyramids, the Sphinx and Statue of Liberty all lack features essential to an architectural work. The tombs of Napoleon and Grant, in contrast, are architectural products. They are designed to enclose a definite type of space. Any elaboration that occurs on the outside or inside walls is incidental, and does not suffice to turn them into sculptured objects. The Washington Monument is also a work of architecture, though this is not so readily evident, for the paradoxical reason that the architecture is so simple, both on the inside and outside.

The surfaces of a work may be painted or carved, and yet the work may be just a work of architecture. Murals and ornaments do not convert an architectural work into paintings or sculptures. The architectural work merely provides these other arts with opportunities. It is not the use to which walls are put for some other art, but their inability to bound an inside space and an environment which shows that they are not parts of an architectural work.

The main differences between architecture and sculpture can be brought under the following six headings.

Interior Space

The inside space of architecture is voluminous and empty. The interior space of sculpture is voluminous but occupied; it is a part of the body of the sculpted thing. The surfaces of a building are boundaries which endow a volume of empty space with newly created tensions and relations; the surfaces of a sculpture are not boundaries at all, but the sculpture's volume made manifest. "Each profile," said Rodin, "is actually the outer evidence of the interior mass; each is the perceptible surface of a deep section . . . the reality of the model . . . seems to emanate from within." A work of sculpture materially presents us with a newly created, voluminous, occupied space.

When the brothers, Naum Gabo and Antoine Pevsner say, "The volume of mass and the volume of space are not sculpturally the same thing . . . they are two different materials," they are not denying, but in fact supporting the view that sculpture is the art of occupying space. The sculptured work is not merely its material; it is the entire volume which that material makes possible, and thus all the holes, indentations, recesses, and protuberances within the ambit of the finished work. Empty space, for sculpture, is a region sculpturally occupied.

Sculpture geometrizes a space in a palpable form. It is its occupied space; the shape of it is the geometry of that space, a new way in which space is made to be. Even when, as traditionally was the case, the sculpture resembled a human or animal form, the sculpture served primarily, not to represent a human or an animal, but to make manifest how a living thing alters the dimensions and relations of the space it occupies.

The inside space of an architectural work is more or less empty, usually visible, and always tensed; the encompassed space of a sculpture is filled, rarely visible and always powerful. The openings in an architectural work are passageways relating inside and environmental spaces; but in sculpture there are no openings, there are only intervals. These, even when in the guise of empty holes, are massive, controlled by and controlling the rest of the work. They are just as terminal and just as relational as are other parts of the sculpture. The architectural

work bounds and relates two spaces; the sculptural work is the very space it occupies.

The holes exploited by such sculptors as Moore, or the spatial areas for figures having a minimal mass, which Giacommetti created, are special types of intervals. They are cousins of the intervals used by previous sculptors by means of which leg was separated from leg, arm from body, protuberance from protuberance. The sculptured work is interval and terminus together, and strictly speaking, it makes no difference whether the interval be a hole and the terminus a solid or plane, or conversely. In neither case does one move through the interval; a sculptural interval is as solid and resistant as the rest of it. If one looks through it, without resting in it, without enjoying its texture and contours, one looks past the sculptural work altogether. If, on the other hand, one looks through the windows or doors or even the inside space of an architectural work, one architecturally moves into an architectural space.

A work of architecture can be a constituent of a sculptural work, just as a sculptural work can be made part of an architectural one. As was remarked before, the intervals between different parts of an architectural work—even the intervals between distinct architectural works—can be dealt with as positive, ponderable elements which dictate to and are dictated to by architectural surfaces. They will then, together with those surfaces, constitute sculptural objects. It is such sculptural objects which are caught in photographs of architecture, leading one to think the two arts can be identified. But sculpture and architecture are different arts, with different tasks, aims, and outcomes.

Exterior Space

A work of architecture has an environment; a work of sculpture does not. The former is placed in a site, and has a limit, determined by act or intent, somewhere beyond its walls. But a piece of sculpture belongs anywhere. It might be made to fit in a niche, but it then will either be made part of a compound art with architecture, or will have its sculptural nature limited in order to serve the purposes of another art.

Although sculpture has no environment, it does have a spectator

space. This is an irregularly bounded region with variable stresses and uses produced by the sculptor for the benefit of the spectator. When and as the sculptor makes his work, he makes the spectator area. He himself works in that area, examining and evaluating what he himself is doing in the light of what he discerns from there. Painters look at their works from various distances and various angles, but they do this primarily to discover flaws and problems which might have been over-looked in the more familiar positions. Sculptors stand at different distances, approach their works from multiple angles because those works are the foci of all these positions.

The sculptor views his work from different distances and angles, and to the degree that he alters that work in the light of what he then discerns he constitutes that distance and angle as part of a spectator area. Ideally, he should occupy every part of an area in which a spectator might stand; actually, he contents himself and must content himself with taking signal positions, making his work in the light of these and thereby defining crucial places from where his work might be approached, and which will help determine the nature of the other positions which could conceivably be occupied.

The spectator must stand at a distance from the sculpture. If the outer limits of the environment of a building could be made up of spectators, the building would have a humanly defined limit to its environment. If the bodies of the spectators were treated as limits of an area in which the sculpture is to be located, the spectator space of the sculpture would have a bodily limit. Humanizing the limits of a building's environment or treating spectators as walls has no effect on the status of the works, but only on the way in which men can function—as spectators in the one case, and as bodies in the other.

Unlike architecture or painting, a work of sculpture is surrounded by a spectator space. By changing one's distance and position in that space, one changes the import of the sculpture. A work of sculpture demands that it be seen from every possible side and from every possible distance, each one of which makes evident a new meaning. This is not the case with architecture. A work of architecture remains unaltered no matter where one stands, even though there may be things seen from

one position that are not evident from other positions. It is the task of sculpture to make an occupied space which has different values from different positions in a spectator space. It is the task of architecture to encompass an inside space and limit an environing one. A work of sculpture, as it were, sheds a differentiated radiance over an external area; a building is the focus of a fixed environing region.

Location

An environment is determined by the way in which a limited external region is made to terminate at the boundaries of a work; a made or fixed external region, not bounded by the work, is not an environment for it. The space surrounding a work of sculpture, though made and fixed, does not function as its environment. Conversely, a work of architecture does not lose its environment even when this constantly changes in magnitude and contour, and is limited by intent rather than by act; buildings may have environments which are neither made nor fixed.

A building is placed in an environment architecturally defined. Any position in that environment offers a proper perspective from which to grasp the nature of that building, and any position outside the environment offers a proper point from which to approach both the building and the environment. But a piece of sculpture has no environment. The sculpture can be placed anywhere without itself being altered, for the surface and spectator area of the sculpture alone define what is germane to it.

Common-Sense Space

Architecture infects the three-dimensional space of daily life with new meanings and tasks, and divides it into an environing and an inside space. Sculpture takes the three-dimensional space of daily life and transforms it into an occupied space which it sets inside an unformed, irregularly bounded spectator space. Like architecture, sculpture submits to the laws, restraints, and geometry of the three-dimensional space of everyday. Unlike architecture, though, it imposes determinations on this in the shape of the sculptured object, thereby occupying, using up this common space. Architecture synthesizes uncreated and

created space; sculpture does not. Architecture allows daily space to function for it; sculpture subordinates that space within its own newly created space.

One cannot avoid standing in natural and common-sense spaces when one takes a position in architectural space, for the enjoyment of the architectural space requires the presence of a man who is at once a natural and a common-sense substance. A spectator of a piece of sculpture is, of course, also a natural and a common-sense man; the sculpture, too, is inseparable from itself as a common-sense and as a natural substance. But the sculpture contains the latter as abstractable aspects, which can be isolated only by ignoring the new determinations which the sculptor introduced. The various dimensions of a sculpture are the three dimensions of common-sense space radically transformed, and thereby deprived of an independent status in the work. Only abstraction from the sculpture will yield the kind of spaces which in architecture exist together with the space that the architect creates.

The geometry of a sculpture is the geometry of common-sense space distorted by the sculpture itself. The being of the sculpture defines the nature of its geometry. The sculptor intensifies, curves, and dissects the space of common-sense substances to produce a new substantial space occupied by the sculptured work. A sculpture is thus somewhat like the matter of relativity, differing in that it curves space, not in proportion to mass, but in proportion to the degree that the material has been creatively transformed.

Architecture unites a created space with a common-sense space. It is an art which makes provision for a possible use. Sculpture does not do this. If a piece of sculpture were made for use, as was the New York Central Park statue of the creatures in the Alice books, this would be an incidental, additional fact about it. Its use is not essential to the being of a sculptural work. There are, to be sure, common-sense necessary conditions which must be met before sculptors can produce solid, observable objects. Sculptors make use of armatures and take account of the need for support and of the fact that their materials must be worked over in common-sense ways. But the common-sense things and space which architecture acknowledges is a component of the work itself, not merely a condition which makes it possible.

Scale

Architecture and sculpture differ in their use of scales. Architecture has a four-fold scale; sculpture has a two-fold one. There is no size a sculpture has to be, and no necessary or desirable way of subdividing it. To understand it we need never compare it with the size of some actual man, or make provision for someone to use it in some routine task. It is not to be entered or occupied, and is therefore not something which need take account of man's body or his work. Consequently, it has no need to employ social or physical scales. But sculpture does use spiritual and emotional ones. Despite its many different meanings from different positions in a spectator space, it reveals, by means of its scales, the single import existence has for man.

Substance

Sculptures are there to be touched, usually on every side, at every point. Buildings are to be touched only at certain places, while paintings, despite their tactile values, are not objects for touch at all. The grain of a sculptured theme is therefore even more vital than it is in architecture or in painting. The grain makes a difference to the theme —a marble curve is quite distinct from a wooden one. Sculpture is, in fact, so conscientious about the grain, that Rodin could with warrant complain: "The ignorant say: 'That is not finished,' but there is no notion more false than this of finish, unless it be that of 'elegance.'" By "finish" I think he meant a wrongly imposed closure, and by "elegance" the avoidance of ruggedness. This ruggedness is conveyed by the rough-hewn grain of the various planes, but this is so only so far as the nature of the material is thereby exposed. Rodin's Balzac is a vital figure in part because the rugged material out of which it is made readily evidences the subterranean forces with which Balzac struggled and which all men feel. If by functionalism one means giving the grain of a material full play, there is no place where functionalism is so persistently exhibited as in sculpture.

One must add, with Brancusi, that the sculptor perceives in visual and tactile ways at the same time. No one, sculptor or not, of course ever merely sees with the eyes, or feels with his fingers. All see and feel

as organic beings, alert to the tactile values of whatever is seen, and the visual values of what is felt. But in sculpture the tactile values are brought out and made visible, made evident to the eyes—or what is the same thing—the visual values are made sensible, evident to a delicate touch. The sculpture visually expresses tactile values, actually exhibits visual values to the sense of touch. Its space is at once palpable and visible.

Touch and sight are senses employed in perception. Since perception yields only abstractions from substances, no sensing or perceiving will enable us to make adequate contact with the created substance which is art. The abstractions we can obtain from a work of art enable us to know it, but the work is also to be enjoyed. It is better then not to contrast architecture and sculpture on the basis of perceptual qualities but on the way they maintain themselves as substances. Both have irreducible powers and integrity, but they maintain themselves in different ways. Architecture offers a work which holds inside and environing spaces in equipoise; the work and the spaces together make a single stable unity. Sculpture offers a work which has its space within itself; its stability is the result of the way in which its parts, solid and porous, are interrelated. Sculpture means, says Henri Lauren, "taking possession of space, the construction of an object by means of hollows and volumes, fullness and voids, their alternations, their contrasts, their constant and reciprocal tension, and in final form, their equilibrium."

Despite these six differences, sculpture and architecture (with painting) can be dealt with together as basic spatial arts. They allow for the abstraction of four abstract spaces—the space of perception, science, events, and value. And they presuppose three others—the space of common-sense substances, the space of natural substances, and the space of existence. The fact that one cannot either move or act in the abstract spaces or the space of a sculpture or painting does not destroy their spatiality. Space is an extensive domain of coordinate, interrelated extended subregions at a distance from one another. It may encompass a few or an indefinite number of dimensions or directions. The spaces of works of art—the inside and environmental space of

architecture, the occupied space of sculpture, etc.—are genuine spaces though they differ in dimensions, properties, and powers.

The space of natural substances is never directly encountered in its purity but only in the guise of common-sense space. Common-sense objects and common-sense space are natural substances and natural space, partly distorted, partly infected with extraneous material, and only vaguely apprehended. To know what natural substances and space are like it is necessary to take the various abstractions which one can derive from common-sense objects and space, and synthesize them.

Existing space, the space of existence itself, is a cosmic space, the space in which natural substances exist together. We can conceive of this space in speculative philosophy, and we can reproduce it in art. But conceived or not, reproduced or not, it is an ultimate, irreducible facet of an irreducible mode of reality. The spatial arts have the portrayal of it as their primary task. The real space which lies beyond the reach of common sense, and which is presupposed by natural substances as a field in which they can be together, can be concretely grasped only if one turns away from the world of experience and engages in an art.

More than any other art, sculpture has been haunted by the temptation to represent, not its proper object, the real space of existence, but particular, familiar things. It never really succeeds, of course, and no sculptor stays very long with the idea of doing so. A living being is a being of flesh and blood and bone, plastic, self-moving, changing constantly, whereas sculpture is dead, stable; if it moves, it is because it has been acted on externally and mechanically. One can conceivably take advantage of the recent advances in cybernetics and make a piece of sculpture which is self-guiding. Could one arrive at the point where it could imitate all the actions of men, one will have arrived at the point where the sculpture has been transformed into a man-like machine, whose sculptured features play only a secondary role. Until that day sculpture will, despite any imitation it might offer, have features whose magnitudes, placement, and roles will be dictated by material, themes, and textures, and the sculptural problems these set, and not by a need to act as though it were human.

The supposition that sculpture is representational, and particularly

of the human figure, brings one against a central problem raised by Lessing. He said that sculpture could not express anguish, or more generally, that it must conceal certain ugly expressions if it is to achieve beauty. He in fact raised two distinct questions, but failed to distinguish them: Can sculpture express anguish? Are there limits to what sculpture can express? His first question is so unmistakably answered in the affirmative by statues of Christ on the Cross that it is hard to see how he could ever have thought a negative answer possible.

In contrast, Lessing's second question does have a negative answer. There are no limits to what sculpture can express. Anguish, weeping, any emotion or state can be exhibited in sculpture, but not as isolated items. They are part of a context revealing a reality having importance for man, an importance usually indicated in ordinary life by means of the emotions. Lessing was content to take the position of a spectator; he supposed that such an act as crying left nothing for the imagination to work on, and therefore presumably had no aesthetic role; he believed that objects which were side by side had to be represented by signs existing side by side; and he thought that sculpture can show only what happens at a single moment. He was therefore unable to acknowledge the rich potentialities of even the sculpture of his own day.

Lessing took a rather simple-minded view of representationalism; he seemed to believe that art must actually mirror an object. If it is mirroring that one is setting out to do, Lessing would be right—one ought then, as one does in life, conceal some things to make others more prominent. But art is not a mirror. An artist neither conceals nor exposes; he makes something be by maximizing here and minimizing there. What is maximized and minimized are not emotions or features, but themes. Only occasionally are these exhibited as entire features; they rarely portray emotions. The emotional effect is produced by the work as a whole. Anguish, fear, crying can, in fact, all be conveyed without making a resemblance of a man. And if a man were portrayed and in one of these states, the result, despite Lessing, could still be beautiful. Beauty can be achieved by making the meaning of anguish permeate every part of the work.

Ignoring the spectator space of sculpture and the varying positions and distances which it allows, one can readily assume with Lessing that

a sculpture catches a man or living thing only as at a moment. Yet the cubists have taught us to see the meaning of movement in sculpture, and since then we have had mobiles and other sculptures which themselves vibrate and move, thereby making evident a multiplicity of aspects in a temporal relation.

No topic or subject matter is the exclusive possession of any one art; no topic or subject matter can rightly be excluded from the province of a given art. Any topic can serve as the occasion for portraying the nature of existence. That existence has an import for man, and it is this import which the arts convey. Sculpture exhibits a space, not because it is concerned with space as such, but because it is concerned with presenting existence in its spatial dimension.

Like every other art, sculpture reports not man's anguish or fear or nobility or struggle, but what yields these in interaction with man. The space of sculpture is existence spatialized, an existence which contains the warrant for man's hope and fear. What is to be seen and felt in that sculptured space from some one of an endless number of possible positions and distances, is a cosmic power, partly expressed in tensions through planes, indicating the kind of pull existence can exert on and through us.

The emphasis put on representation in sculpture has made it at once the most readily understood and the most misunderstood of the arts. The world has quickly grasped the lessons of dignity and nobility taught by Michelangelo, and the lessons of self-possession and basic concern taught by Rodin. These men have made such lessons evident in the lineaments of their sculptured figures. But this very obtrusiveness has prevented men from seeing that the sculptures tell us not about men or any finite thing, in and of themselves, but what existence means for man.

Like the cathedrals, some sculptures were once painted. Painting here functioned as a subordinate art, supplementing and heightening some of the sculptural achievements. With increased appreciation of the inherent value of materials, a fear has grown that colors might obscure what sculpture should reveal. The fear is well-grounded. But it could be quieted. A piece of sculpture can be polychromed without obscuring its texture. One need not paint the sculpture in every place or paint for

any other purpose but to make more evident what the sculpture had revealed. One can reasonably expect that sculptors will soon be poly- chroming their works again.

The simplest theme of a sculpture is a curved line. No perfectly straight line is possible, not only because there are no perfectly even rulers or steady hands, but because every line is pulled by the lines alongside, above, below, and beyond it. There are no perfectly flat planes for the same reason. The lines and planes of the cubists are but lines and planes of minimum curvature which intersect and support one another so as to produce newly created extended regions. At the edges of a work one can see how strongly even an emphatic two-dimensional area is pulled in or pushed out from within and by the planes with which it is thematically related. Gordin's sculptures, with their right- angled black and white steel strips mathematically placed on a simple vertical bar, vary in distance, press in on one another and pull away in unpredictable ways. And as one shifts one's position, the relations be- tween the parts change in value, as they ought. The works, despite their apparent simplicity and rigidity, are highly complex and vari- able.

The most luminous themes are simple curves of some magnitude. Tiny curves are not noticed, and very large sweeps defy the single glance. The shapes of such natural objects as eggs and waves, of such move- ments as a walking step or the stretching out of a hand, and such com- mon directions as up and down, front and back are unreflectively used by both sculptor and spectator to provide unit punctuating curvatures in a continuous set of lines and planes, thereby enabling one to read the newly created space.

Themes which reflect our common usages offer helpful ways of see- ing a sculpture. But if treated as the only themes one can or ought to produce, they will prove to be restrictive and stultifying. The curves of a sculpture are newly made, and ought to suggest, not represent, those with which we are familiar, and then only so far as this will enable us to see the sculpture properly.

Every part of a sculpture is related to the other parts in two dis- tinct ways. Each part is related to every other to constitute the surface of the sculpture. Each part is also related to every other through the

body of the sculpture to constitute an infinite number of planes and volumes. The whole is one modulated continuum, and this whether the sculpture is built up piece by piece, carved out, or put together by combining things. There are no definite resting places or climaxes in the work; every region is sustained by and terminates in others. Each part spaces every other part; what is terminal is also relational, what is relational is also terminal. And since there are countless planes and volumes in even the simplest sculpture, every sculpture has great complexity.

The overwhelming stress of a sculpture is on unity. All parts, all themes, all distinctions are subordinated to this. The work must therefore omit much. But more important it must be pursued by men who have a sure sense of closure. As was noted, Rodin took exception to the idea common at his period that a sculpture should be finished, given a look of completion which it in fact does not deserve. The limitations of the sculptor face him with a need to stop his work before it is perfect. Such stopping, precisely because it conflicts with the drive to produce the excellent, is always resisted by artists to some degree. But it is resisted particularly by sculptors, to whom it is always evident that so much more work always needs to be done.

Whatever the sculptor achieves is but a part of what is still to be achieved. Still, at some point he must call a halt. If he goes beyond that point he will spoil his work. The sculptor who does not conceal the point where his creative activity has come to an end makes it possible for others to see the work not only as having the function of portraying a partially expressed power of the real space of existence, but of exhibiting the limitations of the artist. The unfinished sculpture says that it is unable to do full justice to real space because the sculptor is a man limited in power and perhaps in insight. Could he complete the work he would be perfect, able to represent perfectly the nature of spatial existence by means of an occupied created space.

During the last fifty years painting has undergone revolutionary change after revolutionary change. Architecture, though slow moving and only recently not too far in achievement from what it once was in the time of Greece, has suddenly begun to see how endless are the possibilities which are open to it. Today it is able to meet the challenges of

community, business, and factory as it never could before. Sculpture has lagged behind these two. But in just these last years it has become charged with new energy. For some time it has been aware of the advances made by painters, some of whom were also sculptors—Matisse, Picasso, Modigliani, Braque, and Degas. But only in the present generation has there been a clear and concerted attempt to break away from classical problems and solutions. There is a spirit of adventure, a boldness in the use of new materials, a willingness to experiment among the younger sculptors today which indicates that we are entering a new era. There is good reason to expect that there will be as great a development in sculpture in the next years as there has been in its sister spatial arts in the last decades.

Until the early part of this century, Europe led the Western world in architecture, sculpture, and painting; but this is true no longer. A growing population sprawled over a continent and a sudden demand for skyscrapers, highways, automobiles, and housing have catapulted America's architects beyond the edge of known achievements and forced them to stand alongside the Europeans. The restriction on travel due to the war, combined with a reaction against scenic painters and a quickening induced by Pollock's genius, helped American painters stand on their own feet. They now have a place among the leading painters of the world. And today Americans have suddenly assumed a daring leadership in sculpture. At the present moment it would not be amiss to say that while the Russians continue to lead in the performing arts, and Europe to lead in the temporal arts, it is America that is assuming the lead in the spatial arts. I see no reason why these alignments may not shift at any time in all kinds of ways. But more likely, we will continue to see major developments in the spatial arts close at hand for quite some time.

6. PAINTING

PAINTING makes space visible. The assertion, brief though it is, raises a host of problems, not the least of which result from the fact that each of the terms has a number of meanings, all legitimate and illuminating.

"Painting" is both a verb and a noun. It refers to the creative activity of an artist, and to the art object which is the outcome of this activity. A painter is primarily concerned with the first, a spectator with the second. That is why the one is willing to sell or give away his work, while the other is able to ignore the former's struggle and plight. Since a proper grasp of a painting requires that one go through a process analogous to the creator's (but not necessarily one which has the same pace as his) it is not necessary to separate the two concerns. When he paints, the painter also looks; the sensitive spectator, while looking, also lives through the rhythms of the work. An approach to painting from the side of the painted work does not require one to overlook the creative act of painting. The noun "painting" can properly be taken to refer both to a process and to an outcome.

Painting as an activity is a making, a creating; as an art object it is something made. The making is no mere arranging of parts, a selecting of items, a photographing or mirroring of a world, but a way of bringing something into being. The paints and canvas are but material to be employed. In the act of painting, these materials are creatively endowed with new roles, relationships, and meanings. The outcome is something made, a substance, standing over against all other substances.

Like architecture and sculpture, painting presents us with a newly created space. That space is distinct from the common-sense space in

which we daily live. In the latter, but not in the former, we move about, act, and make. The space of painting is also distinct from the space of natural objects. The former, but not the latter, is directly encountered and sensuously enjoyed. And the space of painting is also distinct from real, existing space. The former, but not the latter, is made by us and tinged with our emotions.

No one of a painting's dimensions is identical with the dimensions of any of these other spaces. Painting space is extended and has multiple dimensions; but it is not conceptually grasped or available for occupancy by full-bodied men. This does not make it an illusory space. To be real, a space need not have the dimensions of a common-sense, a natural or an existential space; it need not be a space in which one can walk, or which can be intellectually grasped. After all, the tree dealt with in common sense is spatial. Yet one cannot walk in it, and it is doubtful if anyone is able to understand it. We usually do not walk in substances, but in spaces between them. And the only substantial space we really understand is the conceived space of nature. The unoccupiable space of a painting can be grasped only by those who sensitively deal with the painting.

The space of a painting is distinct, too, from the space of perception. Both spaces are encountered; in neither can one walk or act. But the space of painting is exclusively visual and is the locus of a beauty which a man has creatively produced. The space of a painting is distinct also from the space acknowledged in science. The space of a painting is voluminous; the space of science is but a locus of numbers, vectors, variables, and distances. The space of a painting is distinct, too, from the space of events, of ongoings; the latter is made up of changing combinations of somewhat independent regions, whereas the former is a single unified whole in which every region is but a delimited dependent part. Finally, the space of a painting is distinct from the space of importance; the latter is a matter of hierarchies and affiliations, intensifications and subjugations, incapable of being sensed or observed. Perceptual, scientifically-known, eventful, and important space are all abstractions; all are derived from common-sense space by acts which cut away the irrelevancies and the additions that common-sense men conventionally introduce into the data they confront. The space of a

painting, in contrast, is without irrelevancies; it is also substantial, concrete, and constitutive.

A painting is a substance different in kind from common-sense and natural substances. That is why its space is distinct from their spaces. Common-sense and natural substances fit inside a larger space, but there is no such larger space for a painting. A painting exhausts inside itself the only space that is relevant to it. All other spaces are simply cut off.

A painting is a visible space possessing the texture and revealing the nature of the space of existence, as relevant to man. Take away vision and you take away the space of a painting. There is then no painting when no one is looking at it—though to be sure it can continue to exist as a common-sense substance, as an object of touch, of science, and so on. The real space which the painting visibly iconizes of course exists whether or not the painting does, but if the painting is not seen, real space is no longer made visible.

A painting is space, substantial and visible. It is not a "semblance of a scene," or a primitive form of photography developed before the age of cameras and inertially continued until today. It has many coordinate dimensions, all equally real, all created by the painter. Any two directions in it can be treated as constituting a single plane, not necessarily flat, and what intersects this can be dealt with as a third dimension. When, then, Berenson says that a picture has only two dimensions and that we read into it a third by projecting our tactile sense, he makes evident that he is interested in identifying paintings by perspective, date, style, price, and painter, but not interested in looking at them. Sleuths such as he have mastered the difficult technique of isolating clues to historic facts, but they ignore paintings as works of art, with their own structures, values, and spaces. Matisse is a better guide: "The work of art, has its own absolute significance implicit within itself . . ."

Visual perspective is a well-accepted way of getting into classical paintings; it is not the only way, and often is not the best way. The third dimension is not distinguishable as a dimension which moves straight from front to back. It is rarely that one finds a simple movement of that kind possible or desirable. Perspective is not only un-

essential to painting, as is evident from the paintings of Orientals, Eskimos, cave dwellers and many moderns, but it has been misconceived even where it has been employed.

Perspective is primarily a teacher's device for getting students over the asses' bridge of two dimensionality; it makes them see that there are more than two dimensions in a painting. At times it offers a quick way to teach comparatively backward students. It ought no longer to be allowed to blind men to the richness of even the most routine painting, even one deliberately created with the rules of perspective in mind. A painting contains a complexity of directions. One can move through a painting from front to back, from back to front; one can move straight or in a curved line, zig-zag, or by jumps and starts. One can leap and one can move gradually. All depends on what is there and how the various parts are affiliated.

There need be no fixed frontal planes, no necessary points of orientation, no inescapable connections made among the parts of a painting. Every part is connected in hundreds of ways with all the other parts. Any one of the parts can be focussed on and used as a point from which 'perspectives' on the rest are to be taken. The perspective may be geometrical, orienting everything with respect to some point taken as foreground or background. Alternatively it may be a gradient of intensities and tonal values, forcing everything else to be supplementary to what is being taken as primary. Many modern painters prefer the latter approach to the former. Not only do they, as their predecessors did, look at their paintings from multiple distances, squint at them, and hold them up before mirrors, but they also turn them upside down, and look at them from below and from the side. They want not only to free themselves from conventional judgments but to be able to see nuances and tones otherwise obscured. A museum, to do justice to the painter's spirit, should hang paintings on swivels. If it permits spectators to turn the paintings around at will, it will do the spectators the great service of enabling them to escape from the hazards of perspectivism, representationalism, and the like.

Every work of art must be dealt with as a single unified whole. Any part or element distinguished within it must be understood as a component which actually affects and is affected by all the others. But there

is no harm in analyzing a work of art by stressing first this component and then that. This is what teachers and critics must do if they are to guide novices and spectators, and are to communicate to them the nature of specific works of art.

To make space visible, it is necessary to use colors. Those colors might be the colors of materials, themselves bodily placed in the painting. They might be the colors of paints, somewhat distinct from those daily encountered. The color of the canvas itself might be allowed a role in the painting. Before being used by the painter, all of these— the color of things, paints, and canvas—are features of common-sense objects. Previously, they were aspects of three-dimensional objects in three-dimensional common-sense space. When made integral to a painting, they become substantial parts of a newly created substantial space.

Color, Goya observed, "does not exist in nature any more than does line." To this one should add Van Gogh's comment about the color in a painting: "Color in itself expresses something; never mind the object." The colors of a painting are new in role, meaning, quality, and value, no matter how much they appear to be like the colors seen every day. And they tell us what the space of existence is like. This is not to say that space is yellow or green, or some such color. It is merely a space; the painter's colors enable us to see it.

Strictly speaking, a painting does not have any distinct colors in it. All its colors interact with one another to constitute a single whole. Inside that whole one can isolate subdivisions which we can call by the conventional names of yellow, green, and the like. Each one of these colors expands and contracts, swarms, moves, insists, and retreats in relation to different parts of the painting. A painting consequently pulsates, beats with the very force of existence. Even a single painted color has a rationale unlike anything known in common experience or optics. Color, Leger rightly remarked, "has a reality in itself, a life of its own." If we were to draw a straight line on a piece of paper and then ignored its thickness, we could take it to be a representative of a mathematical straight line, one which lies evenly between two points. Every subdivision of that line would be like every other and like the whole line, differing from these only in magnitude and place. Were we instead to paint a straight line on a canvas, using a single color of fixed

tone and the most rigid, straightest ruler available, we would have made something quite different. We would have created a vibrant, squirming thing. As we moved along the line, the later parts would be seen to be more or less intense, and would refer us back to the earlier parts. Every point of a painted "straight" line is on an infinite number of circles, ellipses, curves of all sorts and sizes, relating it to all the other points on that line. We have time and sensitivity to concentrate on only a few of these curves. As a rule, we like to be led from point to point on the straight line through the agency of definitely demarcated auxiliary lines, which trace a few of the paths along which the different parts of the straight line act on one another. Often we are able to dispense with such auxiliaries; we can at times directly note how the line varies in intensity as we move along it.

The variation in intensity of a color is in the line, and the line is in the painting. It is tempting to suppose that the variation in intensity is due to the intrusion of what we remember from our encounter with other parts of the line. But then it would be hard to see why the variation does not persistently increase or decrease. Different colors have different rates at which they vary in intensity; the same color differently placed will have a different rhythm of intensification; a change in magnitude will alter the intensity, adding to it up to some point and then muting it after a while, in unpredictable ways. This is not the way in which memory affects things. It is steady, accumulative, particularly for a short span. Nor need we, to account for the variation in intensity of a painted line, invoke a theory of empathy—the view that inanimate objects are aesthetically significant only when one projects one's feelings and attitudes into them. That theory will help us to deal only with the most obvious phenomena—aspects of a work which echo familiar shapes and movements, and then only on the supposition that we actually encounter dead items and have to read some kind of life or feeling tone into them. Prall was closer to the truth when he said that the "feeling" was in the picture. Strangely enough, he didn't really see it there, but since he was a kind of positivist, he allowed himself the positivist's characteristic privilege of deducing that it ought to be there. Fortunately, he deduced correctly. ". . . art is so often said to be the embodiment of spirit in matter. But thinking can have no intercourse

with miracles. And since the simplest thinking finds that works of art do express feeling, we are forced by the obvious character of our data to look for feeling *within* the presented content, or as its unitary qualitative nature as a whole." But the reason we should say that the "feeling" is within the presented content is not because we think it should be there, but because we in fact find it there. The painting has a qualitative emotional tonality directly experienced.

A painting has a design, an arrangement; it is a composition of different shapes and colors. Sometimes it is said that the early painters first made drawings on canvas and added colors later. If they did this, they produced either a kind of script or cartoon, i.e., a preliminary sketch of a painting, or, less likely, they made two paintings, the first a drawing and the second a colored work. If they made both a drawing and a colored work, they produced only one compositional structure. In each there would be similar focal points, but in the one these would have different tensions, values, and roles from what they have in the other.

A painting has dominating and recessive colored areas; these have weights and insistencies unlike those which lines in a drawing have. If a painting is not properly composed, the colored areas will reduce one another's capacity to reveal the texture of real space. A good composition enables the painting to do justice to the values of the colors, and, through their mutually supportive interplay, to the structural complexity of space as well. It is true, as Delaunay remarked, that "Color is both form and subject," but it is not the only form and not the only subject. Shapes, figures, dimensions, tensions also function as forms and subjects.

The unit component of a work of art is a theme. This is a pivotal item which is repeated with or without modification throughout a work. Usually it is expanded and contracted, inverted, flattened, and stressed in different ways at different places. A typical theme in a painting is a short colored line of some brightness. This need not be of primary interest to the painter, nor need it be made by him deliberately. A theme need not be arresting and may be known only to a spectator. But if the spectator is to see what the painter wishes him to see, the painter must make some theme evident, thereby enabling the spectator to analyze the

work at the places the painter prefers. It is best to use a theme which invokes some awareness of the things with which the spectator is familiar, and which is recognizable in varying forms throughout the work, if a spectator is to be able readily to read the painting somewhat in the way the painter would like to have him read it. A painter may, of course, not be interested in helping the spectator; the themes to be found in his work may be but residua of his struggles with the work as a whole, and any tracing of the themes through the work will in effect be a tracing of the signature which the painter inadvertently and unconsciously left behind. Whether this be so or not, the spectator ought not to isolate the theme, detach it from the rest of the work. He ought to see it as a unit which varies in conspicuousness, magnitude, detail, and role throughout the work, and which can serve as a guide in the vital struggle to enjoy the work in its parts and as a whole.

A work of art can have many themes. Most painting have a thematic design and a thematic color which develop in considerable independence of one another. A thematic color need not be the color of the thematic design, and where it is it need not vary in strict consonance with the design. It ought, though, to be relatively bright. The fact that a painting may have only dull colors means only that one of them, though not absolutely luminous, will be so relative to the others. Were a painting to have but a single color, there would, strictly speaking, be no thematic color, but since the color will inevitably change in intensity and tonality despite all efforts to keep it flat and monotonous, one will be able to subdivide it and use the result as a theme which varies in a more or less steady way throughout.

Themes, no matter how arresting, are but abstractions. A painting is a molded work. The features of a painted landscape or face, whether taken as themes or combinations of these, are not aggregated elements in it but places where stresses have been put and which cannot, except by destroying the work, be really held apart from one another. What is done in one place makes demands on what is done in other places; after the painter has worked on those other places he is usually called back to alter what he did in the first place.

Every mark in a painting has a grain. This results from the quality of the paint, from the way in which the paint has been put down, from

the type of material with which it interplays and the foreign substances
which have been mixed with it. There is dry painting and wet painting,
painting on paper, glass, and canvas, paints mixed with sand, paints
added on to paints, colors adhering to common things and made to ad-
here to the canvas. Some of the excitement of Van Gogh is a consequence
of his gift for making the grain of the involved surfaces so palpable.
Collages make grain conspicuous in another way. And where there is
no evident insistence on the grain, there is, as a rule, some variation in
the quality and thickness of the paint, forcing the spectator to shift his
emphasis from place to place.

If one could avoid all modulation between diverse designs or colors,
one would succeed in making a pure arabesque. This would provide paths
for moving through the pictorial space, but would not convey the nature
of that space, its powers, and its tensions. But no such perfect ara-
besque is possible, for every theme is inevitably projected beyond it-
self to terminate with more or less satisfaction in other parts, thereby
becoming more or less satisfactorily modulated.

To acknowledge a theme is to have one's expectations aroused, to be
tensed to follow along the route which the theme initiates, but beyond the
point where the theme occurs. The theme seen here makes a difference to
what is seen there. When a Mondrian or a Rouault confines colored areas
within powerful separating lines, he demands that the spectator infect
the colors with one another under the control of the separating lines.
Usually, though, as a consequence, there are tinges of other colors and
designs to be found in each. Each part of the work contains within itself
subdued reflections of what is to be found in other parts; each offers
a special epitomization of the whole.

Any spatial region, occupied by an object or not, can function as
an interspace, i.e., as a passage to and from another part of the paint-
ing. Interspaces are therefore not identical with necessarily empty
spaces between objects, abstract or concrete. And any interspace can
have a character worthy of being made into a dominant theme. Ideally,
what from one approach was relational can, from another approach,
become terminal, and what was terminal, relational. This is true even in
portraits. One misses what a portrait is conveying if one sees nothing
in it but a head. Relations of the parts of the head to one another and

to the ground are positive elements even in the most realistic portrait. They must be so treated if the portrait is to be read as a painting, which is to say, as more than a record of a face.

A theme cannot be simply repeated. Repetition results in an inevitable intensification or diminution. But this inevitable alteration of a theme is rarely sufficient to give the theme the career it needs. Themes must be developed. A theme contracted in one place should expand in another. As one moves through a work, one should find it varying in magnitude, stress, and internal detail. These significant variations need not be concordant.

A work has a structure to be traversed in a countless number of ways. Any part of a painting can serve as a starting point or end, or as a place in between. Given one starting point and one mode of traversal, some occurrence of a theme will be climactic. The work will develop to it and then descend. As a rule, the intended climax is marked by a signal element or color, and one is led up to it by means of the character of the composition. A powerful painting is one in which the spectator is compelled to attend to the climax that the painter prefers. In such a case no matter where the spectator takes his start and therefore no matter what climax he may arrive at, he is soon forced, by the work as a whole, to retrace his steps, make some other area the proper starting point, and arrive at the desired climax along a route selected by the painter.

The controlled development of a theme results in a structure; the development of a number of interrelated themes results in a complex structure. These structures are insistent and recessive from different positions; what is foreground from one position is seen to be background from another. Each has a fabric of its own, produced by an interplay of thematic grains. The texture of a Seurat is intended to be and almost is the outcome of a mere combining of grains; the texture of a Renoir is intended to be, and is, the outcome of an act in which grain mutes grain. As a rule, a texture of even a plurality of structures is somewhat uniform or has a kind of continuity. Where this is not the case, the structures are related through intervals or intensities. In either way one is enabled to stress the compatibility of a plurality of distinct structures. All the structures of a painting cohere while they contrast,

vary in all sorts of ways without compromising the fact that they belong together. Ideally, they are not capable of unification except as total structures; short of the whole they oppose one another in multiple ways. The resulting tensions are resolved only in a single configuration of them all.

No painting attempts to duplicate an object. Nor could it, for it and the object are involved in different types of space, and are composed of different materials. Emphasis on a story or subject matter is usually the outcome of a stress on some complex theme, inside of which some familiar aspect functions as a climax for a subordinate theme. Since a painting is not and cannot be identical with an object, it must, to convey the nature of an object, omit features of that object. Even the most realistic portrait demands the omission of irrelevant, confusing, misleading parts, and a concentration on the import of the whole.

There are paintings which can fool the eye, and some, it has been said, have fooled birds. This shows that eyes and birds are not the best judges of paintings. Pictures made to fool the eye are in effect attempts at making one incapable of looking at a painting. But this is paradox; if they are paintings they can be seen as such, though one, in opposition even to the painter, may have to resist a rather strong impulse to make easy references to daily experience.

A theme sets a problem. The solution of that problem sets another, and so on through the work. The perfect work would offer a solution of all the problems raised within it. But there is no perfect work. There comes a time when the painter must let the work go, and make another distinct attempt to make space visible. He must stop his work short, aware that he must make still another full-bodied effort to get a grip on the real. If he goes on, refining and altering his painting beyond the point of insight, he but slicks it over or complicates it, and in the end hides from himself the texture, the stresses, and the promise of real space.

Redon spoke for all artists when he said, "My originality consists in making incredible beings live humanly according to credible laws, as far as possible placing the logic of the visible at the service of the invisible." By the "incredible" I understand him to mean objects, shapes, directions not found in daily life; by "credible laws," the structures

which can be experienced without undue strain; by the "logic of the visible," the demands which some embodied idea entails; and by the "invisible," the space which underlies all substances. A painting plausibly interrelates the unconventional to reveal the nature of a real, existing space.

A painting is a locus of significance, a place where a personal or social idea of some ideal prospect permeates visible, extended, textured structures. Without the idea, a work could not be beautiful. All artists provide structures connecting unfamiliar entities in the light of some idea. The idea need not be consciously entertained. Nor need it be divided in the work in accordance with any principles or logic appropriate to ideas. In putting the "logic of the visible" at the service of the invisible, that logic is changed in conformity with the need to do justice to the invisible.

The distinctions through which we have gone are but accents in a single whole. The most compendious statement to be made about a painting, as about any other work of art, is that it is a unity. Each painting offers a unified space made visible in a distinctive way. Each uses ideas, colors, shapes, themes, and structures to make a unique product, to be enjoyed in and of itself, and revealing the nature of a space existing outside it. It tells us what the real space of existence is like, subject to the condition that it is to be seen.

Each painting offers a singular way of exhibiting existing space. When enjoying it as a distinctive sensuous object, we hold it away from the world and emotionally possess it. Our emotions are not exhausted in that act; they continue to operate, spending themselves in a movement over the painting. We are thereby enabled to enjoy the painting as that which satisfies our emotions in the way in which only what is ultimately real can. The painting emotionally accepted by us is a representative of a spatialized existence pertinent to man. In its own way each painting portrays what every other does—the nature of spatialized existence. This underlies all substances, has the power to affect man, and—through the painter—the ability to become substantialized and visible. Through an emotional solidification of the painting with ourselves, the painting tells us what existence means to us.

A painting is a substance. Its space contrasts with the spaces ex-

ploited in other paintings. The artist produces the painting by making it a function of his substantial self. By treating it as a self-sufficient excellence, he holds it over against all other substances. Opposing and opposed by other substantial realities, the painting helps him and us to purge our emotions and to grasp the nature of existence.

Architecture and sculpture impose diverse types of determination on common-sense space. The former alone makes provision for common-sense space to play a role which is supplementary to that of a created space; the latter merely stretches between the limits of the three-dimensional space that it absorbs within itself. Painting too imposes determinations on common-sense space. Paints are made to function in new ways by being used in a painting. But the painting does not acknowledge the independent role of the canvas, nor does it absorb the canvas's common-sense space within itself. This is presupposed, made use of, but is not allowed to be part of the painting.

A building literally takes up a region of common-sense space; a sculpture allows for the abstraction of a common-sense space. Both have magnitudes. But a painting has no magnitude, if by magnitude we mean what can be measured by common-sense rulers. We do speak of a painting as being of such and such a size; we hang paintings in common-sense ways in a common-sense manner. These facts are pertinent not to what the painter created, but only to the possible common-sense roles of the materials of which he makes use. Common-sense space has no role in a painting at all. Nor do inside or environing spaces. A painting is a multi-dimensional whole, bounded off from all else. Its frame encloses a space and excludes one; it is not an integral part of the painting. Paintings begin where frames stop.

Architecture produces an environing space. Sculpture uses part of that environing space for a spectator area. But a painting has neither an environment nor a spectator area. Neither spectator nor painter is at a distance from the painting. To enjoy a painting one must stand away from the common-sense world, and this standing away has neither degrees nor divisions. Though spectators must stand away from the painting to see it and though they are not unaware of its tactile values, they are nevertheless in the painting. The distance between painting and eye is annihilated in the emotional acceptance of the painting as a real

space. This fact brings us up against one of the most influential ideas in modern aesthetics—Bullough's theory of "psychical distance."

Bullough seemed to use the term "psychical distance" primarily to express the fact that a work of art is cut off from the world. He thought that the "cutting-out of the practical sides of things and of our practical attitude to them" was essentially a "negative, inhibitory" act, and that it gives "to dramatic action the appearance of unreality." Because he took reality to be identical with what was encountered every day, he spoke as if the positive activity of holding a work apart were a purely negative, withdrawing act. He was mistaken. The feelings which we express every day, and which must be inhibited in order for us to be able to enter the world of art, are positively manifested inside that world. But if the realm of common sense is alone taken to be real, normative, or basic, the re-expression of the feelings in the world of art will of course have to be viewed as negative, illusory, distortive, not altogether real.

Bullough used the term "psychical distance" to refer also to a disaccord between a feeling and a work of art. For him, to cut off, to frame an object was at the same time to produce a distance between oneself and object. It was this idea that he had in mind when he wrote that it is "most desirable" to achieve "the utmost decrease of Distance without its disappearance." This idea is quite distinct from the idea he had in mind when he spoke of negative, inhibitory acts. Bullough thought the two meanings of "psychical distance" were the same because he thought that the only appropriate object of a feeling was something in the familiar world. But this is not so. Art offers most appropriate objects for feelings.

One cannot overdo the detachment of an art object from the world; there can never be too great a distance between one's daily feelings and those appropriate to the world of art. Distance, as relating to the discrepancy between one's daily feelings and those appropriate to an appreciation of a work of art, ought not to be decreased, since it results from the act of making the work into an object of enjoyment. But while this distance ought not to be decreased, the distance between spectator and painting ought to be decreased, through an emotional participation of the spectator in the painting.

The theory of psychical distance is not peculiarly pertinent to art. It relates to aesthetic objects, objects which are to be enjoyed for their texture and design, which are to be lived with for a while apart from the world. He who does not make works of art into aesthetic objects will never appreciate them; he will deal with them merely as things to be shipped and hung, bought and sold. Yet to take them to be only aesthetic objects is to do for them what one does to a flower or a sunset when one isolates these from the rest of the world and takes pleasure in their immediately sensed qualities. The appreciation of works of art requires something more. It demands the enjoyment of meaningful, revelatory substances, something richer, more illuminating and transformative than merely aesthetic objects can be.

Bullough did a great service in making men see how aesthetic objects stand over against ordinary things. But the more influential he was, the more he made men overlook the difference between merely aesthetic objects and works of art. Also, most of his illustrations were taken from the theatre, which he interpreted as presenting a story that needs to make a quick appeal to its audience; this is why he wanted at one and the same time to place ordinary feelings at a distance and yet keep that distance to a minimum. But the theatre, like any other art, does not demand of us that we decrease the distance between our daily feelings and appreciative feelings. It asks us to abandon our daily feelings to participate feelingly in what is taking place.

In architecture, our feelings are directed towards a building; in sculpture, they await directing by the object. In painting, the feelings enter the work and are thereupon sent along paths which the painter has produced in his created visible space. The painter therefore makes use only of an emotional scale. That scale is implicitly used in the course of the painter's effort to express within the body of his painting cherished ideal meanings interwoven with the emotionally produced space.

When the word "art" is used without qualification, it is normally taken to refer to painting. Painting is then usually paired with music. These two seem to arouse greater interest and passion than any other arts, though there are times and places where story and poetry, theatre and dance have had overwhelming appeal, sometimes even crowding out an interest in painting or music. But only painting and music, written

and performed, at once require a radical separation from everyday interests, are open to ready participation by everyone, and make one signally aware of the nature of man's destiny. Architecture and sculpture have an immediate appeal, but do not stand strongly in opposition to everyday life nor provide much insight into the great central problems that beset man. Story, poetry, theatre, and dance are most revelatory of what existence means to man, but their use of the common counters of daily speech and action make them seem not too alien in spirit nor too far beyond the capacity of ordinary men. Painting, and musical compositions and performances prompt participation and elicit admiration and irritation, love and antagonism to a degree others rarely do. And their creators share with their audiences violent emotions of affection or opposition, particularly with respect to distinguished workers in their field. It is hard to find an outstanding philosopher who, though disagreeing with Plato, Aristotle, Kant or Hegel, would say that they simply did not know how to philosophize. (An exception is Schopenhauer who, among other pleasantries, called Hegel "an intellectual Caliban.") It is hard to find a religious man who would readily say that Abraham or St. Francis, Mohammed, or Buddha lacked religious sensitivity. But El Greco says that Michelangelo is a dauber; Ingres says "Rubens and Van Dyck . . . belong to a bad school of colorists, the school of lies"; Redon in turn remarks of Ingres that "his mind is sterile . . . his works are not true art." His low opinion is shared by Delacroix who says of Ingres' work that "it is the complete expression of an incomplete intelligence"; Ensor speaks of "French impressionists, who remained superficial daubers suffused with traditional recipes. Manet and Monet certainly reveal some sensations . . . and how obtuse." Courbet calls Titian and Leonardo "arrant rascals." *

* Slonimsky's *Lexicon of Musical Invective* offers matches for these with Tchaikovsky's ". . . that scoundrel Brahms. What a giftless bastard!"; J. F. Runciman's "I hate Saint-Saens with a hate that is perfect"; Virgil Thomson's "I found the Second Symphony of Sibelius vulgar, self-indulgent, and provincial beyond all description"; Richard Strauss's (which he later retracted as "the silly tomfooleries of a callow schoolboy") *"Siegfrie*d was abominable. Not a trace of coherent melodies. It would kill a cat and would turn rocks into scrambled eggs . . . My ears buzzed from these abortions of chords . . ."; and Rossini's "Wagner has good moments, but bad quarter-hours." To these one can add Mendelssohn's "Berlioz . . . is really a cultured, agreeable man and yet composes so very badly." "The execution is still more miserable; nowhere a spark, no warmth, utter foolishness, contrived passion

The giants of modern painting are almost without exception men who not only received no support from the established schools, painters, museums, and dealers, but who could not even get a hearing. Despite the fact that they are daily confronted with evidence that the paintings of the future will be unlike those in the present, museums and dealers, teachers and established painters stand, by and large, in opposition to work that is genuinely creative and new. It is usually neither expensive nor difficult to arrange an exhibition; all one need do is to persuade influential men that one's work has merit.

Painting, too, is the only art which collectors have so made their own that they have succeeded in corrupting not only the common taste, but the temper of many artists. The prices that are paid for paintings have little to do with the merits of the paintings and much to do with their scarcity. If a splendid painting has been found to be the work of an unknown, its price plummets; if a poor painting has been found to be the work of a Rubens or a Rembrandt, a Leonardo or an El Greco, its price leaps fantastically. Nothing is more dangerous to the future of painting than the interest which collectors have shown in it. Only in small, backward countries do stamp collectors corrupt the post office; in hardly any country do numismaticians corrupt the mint; but in almost every country collectors corrupt painting. There is no remedy for this except an awareness on the part of painter and public that the concerns of painting, its standards and value, are not to be discovered by attending to the market prices of old masters. To learn what painting is one must move outside the space of the market and get inside the space of a painting.

represented through every possible exaggerated orchestral means . . ."; Schumann's "Wagner . . . can hardly set down (and think out) a four measure phrase beautifully or even correctly. He is one of those people who have not learned their harmony lessons, nor learned how to write four-part chorales and this their work makes plain"; Lalo's "Brahms is an inferior spirit whose pickax has probed every nook of counterpoint and modern harmony. This is his only recommendation. He is not a born musician; his inventiveness is always insignificant and imitative"; Saint-Saens' "the desire to push works of art beyond the realm of art means simply to drive them into the realm of folly. Richard Strauss is in the process of showing us the road"; and Puccini's: "I went to hear the *Sacre du Printemps;* the choreography is ridiculous, the music sheer cacaphony. There is some originality, however, and a certain amount of talent. But taken together, it might be the creation of a madman."

7. MUSICRY

Architecture, sculpture, and painting make a triad of spatial arts. This triad is matched by two others: a triad of temporal arts—musicry, story, and poetry—and a triad of dynamic arts—music, theatre, and the dance. The members of the first triad create spaces, the members of the second triad create times, and the members of the third triad create ways of becoming. All impose conditions on a common-sense world to produce works of art which capture some of the texture, while revealing the nature, of an essential dimension of existence in its bearing on man.

The main concern of this and the next two chapters is with the temporal arts. The investigation demands an understanding of at least five types of time. The time created by musicry, story, and poetry is *created*; it is to be distinguished from *individual* time, *common* time, *abstract* time, and *existential* time. An examination of these will prepare us for a knowledge of the distinctive features of the time which the temporal arts create.

individual time: Each of us lives through his own individual time, having its own pace and qualities. We tend to think of such a time as the exclusive property of men and as occurring only in the dark recesses of our beings or in our subconscious selves. But individual time is not necessarily a human time. Each being has a time peculiar to it. Individual time is characteristic of every being whatsoever, conscious or unconscious, human or subhuman. The fact is often overlooked for two reasons. In daily life we use certain objects as clocks which measure a time pertinent to all, and we soon come to view them as marking a time exterior to all objects. We are constantly tempted to suppose that the clocks themselves are subject to the very time by which they measure other things; we tend therefore to overlook the fact that the clocks, as well as the other things, have distinctive, unshared times of their

own. Secondly, we are aware that many things concordantly pass through a present to occupy subsequent moments. Physicists are today inclined to think that there are many such presents, each governing the passage of a limited number of beings. Metaphysicians usually suppose that there is only one present for all actualities, and that the presents which concern the physicists are but specializations of this. Both the physicists and the metaphysicians in different ways tempt us, once again, to suppose that individual, "local" times are not real.

COMMON TIMES: All beings have distinctive times. We are able to do justice to their times and to our own only if we can somehow mesh theirs and ours. This can be done in four ways.

1) We can make our own time conform to a time characteristic of others. We impose on ourselves the metric of a *public clock* so as to enable us to be in gear with the beings for which that clock provides a measure. Here we function primarily as bodies in a public, socially defined time.

The time of our accepted clock is as peculiar to it as our own time is peculiar to us. This is but to say that any object could have been used as a clock measuring all others. It is because the beats of most objects are so irregular—to judge from the way they fail to match pulse and heart beats, observable starts and stops, and conspicuous recurrent phenomena such as night and day, rainy and dry seasons— that we never treat them as clocks. The clocks we find helpful to use are beings whose distinctive times have obtrusive recurrent beats. These alone make it possible for us to live and work together with others in public.

2) We are constantly aware of our own individual time, the distinctive form time has in ourselves. And sometimes we insist on this, and use it to measure other times. It is then a *personal time*.

If we accept some object as a clock and treat this alone as being worthy of offering a measure for time, we will have little recourse, when we refer to our own time but to speak of it in psychological terms, as though it were unreal, or unusable. We will be content to say that we are bored, excited, that we lost track of ("clock") time. Reference to our boredom or excitement should be recognized to terminate in a time as ultimate as ourselves, and as capable as any other time of defining a

common time. Were we to use ourselves as clocks, though, we will not find many others to agree with us unless we are absolute sovereigns who can make them conform to our rhythms. Because society is our sovereign today, the objects which it accepts as properly measuring what occurs within it—usually impersonal, inanimate ones—are public clocks for all of us.

3) We make contact with other beings by changing our pace to keep abreast with theirs and, where we can, altering theirs to keep abreast with ours. Sometimes we merge our time with theirs to constitute an *emotionally sustained time* which belongs to neither one of us. That time is a common time, discerned by all men. It is through this common time that we live when we love and sympathize, hum or sing or dance together.

4) Sometimes we keep different individual times distinct while encompassing them within a more *comprehensive order*. This we do when, as men of decision, we make overriding plans to deal with the world beyond us in practical, efficient ways. Our rules of investigation, our routines, our tests, and our codes offer different harmonizing, neutral ways for getting ourselves and others adjusted to one another.

No one of the four common times, resulting from the use of public clocks, the insistence on our personal times, the merging of our times with others, or from the decisive ordering of individual times, is produced deliberately. From the very beginning of our lives we engage in them all, though irregularly, without much understanding of what we are doing. Each results from a union of our individual times with the times of others. But in every case we continue to retain some hold on our own times. Our individual times are able therefore to interplay with the very times they help constitute. Not only, for example, do we make our individual times submit to the rule of some socially acceptable clock, thereby constituting a common public time, but we intrude on and are intruded upon by this public time. We joyously live through a quickly passing yet public hour; the beat of the public clock breaks into our privacies to give them new temporal units. The result is a complex daily time. More objectively stated: our daily time is one in which various common times intersect and intermingle rather haphazardly.

The daily time in which we live is a confused, artifactual, uncon-

trolled mélange of various common times. To escape from its artifactuality or that of its component common times, we must plunge into existential time. To obtain a time which we can control we must engage in the temporal arts. But if all we wish to do is to clarify daily time we must abstract limited but manageable aspects of it by subjecting it to definite limiting conditions.

ABSTRACT TIME: Daily time is the most common source of abstract perceptual, scientific, eventful, and valuational times, but these times can also be abstracted from common and created times. Perceptual time is conditioned by memory and interest. It is a time in which we carry over our experiences of the past into the present and dictate what we are to expect in the future. Scientific time is a formal pattern. As in every other time, there are regions in it at varying distances from one another in a single sequence. Unlike any other time, it has no place for an earlier and a later. It relates units merely as before and after. Nor is a genuine present, passage, movement or change possible in it. Eventful time is the time of an atomic coming to be. It is all in the present and gives no evidence of any past or future exterior to it. Important time is a time dictated by the ideal values we face. It is a time in which the future determines the meaning and alignments of what is present and past.

Each of these abstract times can express the nature of daily, common or created time when the time is subject to the limitation that it must be observed, formally expressed, lived in, or evaluated. All can clarify the nature of daily, common or created time, but only at the price of losing the substantiality, the vividness, the concrete vital movement of the time. We can and sometimes do abstract a type of time from a number of common times. We can and sometimes do, e.g., perceive public clocks, our own inward rhythms, our emotionally sustained times, and the times governed by our plans, thereby getting a perceptual time from four different places, each with its own quality and pace. We tend, though, as a rule, to take scientific account primarily of some acceptable common clock, to define an eventful time in terms of our own private rhythms, to attend perceptually to an emotionally determined time, and to evaluate an ordering time.

EXISTENTIAL TIME: All of us exist within a single time, the time of

existence. This is relentless, impersonal, all-inclusive, a sequence of ultimate units, only faintly discerned beneath all other times. We can make direct contact with it only so far as we lose all reference to ourselves and others as distinct beings. But then what we reach is something we do not know. We can of course get to understand it in a speculative, philosophic system. But then we end with only an idea of it, and enjoy nothing of its texture, nor sense what bearing it has on man.

CREATED TIME: There is no better way of grasping the nature of existential time than by first turning our attention away from it and then, by making use of it as it surges up within ourselves, creating a temporal art. The temporal arts portray existential time and convey something of its texture. It is to these arts we must turn if, without losing all hold of ourselves, we are to sense the nature of existential time. Only if we engage in the temporal arts can we become aware of it as a single time which all individual times specialize, common times blur, and abstract times partially express. Only if we engage in the temporal arts can we come to have an emotionally significant acquaintance with temporal existence as the ultimate warrant for our deepest hopes and fears.

The concern of the present chapter is with only one temporal art. It deserves a special name. I revive an old one and call it "musicry." It creates a time specialized in musical compositions and presupposed by both story and poetry.

"Musicry" has three possible meanings. Ideally, it refers to a created neutral common time, in which we would be perfectly adjusted to all else. To achieve it we would have to synthesize the common times determined by public clocks, private rhythms, emotional unions, and comprehensive decisions. No one, to my knowledge, now knows how to produce such a synthesis. But the ideal of it is nevertheless significant. Keeping it before us will prevent us from supposing that public clocks, private rhythms, emotional unions, or comprehensive decisions enable us to obtain common times free from bias. The first puts stress on our submissiveness, the second on our insistence, the third on our sympathies, and the fourth on our constructions. An ideal common time will not favor one of these over the others.

"Musicry" also refers to any of the biased forms of a created com-

mon time. Each of these biased forms puts a stress where the others do not. Each is a topic of a special discipline. *Cosmology* is concerned with the common, public clock-like time that results when we submissively subject our individual times to the time of others. Its characteristic feature is the dominance of metre; by means of this it makes evident what are acceptable objective beginnings and endings. An *historical narration* insists on imposing our times on others. Its characteristic feature is rhythm, by means of which it makes evident the ways we bunch together what occurred outside us. A *musical composition* stresses the emotional merging of times. Its characteristic feature is the dominance of melody, thereby making evident the way in which we and others are sympathetically in consonance. A *reconstructed time* stresses the decisive unification of times. Its characteristic feature is the dominance of harmony, by means of which it makes evident the compatibility of distinctive time qualities and paces. Each of these created common times finds a subordinate place within itself for the features of the others. But this does not overcome the bias that is characteristic of it.

"Musicry" can also be used to refer exclusively to musical composition. Despite the fact that the above first use of the term "musicry" is ideal, and despite the fact that a use of it to refer to any one of four created common times makes possible a consideration of otherwise neglected facets, it is this third meaning which is to be preferred, particularly when dealing with art. A musical composition is the best means we have for creating a single common time, biased though this is towards an emotional union of ourselves and others. It alone makes no claim (as cosmology, historical narrative and reconstructed time do) to be plausible, useful, or true. Its emphasis on the emotional unification of our own times with the times of others, also, makes conspicuous the sensuous quality of both the times, and leads us most directly to an awareness of temporal existence as at once objective, concrete, ultimate, and all-encompassing.

A musical composition, as a rule, is produced for performers. When it is, the musical composition is offered as a script. He who is content to do only this is a craftsman who provides material, scores, which other men are to convert into a work of art. It is wrong, then, to speak

of composers as merely writing scores. But it is just as wrong to take the opposite tack and claim that the composer alone creates. A performance has a distinctive kind of time. Though it may have the same rhythm as the composer's, it can be produced by one who is not sensitive to the time created by the composer.

A musical performance does more than reproduce in an audible way what the composer once produced in his mind. The term "music" when applied to the performance has a meaning distinct from what it has when applied to compositions. Once the distinction is recognized it will be easier to see that musical composition and musical performance are both genuine arts, the one being concerned with the creation of a time and the other with the creation of a becoming. It will also make it possible for one to recognize that musical composition is only a special though highly developed form of musicry, alongside cosmology, historical narrative, and a reconstructed time.

Both in the guise of musical compositions and otherwise, musicry is the art of creating time. This time is new, quite distinct from any time experienced or known in other ways. Each part of that time makes a difference to other parts. No part has a magnitude which can serve as the measure for the rest. Nor is there a measure which can be applied indifferently to them all. Nothing can measure the time of music; its time is one within which all measures, all notes, all subdivisions are to be located. Primarily melodic, it offers a succession of emotionally sustained ways of organizing experience, inseparable from a subordinated objective set of measures (or beats), rhythms (or a distribution of accents), and harmony—more precisely, counterpoint (or supporting contrastive tones and melodies).

Musicry is the art of creating an emotionally sustained, silent, common time. This time is presupposed by story and poetry, just as sculpture and painting presuppose an architectural space. The fact that story and poetry are not forms of musical composition, that the time they presuppose is also occasionally attentive to cosmological, historical and reconstructed times, points up the existence of other types of musicry than that exhibited by a musical composition.* Still, musical

* Because we have not yet achieved an ideal musicry, we are forced to classify stories and poetry as essentially epic, narrative, lyrical, or didactic. The lyrical

compositions are the best cases we have of the art of creating a silent common time.

The best treatment of musicry, and incidentally music, with which I am acquainted, is Zuckerkandl's *Sound and Symbol*. Zuckerkandl is a conductor and a critic with considerable philosophic sophistication and power. His work is shot through with perceptive judgments, illuminating insights, and analyses. He makes it very evident that time is no mere idle structure decorating or externally connecting notes, but is the composition itself. "To form in tones is to form the stuff of time." The time of music "is *content* of experience, *produces* events, knows no equality of parts, knows nothing of transience."

The writing down of a composition is never only the recording of what the composer imagined. It is part of the act of composition. Not only does the composer rearrange his notes because of what he hears to himself when he looks at what he has written, not only does the structure of his written compositon point up to him considerations which he neglected, but what he is making has the written composition as part of its being. He starts with an emotionally defined common time, and struggles to free this from the limitations of tradition, convention, familiar, and limited reference. His notation is part of his act of creating a more controlled, clearer, more comprehensive emotionally-tinged time.

The composer does not literally hear music when he composes. He could not; heard tones take up room, have a dynamics and a power denied to what is not heard. When he imagines a work before he writes it down, he is in fact reading an unseen score, and thus then and there emotionally creating a common time. But no matter how vivid his imagination, he will not have fully produced a work until he actually writes it down, for in the writing he places his notes in definite relations to one another, dictating definite divisions in time. Until he writes his composition his notes are not entirely well-placed, not entirely well-

takes account of the emotional time exploited by musical compositions; the epic attends more to cosmological time; the narrative work is more aware of historical time; the didactic work specializes reconstructed time. Because we know that these forms of common time are the result of specific stresses, we know that there is an ideal musicry more general and neutral than that exhibited by musical compositions. That ideal musicry is presupposed by the compositions as well as by story and poetry.

defined, and he, as a consequence, does not fully control, through an appropriate structure, the time he emotionally shares with other beings.

The composer must therefore write out his composition, not only because he otherwise would not have communicated what he had in mind and would not have provided evidence that he had created anything, but because he would not really have had the notes and their spacing until he wrote the composition. It is not enough to order melodically a common emotionally-tinged time; the time must also be metrized, recognized to have an "empty" structure which could be filled in many ways. The composer's notes are variables, parameters, positions where it is recommended that audible stresses should eventually be placed.

Reference to the composer's use of emotions should not lead to the supposition that he must be excited or must remember something which moved him. The emotions which the composer uses are elicited and exhausted when he composes; they are ways of producing the "matter" of the time that his notation is formally structuring. His emotions give him a resistant grain with which he must struggle to produce a time encompassing him and others, a time in which his emotions are given melodic length, and thereby reordered and purged. His composition is at once his, and external to him; it is a mediator enabling him to hold on to and interrelate the times of others with his own. It is no mere set of notes on paper, black marks organized, but the very structure of an emotionally created sequence, as indispensable to that sequence as that sequence is to it. Without the emotionally created time, the composition would be just a notation. But without the written composition, the emotionally created time would be without a controlling structure.

The composition mathematizes a common emotional time. Another can recover that time only by reading the composition, not as marks on paper, but as the essential structure of a vital melodic interconnection between himself and objective occurrences. The reader must see it as defining how he is to approach the world emotionally, and thus not only as a set of related notes, but as spreading to the world beyond. It is this spreading common time that we articulate when we read the composition properly. The emotions enable us to substantialize it, and

place it over against other times. The time of a composition structures the emotions when and as those emotions vitalize, give body to it.

The time of a composition can be perceived. When it is, we approach it from a position outside it, from a past. It can also be scientifically cognized. It is then given a measure, treated as a sheer structure, a purely formal pattern which can be exhaustively expressed in mathematical terms. If we are to treat a musical composition as though it were an event, we must immerse ourselves in it. And if we are to treat it as something important, we must deal with it as a place where a desirable prospect has been made vivid and present. The time of perception exaggerates the past, the time of science exaggerates the structure, the time of the event exaggerates the present, and the time of importance exaggerates the future of musicry's time. Musicry's time is one which uses the past, acts on the future, produces a present, and exhibits a structure. It is a time with power, with a forward and outward thrust resulting from the fact that it is substantial.

The creation of a substantial common time is a great achievement. The result provides an excellent means both for grasping the nature of an existential time, otherwise impervious to us. It also allows us to exhibit our emotions in a controlled and directed way. But this is only a part of what musicry does and can do. Its time is lived through as self-sufficient, as excellent in itself. Because it makes us aware of what it means to be a man caught in the onrush of real time, it reveals to us something of the time of existence. Our emotional involvement makes us accentuate real time as being pertinent to ourselves. Existence is a perpetual coming to be and passing away, at times ominous and at times benign. Musicry reveals this quality of existence to us, a quality to be personalized by story as tragedy or comedy, and solidified by poetry as a lived joy or sorrow.

There is no environment for a composition, and no spectator space. To grasp it one must identify oneself with it. It is a world in which all parts function both as terms and spaces. The rests are never to be rested at, but rested through. Time presses through them as surely as it presses through the terms. The rests are part of the work itself; they are unaccented rather than empty parts of the time. A good reader will

also attend to the affiliations between motif and motif, phrase and phrase, theme and theme. These constitute a complex of enclosed curves of varying lengths, altogether exhibiting a time as internally rich as it is substantial.

A meaning in the form of a desirable prospect provides a definite and successful approach to the task of creating time—the definiteness forcing one to begin and the success forcing one to end. The prospect does not close off that time from an external past, present or future, from the time of the world about. That was accomplished in the act of engaging in the production of the work of art. Starting inside that closed off area, the prospect stretches from the end to the beginning, at the same time that it divides into pivotal points and measures. When a musical work is produced, the prospect is given lodgement through-out. As the prospect seeps through the work, it is broken down into accents, loci of values. Were there nothing but the prospect, the work would present us with only a bit of accented time. Without the prospect, there would be no reason ever to begin or end. Because the work is grounded in existence, it has an appeal and a compelling rhythm, and because it has a meaningful structure it has measures and notes. The penetration of the prospect into the rhythm makes the whole beautiful, an ordered whole perpetually resolving a disequilibrium, a time which loses nothing of its movement by being given a beginning and an end.

A musical composition has a unity in which rhythm and metre find a place, heightening one another's effects. The stretch of time it contains has already ended. Before it ended its beginning was but a definite way of starting out. By arriving at the end, its beginning is made into the beginning for that end. The unity of the work is attained only when we reach the end of the piece.

The composer here answers what is in essence a problem that has perplexed philosophers over the centuries. Has time a beginning and end, or not? Aristotle said it did not; Augustine said it did; Kant said the question had no answer. But composers show that meanings stretch time to a beginning and end. Carried over to philosophy, their answer leads to the recognition that a providentially governed time stretches between a definite beginning and end, internally defined. (A time not so governed would begin and end at every moment in a process which had

neither beginning nor end.) Each and every man, each and every society, each and every history, and the entire history of mankind has its own stretch of time. What lies outside them all is a time governed in the same way they are. It is a time which stretches out more and more, both backward and forward, the more it penetrates into the world. When an ideal value, at the root of all prospects, has penetrated time completely, time will have been stretched to its limits. It will then, and then only, achieve an absolute beginning and end. Only when the world becomes perfectly meaningful, completely governed by providence, will the day of creation and the day of last judgment at last both have come to be.

Because a composition provides us with a temporal articulation of the ominous-benign quality of existence, it has a great appeal and effect. Everyone is therefore ready to evaluate it as vital and revealing, or the reverse, and everyone is able to learn from it just what it is that existence means. We must engage in the production of works of music again and again, for the insight one gives us lasts only so long as our emotions are aroused and sustained. We are better for having gone through it. Because of it we know time a little better than we had before. Since what we thereby learn of time is grasped not in concepts but in the enjoyment of the art, we cannot maintain a grip on it for long, or know how to communicate it to one another or to our later selves except by sympathy, suggestion and a recommendation that the experience of it be repeated.

When one attempts to relive an experience of a composition, one finds that it has been changed. It is not only affected by multiple associations, not the least of which is the fact that the piece had been enjoyed before, but by the time through which one is living apart from the experience. Music is open to all and participated in by many, though it is hard for most to remain inside its confines for long. Yet the sensitive reader does share in the time created by the composer. Written compositions, to be sure, are readable by very few. But their elements are readily learned, and their content readily remembered and identified. With the development of high fidelity machines and records, music has suddenly become part of almost every student's life, and this knowledge has had its repercussions in a growing interest in musicry and in the myths and techniques which composers use.

Music has always been part of an educated man's life. This is not true, to the same extent, of any other art. Not even story or poetry has captured so much of the attention and the pocket-book of students inside and outside school walls. Now that education has been made available to the multitudes we can expect sophisticated and subtle music to become more widely known. And that, it is to be hoped, may prompt composers to exhibit more unsuspected contours of time.

8. STORY

THE language we use every day is no single, seamless whole, with well-defined principles, structure or point of view. Rather, it is a mixture of a number of distinguishable sublanguages, each with its own grammar, usages, and roles. The language of worship, work, sports, action, reflection are parts of everyday language. Each of these languages makes demands as stringent as those made by the language of the sciences. The sublanguage of religion is highly technical; a failure to use it in appropriate situations or times entrains the charge of blasphemy. The sublanguage of work makes different demands, and is itself broken up into a number of subordinate languages each with its own peculiar vocabulary and requirements. The butcher makes a dozen distinctions where the plumber makes only one, and conversely. Both share, over against the users of the sublanguages of reflection and worship a sublanguage of work, of doing and making. To violate the requirements of this language or its subordinate specializations is to be guilty of amateurism. Reflection has a sublanguage of its own, and in this too there are subordinate languages. Philosophy, mathematics, law share a sublanguage of reflection and express it in specialized ways. Improper use of the sublanguage of reflection, or its specialized subordinates, opens one to the charge of pretentiousness and pitiable ignorance.

The most obtrusive, commonly used portion of everyday language is a sublanguage which relates to matters of ordinary identification, manipulation, and communication. This has no more rights than the sublanguages of religion, work, or reflection. Also, it is a sublanguage peculiar to our culture. In other cultures there are other languages used for identification, manipulation, and communication, with distinctions which we do not ourselves acknowledge. The Eskimos, as Whorf observed, have names for different types of snow; hunters and

medicine men have their own vocabularies and usages. Their languages are not devoid of precision, nor are they inconstant. What they lack is the formal structure and applicability which characterize the language of reflection that is used in our mathematics, in our courts, and in our philosophy. (They also specialize a transcultural language of gesture and act which makes it possible for men in different cultures to communicate with one another. This transcultural language should guide our translations from the language of one culture to that of another. However, it has no distinctive vocabulary or grammar, unless it be that which is provided by human acts of sympathy and love, which emotionally unite the times of individuals with one another.)

The various sublanguages in our society are not well bounded. Men's interests, and activities, their roles and needs fluctuate too much and are too vaguely separated one from the other to make it possible for any man to be a language purist, insisting on the rules of some sublanguage, for long. Again and again, sublanguages are united in a rough and ready way to constitute the going language of everyday. And what is true of our society, seems to be true of others too. Even the daily language of primitive societies seems to have some place for sublanguages of religion, work, and the like.

Some men try, and urge others to try, to stay within some specialized sublanguage. They think that this is more "true" or germane to reality than any other, and they want to keep it pure. But every sublanguage is infected by, and infects other sublanguages. Only by making use of all the major sublanguages can we do justice to what we do and know everyday. Evident though this observation seems to be, it is one which is sometimes overlooked. Today some thinkers urge us to use only the language of science; others say that we should use only the language of mathematics; still others say that the only proper language is the most obtrusive, commonly used portion of daily discourse. The predecessors of these thinkers insisted with equal fervor on the exclusive rights of the language of work; these in turn were preceded by others who held that only a religious language was precise, clear, and referred to what was genuinely real. It would be crass and wrong to say that no one of these philosophers ever read a story or a poem, but it surely is

the case that their theories of language are based upon a neglect of what they themselves constantly acknowledge in practice.

Daily language reflects the spirit of a culture, betraying its values, suggesting the character of its ideology, and outlining the nature of its myths. Only he who, even while using some specialized sublanguage, makes use of this more inclusive, somewhat confused daily language, is ready to enter the world of story. No story keeps to daily language, with its conventional, stabilized, unimaginative usages. But it does use it as raw material in the creation of a new language where ordinary words get new meanings and roles. This new language expresses in a vivid and palatable form the basic outlook, usually of a culture and ideally of mankind—an outlook which is dimly evident to all because already incorporated in the daily language.

The child's language has the comprehensive character of the adult's daily language, but the child has no adequate grasp of the rules, powers, or nuances of that daily language. Its language lacks the vocabulary, the texture, the complexity, and the associations of the adult's. The child cannot therefore adequately express itself or what it discerns. No child consequently can rightly be said to have fully grasped the language of a story, for this presupposes a mastery of a language beyond its powers.

A child is able to enter the world of story quickly and wholeheartedly because he has never made use of the specialized sublanguages which structure the practice of adults. Because the child is never trapped, as some adults are, within some sublanguage, it is more ready than those adults to enter the world of the story; yet what it understands and enjoys is but part of what they can. Only adults can tell a story properly; only they can really enjoy one. The adults must, however, first get over their preference for some sublanguage, and resist the temptation to be content with the language of everyday.

A story is held over against the world of everyday. It is bounded off from that world, and within its boundaries develops according to a logic of its own. It is a framed work of art. Daily life and activities have habits imbedded in them by means of which we apply and understand our language. The habits provide us with a semantics telling us how to

treat the usual type of sentence as a completed unit, either true or false. That semantics is not suited to sentences which are inside a story's frame. Sometimes the story's frame is created by a device designed to alert one to the fact that what occurs within the frame is to be considered apart from its conventional use. One such device is "Once upon a time." It means "At some time or other," for the old and for the young, signalizing the fact that what is to follow is to be understood in detachment from its role in ordinary practice. Sometimes the frame for the story is given by assigning to the story a time or place with which we can have no acquaintance. This is the device employed in *Robinson Crusoe, Gulliver's Travels, Alice in Wonderland.* Sometimes it is produced through the use of archaic expressions, as in *Ivanhoe.* And sometimes it is conveyed by the attitude or tone of the speaker, or the kind of situation in which the story is told. But the most certain way in which to frame a story, a way which, if properly pursued, will enable one to dispense with the others, is by making evident that the story's sentences, even when grammatically impeccable, are incomplete. The reader is then forced to move on to the subsequent sentences, thereby avoiding the temptation to use anyone as a designation for some common-sense occurrence.

Even when all a story's words are identical with those of a complete report, the sentences of the story are incomplete, not to be dealt with in isolation. If I write, "Tom Jones broke a rib on the 14th of July, 1864," I write a report. It can be true or false. It can be taken out of one discourse and put into another without seriously affecting its truth or meaning. And it could be made part of a story. But if it is, it will change in nature; it will then cease to be a report to become instead an incident in the story of a reporting. That story of the reporting contains indications that it is a framed story, not a report in fact. The indications are of many sorts. An easy and evident one—and therefore one that can be abused—is that of inverting the usual order of the words. If I write, "On the 14th of July, 1864, Tom Jones broke a rib," my sentence has every word identical with those of the initial report. If I hold this inverted expression over against the world of everyday by an explicit or understood use of a frame, I have evidently begun a story.

The inversion of the usual order of the words has made the reader expectative, revealing that this sentence is to be followed by another which will help complete it. I have given it a structure which shows that it is no report, and therefore is not to be taken as an isolatable sentence, true or false. Inversion is a major device for indicating that the sentences are not to be understood to belong inside daily language or one of its sublanguages, but only inside a framed, created one.

I do not accept an inverted sentence as making a completed assertion, but look from it to other sentences. The sentences of a story make no claim severally, but only together. Only together do they offer a unity which could be used to refer to a reality outside the discourse. It is a set of sentences in a story that makes a statement. That statement, which may cover a paragraph, a chapter or an entire book, makes us attend to man as having certain features and promise and thus as being more than an agent or patient of actions. The story uses conversation and dialogue, presents incidents and occurrences, and expresses dispositions and habits, to reveal the ground of man's intents, decisions, suspicions, fears, and hopes.

Men are unities sustaining and expressing dispositions and habits. A set of these dispositions and habits constitutes a *character;* an essence is exhausted by a number of characters. But no character or set of characters ever exhausts the *nature* of an actual *individual.* Individuals are determinate, unduplicable, irreducible beings. Dispositions and habits are general in import, exhausting only the repeatable, general aspect of individuals, the *essence* of a man. Any man which a story might name, describe, or portray is partly indeterminate, having only an essence which is there articulated by showing how his characters function.

An actual individual expresses his character in distinctive ways in different circumstances, adding to it an irreplacable vitality and flavor. No matter how distinctive the expressions of his character, he is never fully caught within it, for he always has some being in reserve. He is never fully explicit, never fully realized, never fully public. He is beyond the reach of a story. A story is not concerned with portraying him; nor is it concerned with describing characters. It uses characters

to make evident what man in essence is like. This it does by showing how a man, if he had such and such a character, would respond in such and such a circumstance.

A single story has a single time, though this may cover generations and embrace a great number of distinct occurrences. Ideally that time is made up of atomic moments, each of which spans a step in the formation of a character. These moments follow hard on one another, thereby making possible a smooth movement in which incidents are related, effects accumulated, and characters revealed. Since the characters the story deals with are those which a man might have, and since the incidents and interactions of the characters express the action of existence, we can learn from story what existence imports for man.

Inside the story the words and sentences make possible the treatment of characters in a time which is produced when and as those characters take account of themselves and one another in conversation and action. The conversation and action are steps in the unfolding of a plot, over the course of which the characters are formed, developed, and exhibited. The development need not follow the routine courses of ordinary things; it may subject its characters to adventures and elicit reactions which have no place in ordinary experience. But there must be a plausible connection between what is supposed and what is made to follow on it, a connection which was originally discerned in common experience. The words and sentences in the story are not entirely freed from the meanings they have outside it. It is these outside meanings that give the story its environment, an environment which is indicated by having the characters speak and act in a plausible way.

A poem, in contrast, has no environment. Both story and poetry have, to be sure, often been lumped together as differing only in degree. Each is usually broken down into subspecies, some of which are given subspecies of their own. There is considerable value in distinguishing short stories and novels; political, social, and historical plays; epic, narrative, lyric, and didactic poems. Each type raises particular problems of technique, structure, history, interpretation, and evaluation. But our classificatory scheme indicates that these different types of story and poetry do not raise distinctive questions of principle. What

does raise such questions is the different kinds of time which story and poetry create.

A musical composition creates a structured, melodic, emotionally constituted common time which it offers in place of the common time men constitute when they sympathetically interplay with what lies outside them. Poetry creates a new time in the shape of a new language. It uses common language and the time this embodies as an adumbrative component to give the new language a grain and to provide evidence of this new language's connection with everyday. But a story environs the time it creates, supplementing it by a mixture of common times—historical, cosmological, and the like—incorporated in daily language. The result is a complex time, one part of which is created in the story, and one part of which is produced by men in the effort to adjust their individual times to the times characteristic of others.

Like poetry, story never frees its language from the associations characteristic of the common language of everyday. But unlike poetry, it accepts these usages as pertinent to those which it creates. Its words are creatively used as also having a role outside. Each of its words thus has a double meaning; it is a word in an environment and a word in an environed art. The poet, instead, takes daily language to constitute a poetic situation, a spectator space; from that position he reads into the poem all the meanings which he there enjoys.

A story is produced through the help of the emotions. These make it more substantial than any object of perception could be, but not more substantial than common-sense objects are. The characters and occurrences in a story, contrary to the opinion sometimes expressed by critics, are not more real than anything we perceive or daily know. The fact that the characters are more clearly etched in a story than they are in experience is not enough to make them more real. It merely makes them better known. The characters in a story, their actions and their time are all as they appear to be, and nothing more. We can know them more thoroughly than we can know anything in experience because they hide nothing from us. No one has plumbed the depths of *Oedipus* or *Macbeth*, not because there is some subterranean aspect of them which we have yet to probe, but because they are so complex. We create a

story bigger than we know, and we read a story smaller than that which was made, but we could conceivably know it all the way through. Though a story may not be more complex than a grain of sand, it—but not the sand—can conceivably be thoroughly known.

Through the use of emotionally charged words the storyteller makes a story into a work of art. The words make possible the portrayal of characters in a series of interrelated, mutually supportive incidents and actions. The result is a sequentially produced time in which an idea is vitalized and made to stretch backwards over the whole story. This time differs from musicry's. There the time is primarily rhythmic, governing the operation of a metre. In story the opposite is true; an irregular metre, constituted by incidents and actions, governs the rhythm.

A musical composition cannot be communicated in words or concepts, for the ideas it uses are exhausted in it; but a story can be retold with different words, and even conceptualized, by pulling the ideas out of the vital, emotionally charged movement in which they were imbedded. Of course, when the ideas of a story are extracted from it, the story ceases to be a work of art; rhythm and metre, emotion and ideas are, as in poetry and musicry, interlocked within it.

Each word in a story, as was previously remarked, has two primary senses; it is part of the tissue of the story, and is inside the environment of the story. It also has two subsidiary uses; it helps constitute the texture of existence and it expresses a meaning. No one of these senses or uses can be completely cut off from the others. Because they cannot be separated, a story is not only something that can be understood by a number of men, but is comic or tragic for all.

A story makes vivid and immediate the tragic or comic import of existence, not in outline as musicry does, but in the shape of characters and incidents which embody, possess, and control the movement of that time. Richard Sewall has recently shown how the tragic story, both in play and novel form, provides us with a "vision," an awareness of the "blight man was born for." With great sensitivity and considerable subtlety, he makes evident how the tragic story is keyed to the fact that we men live surrounded, intruded upon, challenged, and infected by a remorseless, unheeding existence, sweeping along with no regard

for us, threatening our continuance and the continuance of our values. "The tragic vision . . . calls up out of the depths the first (and last) of all questions; the question of existence: What does it mean to be? It recalls the original terror, harking back to a world that antedates the conceptions of philosophy . . . It recalls the original un-reason, the terror of the irrational. It sees man as questioner, naked, unaccommodated, alone, facing mysterious, demonic forces in his own nature and outside, and the irreducible facts of suffering and death." "Each age has different tensions and terrors, but they open on the same abyss."

James Feibleman supplements Sewall with a stress on the ideational component in tragedy. "Tragedy depends," he writes, "on the fact that values as actual affairs cannot persist forever." His observation points up the need to dramatize the tragedy. We would be only saddened by the knowledge of the passing of values and not feel it to be tragic if it were not high lighted. The tragic idea in a story is a dramatized idea. It is traditional to say that it relates to the discovery of a single, fatal flaw in man. A tragedy, though, need not focus on a single flaw. Its tragic hero may have many flaws. Othello is not only jealous; he is also bombastic, impetuous, naive, gullible. More important, its tragic hero need not have a flaw at all, unless it be the flaw of being an existent man. Is ambition a flaw and laziness not? Is jealousy a flaw and indifference not? Is doubting a flaw and ready belief not? Each of these is a flaw, but only because it is a vital part of man, weak, frustrated, confused, incomplete, inescapably flawed.

Any side of man, any feature or virtue, accomplishment or effort can become the pivot around which a tragedy can be swung. The tragedy that faces man is the very tragedy that faces art itself and any other thing that he might produce. There is no wall so artfully contrived, be it in the shape of man himself or any of his works, through which existence will not surge. There is nothing he can make of himself or of other things which it cannot blot out, overturn, submerge. To make the tragedy more poignant, more vivid, it is often desirable to remark on some outstanding feature which testifies to the fact that a man is about to be successful in the arduous task of existing. Tragedy strikes more vividly when it catches a man who has just managed to build up a fortress in which he can live as a full man, bounded off from nature.

The tragic story makes the fact of tragedy unmistakable by giving it a substantial being of its own.

When Aristotle said that neither a morally excellent man nor a villainous one could be topics for tragedy, he overspecialized and thereby distorted a penetrating insight. The most virtuous or accomplished man can be suddenly overwhelmed, and his values and achievements snuffed out. Aristotle thought that the story of such a man would not be truly tragic, and could only shock. Yet *Oedipus, Lear,* and *St. Joan* are good tragedies. And there can be a tragedy in a saint's fall from grace, a great general's failure of nerve, a rich man's loss of fortune. We want, of course, to see something in them that invites this fate, enabling us to sense some modicum of justice in the overturn. But the tragedy remains even if no justice can be discerned.

Aristotle made a stronger point when he said that the overthrow of a genuine villain is not tragic, that it merely assuages our ethical sense. This, I think, is due to the fact that the villain is seen to be one who is no longer a man like the rest of us. In a previous tragic occurrence he changed from ordinary man to villain; now he no longer shares (as a merely bad man would) in the common human effort to perfect himself somehow. His ambition, greed, conceit, brutality have already conquered him. The tragedy, so far as he is concerned, is over; he can function in the story only as an instrument of existence. Iago was already almost wholly undone before the play began; in the play his villainous nature is uncovered, not really developed.

The values which are extinguished by existence are precious and irreplaceable. This fact is at the centre of the controversy as to whether or not there can be a Christian tragedy. If men are denied and defeated only as preliminary to their being raised and ennobled, there is no tragedy in their overturn. But if they are denied and defeated by a power which acts without apology, preparation or excuse, tragedy results from its operation. There is then no tragedy for orthodox Christianity, with its day of last judgment and possible salvation for all. There is tragedy, though, in a Christianity which takes history seriously, which sees God working through time, guiding but not controlling the forces of nature. There is tragedy, too, in a Christianity which speaks of God's arbitrary elections and rebuffs. In these latter

cases, Christianity repeats in another guise the pattern which underlies Greek and Hebrew tragedy.

Auden has taken a somewhat different view. In Greek tragedy, says he, the spectator is made to feel "what a pity it had to be this way," whereas in Christian tragedy he is driven to feel, "what a pity it was this way when it might have been otherwise." This antithesis would force one to say that there is a Greek element in Christian tragedy—which is perhaps harmless—and (what would be paradoxical) a Christian element in Greek tragedy. There are causes which lead a Christian to sin, even though it be the case that in the last resort the sinning is up to him. And no matter how thoroughly he may be caught in the web of necessity, no matter how strong pressures, foreknowledge and the fates may be, there are alternative things a Greek could do. Auden goes on to say that the Greek suffers the flaw of knowing himself to be strong while supposing that nothing could check him, whereas the Christian is beset by a sin of pride, knowing himself to be weak and yet believing that he can transcend this limitation by his own efforts. But a Greek does not really plume himself on being strong; he takes this for granted while believing that existence moves blindly, intruding on man in the guise of a thoughtless fortune. The Christian, on the other hand, does not know himself to be weak and he often supposes that he has been given sufficient grace to meet whatever must be met. It is not necessity and will, *hubris* and sin which separate Greek and Christian, but the fact that the Christian does and the Greek does not conceive of himself as eventually living in a realm where existence, brute and unyielding, is ineffective.

Nevertheless, no matter how keyed a Christian may be to the brooding presence of the divine, he, like the rest of us, lives in a world in which existence's remorseless power is suffered and felt. Like the rest of men he is defeated by existence. It pierces his hopes and crumbles his resolves, inevitably. It will not be denied, no matter what the period or the creed. A story which showed how existence loosens a man's grip on eternity would present a genuine Christian tragedy, telling us how this world, in the guise of sex or hunger, honors or guile, crowds in on his contemplation of eternal glories to make him a worldly man.

According to Brooks and Warren, a tragedy takes a flaw literally

and then exaggerates the punishment it should receive to make it fearful and pitiful. They contrast it with comedy as that which distorts a flaw by caricature and then reduces punishment to discomfitures and mortification. But what could be meant by taking a flaw literally, if flaw there must be? In what sense is a punishment exaggerated? Does justice demand that Macbeth not die? Does one leave a tragedy with one's sense of justice outraged? I think not. Is it the case that a comedy distorts a flaw? Or is it not rather that a defect is made conspicuous in order to be dealt with dramatically? The latter seems to be the case.

Tragedy and comedy can be contrasted. But I think one cannot, with Cook, do it by setting the wonderful against the probable, imagination against reason, ethics against manners, soliloquy against the aside, the handsome against the ugly actor. Any of these can be found in either tragedy or comedy. The contrast between the soliloquy and the aside, however, does bring one quite close to the heart of the difference between tragedy and comedy. In tragedy we have a man ominously intruded upon; we must go to him to know what he is like, what the destruction will encompass. This the soliloquy helps us do. In comedy existence is benign, and in the aside one can represent it while still remaining part of the story. The aside enables a man to emphasize the fact that he is not a being with a definite character having a limited role in the story, but one who is functioning on behalf of existence. His aside can therefore relate to himself as well as to others. Tristram Shandy and the characters in Wilder's *Matchmaker* never step out of the story, no matter how often they talk to the audience. And so far as they remain in the story they are themselves made the creatures of the benign existence which they allow to be manifested through themselves.

In a comedy there are places reserved for representatives of, or reassessments by existence, all serving to free men from a mistaken set of values. The clown and buffoon function primarily as loci for existence. They adventure in ways the rest of men would not, getting into difficulties because they are not as protected as others are by habit, convention, or good fortune. As is sometimes said, they are "comics," beings who already exhibit the outcome of a comedy. Already freed from ordinary conventions—a fact usually underscored by their bizarre

attire—they point up what can be said and done without fear. But they function merely as avenues through which existence will make its benign nature known. When they are beaten, they are beaten not as characters but as man, and only as a way of exposing the power and irresponsibility of an existence which, though benign, is indifferent to what men think is good or desirable. As part of a story, they open up in other characters ways in which these can attain authenticity on a more sober level. The clowns and buffoons in the circus have a different role, serving there only as reminders, occasions, avenues for escape, who by their freedom and escapades elicit laughter but no understanding. They demand not an appreciation of comedy but only of the powers which a comedy should clarify, utilize, and artistically present.

In the story, the comic character makes evident what we have hidden from ourselves, and provides an opportunity for exhibiting a neglected truth. He need not, in word or station, in character or mien, be lower than ordinary men, any more than a tragic hero need be higher. That he has pretensions, a wrong sense of values, must be made clear. But these he can have no matter what his nature, station or role. National leaders and mighty sovereigns, the saintly and the heroic, have been successfully made the butts of comedies.

In the war between men and women, existence is used to challenge and overturn the pretensions of the mere male or female. In *Lysistrata* existence helps females conquer males ; in the *Taming of the Shrew* it helps a male master a female. A thousand stories on television and in the movies tell of the conversion of an irritable elderly male or a spinsterly female by means of the vital existence in children, girls, or lovers, to become, like them, human in nature and appeal.

Insistent powers impose conditions to make men not what they would like to be and even ought to be, but what they must be in this cosmos. Comedy makes men aware of what would be an authentic state of being for them. It reevaluates men, recovers better values for them, and thus at once frees them from improper restraints and enables them to expand in new ways. It ends with an opened world. Happy reconciliations, renewed determinations, the joyous meetings of lovers, and the like serve to mark the fact that men have escaped from unnecessary restraints, and are ready to live fully and well. Comedy closes with rising turns

towards a life which has been freed from encrustations that have weighed it down before; tragedy instead shows us relentless forces at work, forces that do not take account of our needs. From comedy we learn how men ought to live; from tragedy we learn what existence will do to them.

Values are recovered, produced, revealed in comedy, replacing those which are irrelevant to man's true nature. Authenticity is achieved, false values are pushed aside. The process may prove sobering. It is laughable, though, while being gone through. Through error and stupidity, convention and tradition, men come to identify themselves with values which do not do justice to the vitality and richness of existence either as manifest in them or in the world beyond. Circumstance, personalized or indifferent, sheers off the pretense; men are buoyantly reassessed through the action of existence. We who, by the privilege of being audience, are privy to the false values which the author is exposing, adopt the position of existence too. If the pretensions are those which all of us share, a wry comedy results; we smile as philosophers, not as men caught up suddenly.

Comedy calls up emotions and energies which either had not been used or which had been directed elsewhere, and abruptly releases them, lets them explode as laughter. The laughter is not directed at any character, or even at a situation; it is just elicited, just a way in which a story makes it possible for the energy of existence to be suddenly made manifest through us. With justice it can be said that it is existence which here laughs, using and shaping us to respond to a presentation of itself as benign. We use up energy when we laugh, but are renewed because we are thereby readied for further action. The energy we use when we suffer the course of a tragedy, in contrast, serves only to make us more controlled, more ready to stave off the existence whose threat the story exposed. When we cry at the tragedy, we are actually exhibiting how existence is preparing us to deal with it as ominous.

The pity and terror that tragedy elicits are "purged" by being directed at the story's icon of ominous existence. Having learned what the world is like, we are made wary, able to deal with the world better than we had. Comedy also purges. Lane Cooper has suggested that it purges us of the feelings of envy and malice, but more often and more conspicuously it seems to purge us of feelings of superiority and de-

tachment, finally making us more human and humane. In both tragedy
and comedy the feelings are purged by being harmlessly spent, the one
in tears and the other through laughter, and we as a consequence altered
in relation to the world or in ourselves. In comedy we learn how to
accept ourselves as instances of a benign existence; in tragedy we
learn to assume a new distance and attitude towards an ominous ex-
istence.

"Without a sense of the tragic, comedy loses heart; it becomes
brittle, it has animation but no life. Without a recognition of the
truths of comedy, tragedy becomes bleak and intolerable." Sewall
here speaks more to the point than Socrates did when he said "the
genius of comedy is the same as the genius of tragedy, and that the
writer of tragedy ought to be a writer of comedy also," for the im-
portant consideration is not whether a writer of one form can be a
writer of the other, but whether or not the two forms can be mixed. I
think they can. They can also be made to space one another in a single
work. Though comedy and tragedy are concerned with quite different
events, they can often be profitably combined. There should, except
where stories are quite short, be comic elements in a tragedy and tragic
elements in a comedy. Existence is both benign and ominous; a con-
centration on one of these facets, to the neglect of the other, tires and
distorts. The unrelieved tragedy exhausts, the unrelieved comedy
wearies. Each is heightened, accentuated by a subdued use of the other.
The effectiveness of a tragedy is increased by making evident the
threat which lurks behind the most benign expression of existence. We
are tensed when we see the comic in danger or on the verge of death;
when he escapes, our feeling of relief readies us for an expression of re-
lease.

Each incident in a story presses onto other incidents, to make the
story a single whole in which no part can be said to be external to any
other. That whole is a molded thing, organically produced. Distin-
guishable incidents are properly speaking only emphasized stadia in
it, spaced by descriptions, other incidents, pauses, and characters, until
a climax is reached. The climax is its nodal point, a knot into which
all the various incidents are pulled and out of which others follow.
Lesser occurrences feed into it and it itself seeps out into the occur-

rences that follow after it. It ties them together and they in turn sustain it, making it not a single occurrence but the entire plot epitomized. The climax has a maturation period; it is arrived at. Different movements can begin at different parts of the work and can end before the climax, to help start or constitute some other having a direct bearing on the climax.

In ordinary life a crucial occurrence can take place in an instant. A man's life can be cut short without warning. In the story there are no occurrences of this sort. If there is a crucial event referred to in a story, for which no preparation has been made and which leads to nothing, it can be only something referred to. It can never be more than a minor incident in that story. A child's story includes a hundred deaths, all of which are of minor import. There can, of course, be inadvertent statements, mischances, contingencies; there surely are unpredictable events and outcomes in a story, but every one of these must be prepared for and have effects in other incidents and on the characters of men.

Since we do not know the men in a story except so far as they are revealed to us in it, and since a storyteller has but a limited time, he must use only those items which have a contribution to make to the production of the character, plot and climax. Whatever accidents he allows to happen have an essential, not an accidental role in the story; their occurrences express some power carrying out some design. The accidents in a story are thus inevitable, and therefore not genuine accidents at all, precisely because they contribute essentially to the meaning of the whole.

We can be caught unawares in daily life, and forced to express emotions we never wanted to exhibit or imagined we had; but even the minor incidents in a story are intended to build up emotions which come to expression in a climactic occurrence. On the other hand, the emotions in daily life usually need some preparation, whereas the emotions elicited by a story can be quickly awakened and as quickly dispelled. Many of the incidents in daily life are met by most inappropriate emotions, and much of the preparation in a story is irrelevant to the kind, strength, and duration of the emotion the reader is ready to express. But ideally, we prepare for what is to come, both in and out-

side story, the one through an habituated readiness to act, the other by an elicited readiness to express elicited emotions.

Poetic justice is the product of an existence which injures men proportionately to their vices, and therefore their presumed desserts. It would not be poetic justice if a man were killed by a gun he bought to shoot a prowling animal or to protect the money of an orphanage. He is neither good nor bad when he does the first, but is good and not bad when he does the second. There would be poetic justice, though, if he were killed by a gun he bought to kill an innocent man. Such justice could not be exhibited in a story if one merely recounted the facts. One must *show* that the man has vices and what these are, making this evident in the way in which he buys the gun, loads it, waits for the victim, and so on. Ideally, the victim in turn must be shown to be innocent through analogous actions.

There ought to be as many themes in a story as there are pivotal men in it. Each, through his actions, should further the plot. If he does not, he is, where not wrongly intrusive, merely background. The development of the many themes together yields a complex structure. This allows for protuberances and hollows, straight-aways and turns. It does not allow for breaks anywhere. If it did, the story would no longer be one. Countless omissions and an imposed closure are possible, so long as these are consistent with the permeation of a verbalized time by vital ideas.

Short stories differ from novels not in size but in the operation of incident on character. The short story keeps in focus a single incident (or at most a few) and has this reverberate throughout, showing its effect on character but not having time enough to develop the character. The novel uses many incidents in order to make man's essential nature clear. *Ethan Frome* is a short story, though longer than some novels. *Catcher in the Rye* is a novel, though shorter than some short stories.

In short stories and novels existence operates primarily through incidents, but in a written play, existence is expressed primarily through the avenue of characters and actions. In short stories and novels the primary focus is on the effect which existence has on character; in

plays the primary focus is on the action of existence. The former shows existence in operation in order to show its effects; the latter shows existence's effects in order to make evident the nature of its operation. A written play—but no short story or novel—can function as a script. The novels used by playwrights are raw material from which incidents or characters can be extracted; written plays can themselves immediately function as constituents of the quite different art of the theatre.

Story is the art which readily appeals to both young and old, ignorant and wise. Like every other art it must be entered into on its own terms, the most important one of which is that it is to be written and read in a new language quite distinct both from the flat-footed prose of everyday and the high-flown turns of schoolgirl poetry. It is a language compressed between emotion and idea, and exhibiting in its rhythm, metre, and texture what a temporalized existence imports for man. It can be mastered without going through a period of professional training. Students are affected by the stories that are recommended to them; they are impressed with financial and historic successes, and overimpressed with the need to use words in a "literary" way. They forget the "illiteracy" of Molière and Shakespeare, Anderson and Faulkner, Dickens and Dostoevsky, who knew how to tell a story because they attended primarily to the demands of the story itself. This is what every storyteller and reader ought to do.

9. POETRY

A MUSICAL composition creates a new time by imposing an order on an emotionally sustained common time. A story creates a new time by supplementing a mixture of common times with a time produced by the interplay of incident and character. A poem, in contrast with both, creates a new time in a new created language. Like a painting, which makes a new space having its own geometry, a poem makes a new time having its own arithmetic. Both poetry and painting are set over against the world of common sense; but the poem unlike the painting courts and uses echoes of the common-sense world. The time of a poem replaces common time as thoroughly as the space of a painting replaces common space, but in poetic time there are always resonances of the common-sense world. Precisely because it makes use of words, grammar, silences which play a role in daily life, a poem never cuts itself off, as a painting might, from common-sense demands. It is as if a painting, within its newly created world, hinted at the nature of the familiar world which it had left behind.

A poem is a substantial mass of words and silences, terms and connectives, movements and rests, the lyrical and the prosaic. It is opaque time, a created time embodied in a newly created language. It is a solid, completed whole of time, with a distinctive grain, rhythm, and pace. Nevertheless like every other work of art the poem is revelatory primarily of some dimension of existence, and secondarily of the poet, his ideas and ideals, the prevailing myths, and the social goods at which these point.

Though the poem is opaque it is also translucent. Indeed, it is translucent because it is opaque, revelatory because it is self-enclosed. The substantial time it presents to us has a texture identical with that of the time of existence itself; it conveys the meaning of existence in its bearing on man. Yet MacLeish has said, "A poem should not mean

but be." How could it "not mean"? Because a poem is, it means. That is what it means for a poem to be.

The meanings of his words are created by the poet, but not without regard for the meanings they have outside the poem. He begins by occupying a position in common time, usually as it is grasped in daily language, and sometimes as it is used by story. The daily language is a condition which is allowed to reverberate in the new language which that daily language made possible. The poet does not, as the composer does, live wholly within his created time; nor does he, as the storyteller does, recognize a time which supplements the time through which his creatures move. Poetry and story make entirely different uses of language; the two remain distinct even when the former tells a tale, and the latter is put in verse.

The poet is aware of common time as a counter movement inside his created work. Theodore Weiss writes me, "Part of the basic drama of poetry lies in its counterpoint to the established metric . . . The poet uses time against time." He must never allow common time of daily language to have any but a minor role; but also he must never try to eradicate it completely. If the first occurs, his poem is banal; if the second, he fails to communicate.

Poetry contrasts not only with story, but also with prose. Prose makes use of the words, grammar, and rhythms of daily life to report, signal, cue, guide, and stimulate men to respond to one another and the world about in concordant ways. In story this use is supplemented by another where it is made subservient to the needs of the characters and plot. In neither case need the prose be flat or uninteresting.

Prose does not allow itself to be guided by metaphor except incidentally; it does not emphasize the clues which sounds provide, nor allow accent or rhyme to dictate what is next to be put down. It does not use a steady beat throughout. It has no fixed metre. It makes use of rhetoric to gain elegance, subordinating this and other devices to the need to achieve some end such as persuasion or pleasure. But whatever poetry says is integral to it. Any rhetoric or other ornament it might use is as much an integral part of it as its words and silences are. It need not persistently follow any rhyme scheme, nor move at any prescribed pace; it may make use of a steady beat or it may accelerate and hesitate,

flat and slur its terms and accents. Sometimes it pursues a regular, sometimes an irregular course, depending on what must be done to overcome tendencies towards monotony, triviality, and conventionality. All that matters is that it create a substantial irreducible time, qualitatively rich, freely developing, and endlessly plastic.

The writer of a story also desires to avoid monotony, and attempts to do justice to the nature of time. But he is not concerned with creating a time whose entire being is contained in a created language; language and time for him have another role outside the language and time which he uses to exhibit characters and plot. They there act as measures of what is plausible and meaningful to the characters and plot. The poet, in contrast, without denying a role to ordinary language and time, uses, determines, and subjugates them. Even a purely narrative poem has these features; its plot, development, and climax are carried in good part by the created meanings and the sounds of words, and not, as in a work of narrative prose, solely by incidents, actions, and the interplay of characters.

Daily language is sometimes said to be an attenuated poetry, a poetry flattened out, become stale with use. But it is not a genuine poetry. Nor was it ever so. It was never creatively produced; never existed as a fresh union of stable finite forms and cosmic meanings; never was set apart from the world of everyday. When, in puns, little rhymes, in attention to the quality of our speech, we take our daily language to be solid and substantial, we turn it, not into a work of art, but only into an aesthetic object. We then do not live in it, actually make a new time out of it; we merely set it over against the rest of daily language as something to be enjoyed.

Every word of a poem is primarily part of a language which exists only in the poem. That language has layers upon layers of meaning which no external use of its terms could ever express. Still, every word and meaning in a poem can be isolated and described, but of course not without reducing the poem, losing the unexpressed connections which make the poem the particular substantial unity it is.

There are no rules which tell one how to use the words in a poem. We can bring them in solely for their tones; we can use them to make assertions; we can make them carry scientific, religious, or moral truths.

We can turn them into paradoxes, make them express some quaint imagery, use them to provide unaccented connections. Every poem does some of these things, and one might for a while concentrate on any one of them. If by poetry we mean the lyrical, the heightened, unusual values of words and phrases, then no poem—as Coleridge observed—ever is all poetry. But the poetic side of the poem, the fresh, created time of it, must stretch over the nonpoetic elements to make them integral parts of the poem. The nonpoetic usages must be subordinated to the poetic to make a universe of language, revealing something of the universe outside, something of our deepest selves, and something of our highest aspirations.

The poet does not necessarily like the characters or events he salutes, except as in that context. He produces a qualitative whole with its own rationale and value, thereby enabling us to see what in fact is, and to face primary issues in an appropriate way. His poem does not exclude any associations, not even the banal. His words have all the meanings that they in fact elicit, when they are brought into relation with one another in the poem. Some of these the poet might reject were they stated explicitly.

Every poem tells a lie, for it changes the form, meaning, and role of the words which we use when we speak truthfully in ordinary life. In a deeper sense, every poem tells more truth than daily discourse permits, since even when it sings of routine things, it reveals what existence is in itself, for the poet, and what it promises all of us. Wisps of old meanings cling to the poet's words. Sometimes the old meanings almost overwhelm the new. Depending on the side of existence to which they were attached or with what dark or light words they were associated, the words in a poem are themselves light or dark. They had a bias towards one side or the other of existence before they were parts of the poem. "Joy" and "spring" and "birth" are usually light; "death" and "night," "sickness" and "weakness" are usually dark. In between are "and," "but," "if," and "then." In the poem the meanings and colors of all of these change; shadows fall across what had been light; rays pierce the words whose meanings were quite dark. Death can be welcomed and light disdained, and yet basic truths revealed.

Since a poem is many moments, many incidents, even the poet's en-

tire past and that of his society epitomized, a poem is more than the poet is now, and more than what he now can do. The struggle and creative spark is his but not their summation and fulfillment. A poem is the poet idealized, rectified, improved by trial and error and reflection, the poet redirected by a language partly beyond his control. Yet the poet is more concerned, as all artists are, with the process of producing his work than with its outcome. He rebels against the common view that his poetry is wholly contained in his poems. Poems are for him but residua, records, markers along the path of his life-long struggle to give the infinite a finite form.

A reading of the poem revitalizes the vivid time which the poet created; it realizes the ideal prospect in a particular form, and allows the meaning of the poem to find a place in the lives of men. As a rule a reader recovers only a part of the poem, and then often what the poet himself did not know was there. Nothing is amiss; the poet is not his own best critic and often makes well what he had no intention of producing and which he might even overlook.

A poem has a different meaning for each reader. This fact does not support a relativistic theory of poetic meaning—firstly because men share in a common human nature and experience; secondly because men do not differ in essence; and thirdly, because the diversities in interpretation occur inside a more or less fixed set of meanings. Though a poem is by an individual, he not only makes use of powers, drives, sensitivities available in principle to all, but in fact shares in a common human life, customs, and meanings.

The reader is a poet after the fact. Unlike the poet who had words and ideas which he had to transmute, the reader starts with the transmuted terms, and must read them as carrying within them a meaning all their own, resonant with the meanings they normally bear. But to appreciate a poem the reader must do something similar to what the poet did when he made the poem. The poet made his poem in a poetic situation; he started from daily language and a common time and ended with a language charged with new values. The reader must begin near where the poet did, and then move to the poem. To read it properly he must read in a new way the words which bound his common day; he will then for a while live in a world replacing that of daily life. Each

word in the poem must be seen to affect others by virtue of the meanings it shares and opposes, and by virtue of its sound. Assonances and alliterations, paradox and rhyme, timbre and pitch must be used to help him to affiliate each word with others. If he reads it properly he will find the poem to be solid, thick, one continuum of rhythmic, metred, verbalized, revelatory time, at once overwhelming and inviting, possessed and defeating, satisfying and frustrating. Robert Lowell writes me: "I think of a poem as something that can reach almost to the infinite, or say, to *War and Peace*, in its inclusion of experience; at the other extreme, it is a musical organization, bound together by sound, motion, voice, tone, imagery, syntax, etc., and all but verbally meaningless. The poem is a life and death struggle between the lived experience and the organizational apparatus."

Here is the sixth stanza of Yeats' *Among School Children*:

> Plato thought nature but a spume that plays
> Upon a ghostly paradigm of things;
> Solider Aristotle played the taws
> Upon the bottom of a king of kings;
> World-famous golden-thighed Pythagoras
> Fingered upon a fiddle-stick or strings
> What a star sang and careless Muses heard:
> Old clothes upon old sticks to scare a bird.

This stanza is very rich. An entire chapter would not be enough to do it justice. But it will help us see how rich it is if some of the more obvious associations in it are set down. "Plato" has obvious verbal affiliations with "plays" and "played" and obvious associated meanings with "Aristotle" and "Pythagoras." Through "plays" it has an ideational bearing on "fingered"; it also has an ideational and faint verbal relation to "sang," while "fingered" has somewhat similar relations to "sticks" and "fiddlesticks." All four are related primarily by meaning, and some also through sound, to "strings," "star" and "muses." "Thought" is related to "things" and "taws" in one way and to "spume," "Aristotle," "Pythagoras" and "Plato" in another. "Nature," "solider," "Aristotle," "star," "bottom," "bird" belong in

one world of meanings. "Spume" goes with "ghostly," "upon," "golden-thighed," "careless," "muses," "clothes"; through the agency of "thought" it was part of a previous set. "Paradigm" moves through another group of terms. Some of the associations of the words are controlled, others are adventitious. All are legitimate, but only the controlled associations give the root meanings of the poem, and then only so far as those meanings are grounded in a vision of the whole of things and express something of the deepest recesses of existence in man and outside him.

A poem is more than words associated; it has a structure and an organization. And its words express ideas. Plato, Aristotle, and Pythagoras are here contrasted as thinker, teacher, and student of music, as otherworldly, materialistic, and artistic; all three of them are set in opposition to the spindly body, they—despite their achievements—eventually possess, and which is now apparently possessed by the poet. The poem tells us what nature was for three philosophers and what in fact is the case—that all men in the end are frail, thing-like in looks and ways, and yet strong enough to challenge the free-winging, and unconfined: thoughts, boys, music, songs, and birds.

The last line of the sixth stanza helps us jump a stanza to the brilliant eighth:

> Labour is blossoming or dancing where
> The body is not bruised to pleasure soul,
> Nor beauty born out of its own despair,
> Nor blear-eyed wisdom out of midnight oil.
> O chestnut tree, great rooted blossomer,
> Are you the leaf, the blossom or the bole?
> O body swayed to music, O brightening glance,
> How can we know the dancer from the dance?

Sound alone affiliates "blossoming" with "body," "bruised," "beauty," "born," "blear-eyed," "bole," "brightening," "dancing," and "dance." Its meaning is offered opposition on the next three lines; it reappears in the fourth and fifth, and in another guise in the last two. The whole says something, but what it says is not to be found by treating it as a

tissue of assertions. Nor can it be found by noting the various reverber-ations of the words and phrases, or the development of a meaning. Susanne Langer has made the point splendidly: ". . . though the *material* of poetry is verbal, its import is not the literal assertion made in the words, but *the way the assertion is made*, and this involves the sound, the tempo, the aura of associations of the words, the long or short sequences of ideas, the wealth or poverty of transient imagery that contains them, the sudden arrest of fantasy by pure fact, or of familiar fact by sudden fantasy, the suspense of literal meaning by a sustained ambiguity resolved in a long-awaited key-word, and the uni-fying, all-embracing artifice of rhythm." She gives body to Eliot's observation that the poet dislocates language into meaning, breaking down the familiar usages and structures, realigning words to make them elements in a new meaning. That new meaning is a new time, in which there is no separation possible between dancer and dance, between leaf, blossom or bole.

The early I. A. Richards maintained that "the statements which appear in poetry are there for the sake of their effects upon feelings, not for their own sake . . . to question whether they deserve serious attention *as statements claiming truth*, is to mistake their func-tion . . . many, if not most, of the statements in poetry are there as a means to the manipulation and expression of feelings and attitudes, not as contributions to any body of doctrine of any type whatever." The negations here, not the affirmations, are defensible. A poem may contain assertions, propositions; it may even be written to express a scientific or commonplace truth. But it never allows such considerations to be of a primary concern. If, as it sometimes does, a poem includes lists of ships, shards of nonsense, and plain, factual announcements, it does so by making them parts of a richer whole. Also, it is not alto-gether correct to say that it is a function of poetry to affect feelings or attitudes. We look to it to present us with a reality which is tem-poral, sensuous, humanly important. And this it can do because it deals with language and ideas emotionally.

A poem is produced with the help of the emotions. As a consequence, it is an object capable of eliciting emotions from those who follow the lead of its language. The emotions are the instruments for poetry as

surely as poetry is an instrument for them. They are not necessarily violent. Poetry can be written in tranquility or in a frenzy. But at neither time does it implicate the whole man. Grounding the poem in himself, one whose emotions are expressed through mind and body, the poet makes the poem—a substance in which he and the world can be harmoniously together—stand apart from himself and the world.

The poet's emotions are motions, imparting a rhythm to words. Those emotions are aroused by what the poet glimpsed of existence under the guidance of some arresting idea. By making use of his emotions, his words are turned into components of a new time in which idea is submerged in rhythms, and rhythms are cross grained by idea. The poet as a representative of mankind is epitomized in the poem, even though the poem may not expressly speak of him.

The language of the poet is primarily emotional; the prospects which his ideas express are made subordinate to a time emotionally sustained. Each focal term in his poem has two intertwined roles supplementing its emotionally charged meanings. Each term has a role in daily language, and each acts to relate us to existence. Critics are inclined to attend mainly to the meanings; paraphrasers note the daily values of the words; sentimentalists lose themselves in the relation. But all belong together. The meanings, daily values, and the relation are not isolatable in the poem; a poem is not a set of meanings or a report. It becomes whatever it conveys to anyone who reads it; it *is* in fact whatever it conveys to anyone who is sensitive and experienced, and knows how to read a poem.

Despite its ostensibly limited topics and flimsy material, a poem encompasses a cosmic truth. What is said in and by it is, "here is humanly relevant reality in the guise of time." But instead of communicating this as a solid unit of truth, the poem exhibits it. To make that truth our own we must read the poem not for the truth but as a poem. We can free ourselves from the poem and its emotive language. But if we do, we will not only demolish the poem but will also preclude our learning what the poem is saying.

Only by moving through the poem's emotionally-charged language can we experience the texture and rhythm of real pertinent time, at once sustaining and corroding, abiding and passing away. That time

is a present. Over its span both past and future stretch, the one carrying the emotions, the other meanings, to make time at once perceptible and important. Unread, the poem is sheer structure, a formal time; read, it has the urgency and boundaries of a unitary event.

Time has a varying thickness whose most sudden dips and swells are made evident in the poem by accent and rhyme, stanza and strophe. Did time merely flow, had it no beats, it could not be enjoyed. One would be swept along by it, at sea, disoriented and discommoded. Like the musician the poet also makes use of a metre. "Poetry," said Bridges, "selects certain rhythms and makes systems of them, and these repeat themselves and this is metre." Metre promotes a purchase on the poem, for without breaking the poem's continuity it spaces it and thereby paces it.

Metre and similar devices are the topics of a science of prosody, the only aspect of poetry that can be taught. The rules of prosody serve to tell us that time pounces and springs, moves up and down as it moves along. Unlike music which acknowledges an external, clock-like time, poetry keeps its measure wholly inside. The rules of prosody are not imposed on it; they are exemplified by it. Time's beats are determined by what time contains. "When Ajax strives some rock's vast weight to throw/the line too labors, and the words move slow."

Poems have different rhythms and metres; they speak of different topics; they have different lengths. And as we move from country to country we find that they have different forms. The question which every art inevitably raises, how can different instances all exhibit the same reality, therefore becomes acutely insistent in a discussion of poetry. Time cannot at once be both fast and slow, smooth-grained and rough-hewn, tense and loose; yet poems are times which differ one from the other in these respects. It seems reasonable therefore to say that each poem catches one facet of time and that we need all the poems that man can make in order to catch them all. But were this true, it would be hard to understand why we do not feel dissatisfied, why we do not feel something lacking, why we do not, having enjoyed one type of poem, move on to another, particularly one of a contrasting type. It is true that a proper enjoyment is exhausting and that we have not

the energy or the time to engage in another adventure soon. But we ought to feel that such an adventure should be made. We do not. A poem is enjoyed as complete, self-sufficient.

It is no more satisfactory, in answer to the question as to how different instances of art can exhibit the same reality, to say that each instance presents the whole of reality in one of a number of possible guises. If time is really slow or coarse-grained, a poem which exhibits it as fast or smooth is distorting it, misconstruing it, not presenting it at all. If it be said that the poem may give time a special twist as testimony to the fact that it is a time made by man, what reason would we have for rejecting any bit of writing as a way of presenting time? There would be no real need to go to poetry to learn what existing time is like; we could find that out by making the simplest statement in prose. Or rather, we would not be able to find out anything about time from either prose or poetry, since the only time we would be presented with, on the hypothesis, would be a time which can be unlike real time in quality, structure, pace, and beat.

A dilemma, neither of whose alternatives is acceptable, is one which has been poorly forged. An alternative must have been overlooked. The time in a poem, like the space in a painting, is neither fragmentary nor unlike the real. It is all time given a verbal humanized form, with an emphasis on one aspect in one poem or in one line, and an emphasis on another aspect in another poem or line. The poem is never merely smooth or coarse, slow or fast. It is a smooth time within which a coarsening can be discerned, a slow movement riding on the crest of a faster one, and so on. The poem presents us with one or two sides of time uppermost, but also finds a place for an infinitude of other sides, not immediately evident. Our initial dilemma was framed for a time supposed to lie evenly inside a poem, joining the first syllable to the last in a straight and simple way. But time swirls; it has eddies and crosscurrents, backwashes and waves. The poem exhibits this in an individualized, humanly relevant, verbal form.

The time of daily life has an external past. That past is relevant both for the critic and the poet. It is to this past Livingston Lowes turned in order to account for the images and ideas in Coleridge's *Kubla Khan*.

That past provided him with clues to associations, obscure meanings, and ways of reading the poem. But no one can hope fully to understand the poem from this perspective alone. No study of the poet's past will explain his poem. Not only are the power and meaning of the past transmuted in the process of creation, but the act of creation adds something to that transmuted past.

If we are to understand how a poem comes about we must take note not only of the past which the poet uses, but of the present in which the poet is working, and of the future meaningful prospect he is concerned with making real. When account is taken of all three, the poem is of course an inevitable product. But the creative process exists only in the present time through which it goes. We cannot lay hold of that creative process to explain the poem's presence or nature, without going through it and its now departed present, all over again.

The poem also takes account of a possible reader who is to be vitalized through the action of the poem. The poem is made to be read and is made therefore with a reader in view. We can say that the poem exists while not read, because we attach it to the prospect of its being read. Such a prospect must have a being outside the poem and outside the poet. It can be no mere thought, for it would then express only a hope that the poem will be read, and not the possibility of such a reading. Nothing will happen unless it can happen, and what can happen is the possible. Each poem points to a particular type of reader now, and to mankind eventually. Though at times deliberately written for children and lovers, for other poets and critics, for state occasions and declamation, poems are in root written for all men.

The standard of excellence for a poem is obviously outside it. Were there no such standard, poems could not be significantly judged to be better or worse, successes or failures. It may not always be possible to speak with surety on this question, but it should always be possible in principle to provide an answer. We must affirm that there is a standard even though we may not know it in full detail or how to apply it well. That standard cannot be given by ethics, religion, or society. These provide conditions alien to the central meaning and value of works of art. Nor can the standard be existential, objective, cosmic time. This

is exactly what the poem reveals to us.* The standard is particularized in ideas and realized in poetry with a success whose degree is determined in the end by mankind as eventually satisfied, completed by the poem. Each one of us, in judging a poem, takes upon himself the onus of representing the final judge of it. Each one of us stands for all men, offering his judgment in advance, making concrete and expressing in an individual form that which all need know: what existence in a temporal guise imports for man.

To judge a poem is to take a risk. Having arrogated to ourselves the position of being representative for all, we are to be condemned as being mad, perverse or biased if we are wrong. This is the kind of judgment we pass on critics of a previous day. Those men judged for us. If we find that they failed to see what is there to be seen, we rightly condemn them for having stepped out of place. We ourselves of course may be in error, and may in turn be subject to a later adverse judgment on the part of those who see better. These in turn may be in error, and so on through history. There may never come a time when all mankind will read poems properly. To suppose there must be such a time is to make the mistake that Marx, Peirce, Royce, and Dewey made when they turned the Hegelian philosophy into a naturalism, and supposed that ideal goals will inevitably be realized by men.

The poet wants to communicate, but he does not want to communicate what the mathematician, philosopher, or scientist does. These want to convey ideas, without loss or alteration, from mind to mind. Nor does a poet want to communicate in the way they do. They seek to communicate living ideas. Neither textbooks, nor technical articles communicate their truths; rather, they freeze those truths for us. Only when thawed out in a vital use are the ideas of mathematics, philosophy, or science communicated. But to adopt an idea is to transform it, to

* Philosophy, when pursued as a systematic, comprehensive, speculative discipline, does come to understand what existence is, and thus the nature of real time, space, and becoming. But its knowledge does not exhibit the texture of these, or grasp their emotional value. It serves only to mark out abstract cognizable features of them. These the poem must also exhibit, but it is not content with them. Because poetry gets closer to the being of time than philosophy can, it offers us a measure of a philosophic understanding of time in somewhat the way a religious experience measures the adequacy of a philosophic view of God.

make it part of oneself, below the level where public observation and interplay occur. Now this is just where poetry has its effect. The poem does in one step what other enterprises do in two ; its meanings are never stabilized somewhere between author and reader.

The poem can of course be dealt with in a two step way. We do have some understanding of the words the poem uses. Remaining with these we can identify a meaning which might be shared by a number of men. That meaning is somewhat imprecise, as is to be expected from terms employed in ordinary discourse and affairs. But a hard nucleus is recognizable, enabling one man to share his knowledge or opinion with another through its agency. The nucleus is charged with a power which words do not usually have in ordinary life. Without the help of the poem, it is impossible to take the second step and vivify the shared terms to the degree or in the manner which will do justice to the meaning of the poem. By stopping at the first step we lose the grain and vitality of the poem's time. In reading a poem, therefore, one ought never to do more than hesitate at the point where philosophy, mathematics or scientific communication is content to stop for a time. The entire force of the unity of the poem must be put behind the words at which one hesitates, thereby giving their meanings a transforming, dynamic context.

The discovery that people differ widely in their interpretation of poetry, as they do in their interpretation of other arts, is a testimony to the fact that they either have not read properly, or that when asked to report what it is they have learned they turn into termini the terms at which they hesitated. We can repeat what a science has learned because its communication stops at just that point, leaving to the individual to decide for himself just how to make that knowledge his own. But we cannot repeat what the poetry has conveyed, except by exteriorizing ourselves, and then only in the guise of the language which the poetry originally provided.

One interpretation of a poem is not as good as another. One man may miss what another sees. We do not check the adequacy of men's understanding of the poem, as we do in mathematics, by making them draw consequences and seeing whether they come out with the results which a trained student does. We check their paraphrases, and how

they read the poem, with what a trained student of poetry says about it and by the way he reads the poem. The meaning of a bit of mathematics, also, is given by the consequences, whereas the meaning of a poem is given by going through the poem itself.

Just as one can teach a man to infer better, so one can teach a man to read better. He who did not see how "Plato," "plays" and "Aristotle" affect one another in Yeats' stanza can be taught to see that. Yet there comes a point beyond which some men's intelligence, sensitivity, energy, or interest does not go. Those who move beyond that point do not move into some esoteric realm, but into one in which a limited number of men persist in using the same procedures that had been used by a larger group for shorter spans.

The interest expressed by some critics in communicating a poet's intent is often based on a double misconception. They suppose that the poet had a definite intent and that the poem's meaning can be repeated in other words. But the poem contains more than the poet intended, and it conveys this directly and more or less completely to the reader who reads it as a poem. The more we attend to a poem and the more we learn from it about the structure, the rhythm, the texture, and the import of time, the more we know either that the poem is superior to other poems which yield less, or that we have a capacity to extract from it what others do not, but which they may perhaps extract from other poems. We can show why Milton is a greater poet than Poe; we can convey to students something of the way to read both so that the difference is quite clear. But we cannot surely say that Milton wrote better poetry than Wordsworth or Yeats; there is an infinitude to be extracted from each, and none of us has gone so far in the understanding of any one of them to be sure that the others have been left forever, and in every way, behind.

There are no terms peculiarly suitable to a poem. On the other hand, there is no doubt but that the words in a poem affect one another. Each operates in the domain of others. This is, of course, also true of the terms we use in daily life. These have at least an occasional effect on one another. It is hard to remain concentrated in one area, to exclude all associations, to keep a language pure, free from all admixture. It is perhaps impossible. Almost every term in living discourse and in

poetry is in effect a metaphor. Strictly speaking, a metaphor is an expression where words, known to have a preferential or primary use in one context, are explicitly employed in another.* Read as though the words had literal application in that other context, the metaphor conveys a falsehood.

What alliteration and rhyme do for words somewhat separated, metaphor does in one place; it associates meanings and emotions which otherwise would not have been related. Metaphor, too, breaks through different segments of discourse and interest, normally kept separate, thereby enabling one to present truths not readily within normal reach. For these reasons, metaphors are favorite devices of poets. But no poet need make use of them; metaphors are not essential to poetry. Indeed, no particular words or combinations of words, no ways of manipulating or using them are. But since metaphors are constantly in use in poetry, their nature ought to be discussed.

An old metaphor, and an easy one, will help make evident the nature of all. "Richard, the lion-hearted" was, of course, not at all lion-hearted. He could not have had the heart of a lion without being a lion. But then, if he were a lion, it would not increase our knowledge much to say that he had a lion's heart. By means of the metaphor we want to say that Richard is brave, but also something more. The metaphor enables us to express two truths at the same time, starting from opposite sides: "Were Richard an animal he would be a lion," and "Were a lion human it would be a Richard." The first says that Richard is courageous, the second that lions are rulers. It would not therefore be as good a metaphor to say of Richard that he was "tiger-hearted" or "elephant-hearted" no matter how courageous these were. We tend to say not "strong-hearted" or "lion" but "lion-hearted" to indicate the locus of

* It is sometimes supposed that metaphors have no place in science. Yet if assertion involves conviction (and thus emotion), scientific discourse, no less than the poetic, involves the use of metaphorical language. "Heavy" and "big" are ordinary terms achieving scientific import by the way in which they are related to other terms inside the world of science. They are metaphors no less than "lion-hearted" is. "Ion," "positron," "world-line," "light-wave" and the like are more than mere counters in an impersonal discourse. They not only refer to the objects of scientific expressions, but to the termini of scientific inquiry, where they function in ways not ascertainable by one who knows only the formal definitions. A common-sense term such as "heavy" is no more and no less a metaphor in a scientific vocabulary, than some such scientific term as "ion" is, in the living discourse of scientists.

what we want to use as a characterizing feature of Richard. "Lion-hearted" is ruling, brave strong-heartedness. Achilles too was brave. Yet if we called him "lion-hearted" we would isolate a different aspect of a lion from that which our present metaphor permits. Richard is a ruler who is brave, a brave man who is a ruler, but Achilles is a brave man who did not rule. If we called some king in ancient Egypt or Greece "lion-hearted" we would again make a different metaphor, for such kings are rulers and brave in a sense different from that in which Richard is. Their "lion-heartedness" might refer to their dominance over their households, their stentorian demands, their combativeness and the like; Richard's does not.

Since Richard is a king, he should be associated with other assertive rulers. Nor would it do to say of him that he was purple, though this a royal color, or that he is a rose or an orchid or a queen bee, though these do stand first in their own domains. We want to express Richard's bravery, and want to do this concretely, thereby making possible the ready grasp of its implications in fact. Our metaphor says that Richard's bravery is not merely an abstract or isolated bravery, but a bravery as concrete as that of a lion's, and like that bravery involved with persistence and strength. The metaphor is exhausted in "lion-hearted" and a limited number of affiliates: we do not usually care about the lion beyond its capacity to provide a locus for the character "bravery" and its associates, "persistence," "strength," and so on. The lion's other characteristics are ignored, though some of them may be essential to the very nature of a lion—e g , having been a cub, or being capable of mating only with another lion or tiger, and so on. Similar observations are, of course, to be made with reference to "heart."

The metaphor provides "Richard" and "lion-hearted" with new contexts. "Lion-hearted" tells us what Richard would be like were he in the animal kingdom; equally it tells us what the lion would be like were it human. It is then no compressed comparison or simile, but a "translation," with an indication of where it originates. The metaphor points beyond each to the reality they diversely express, articulating a power common to both, telling us that both have an intrinsic nature, a courageous kingliness, which is expressed and deserves to be expressed in a ruler. The emotion which Richard entrains is made to interplay

with what "lion-hearted" does, with the result that courageous kingliness acquires a new emotional value.

The metaphor says that Richard is courageous and lions are rulers; it also says something more by referring us to what is common to both Richard and lions, to what makes possible their status as rulers and their character as courageous. This is taken to underlie them both. The point can perhaps be made more evident by attending to the fact that an expression such as "Were Richard an animal he would be a lion" is a conditional contrary-to-fact. Such conditionals explicate, mark out the outlines of a potentiality, the core of a substance: "Were I king I would set all prisoners free," is intended to remark on my generosity or wisdom. It talks about me and about me now; it tells about a capacity I have, but which I cannot or do not now use. "Were Richard an animal he would be a lion," tells us that Richard is natively courageous, a natural ruler; "Were a lion human it would be a Richard" tells us that a lion has the right to rule. The two together then tell us that Richard and lions are rulers by nature in the double sense of having a native gift to rule and a native right to rule. They are substantial beings possessed of gifts and rights, who deserve to rule because of the rights and who now rule because of the gifts.

A metaphor can serve as a theme; so can a word, a phrase, a line and even phoneme. It would be best if the theme were suddenly illuminating or obtrusive, with a grain that distinguishes it from a grain characteristic of ordinary words. Molded by the needs of the entire poem, spaced by other themes, syncategorematic terms, punctuation, and metre, developed in idea or form over the entire work, the theme has a place where it stands out most conspicuously, a climactic position towards and from which the other usages and variations can be said to lead and proceed. There is never, though, even in the simplest poem, just a single theme. Every poem exhibits themes of many different types, all of which should be in harmony, to constitute a structurally complex whole.

The brevity of even the longest poem forces the poet to omit far more than the storyteller can allow. But the metaphorical and intensive use of the poet's words enable him to retain what he had omitted, though in an adumbrated, not in an explicit form. Every facet of the poem—

rhyme, and metre, paradox, alliteration, etc.—plays a role to constitute a unity in which all are together in new, created, unduplicable ways. These characterizations of the essential properties of poems, as was the case in connection with the works of other arts, refer to an ideal work. One poem may exhibit some features of the ideal superlatively, another poem may favor a different set. Sooner or later the poet must force a closure, end work on the poem before the poem has been perfectly made. All the while he will be guided by the prospect of a perfect reader who will measure the success the poet has had in making an idea permeate the poem.

The poet stands out for all as the superlative maker, a true artist who strains to make a work of art and nothing more. He is not alone. There are composers and painters, some sculptors and actors, an architect or two, many dancers, singers and conductors who also passionately seek to produce works of art. But poets appear to be more numerous. Since the poet's language seems to have an apparent immediate relation to what we do every day, and surmise in between times, it is inevitable that the poet should stand out in history and in education as one who can lead us quickly into the world of art. But like every other art, poetry most inspires and enriches, if taken to be an art and nothing more. We lose the value of poetry and the value it has for us if we refuse to accept it on its own terms, and thus if we forget that the time of the poem is real time verbally displayed.

10. MUSIC

EXISTING space is diversely intensified in individuals; existing time is pulverized by them; energy is channelized through them. Existing space, and the individuals said to be in it, differ in degree. Existing time, and the private times into which it is subdivided by individuals, differ as a one and a many. Existing energy, and the individuals who transmit it, differ as principals and agents. The individuals in all three cases have beings of their own. Each is an independent reality, an irreducible substance which publicly interplays with others. Each partly exhibits what it is by the way it intensifies existing space, individuates existing time, and transforms existing energy. Living beings more distinctly qualify these different dimensions of existence than nonliving things do, and men do it better than other living beings can.

Artists stand out among men by their conspicuous individual expressions of the existence which is within them. Their creations are the outcome of acts that make the existence in them take the form of spaces, times, and energies representing the whole of the existence outside them. Since all of us are artists more or less for rather short and separated periods, all of us are fleetingly aware of the reality which underlies and partly controls the destiny of the things which make up the spatio-temporal-dynamic world.

Daily space is an emptiness dotted with palpable objects. In the course of the creation of a new space, architecture scales the daily space, sculpture occupies it, and painting transcends it. The resultant created spaces have their own geometries and exhibit the texture and significance of the existing space that underlies daily space. That existing space can be fully enjoyed only by participants in the spatial arts.

Daily time is a product of the multiple adjustments of individual times to one another. The temporal arts select and refine one or more of these products. Musical compositions structure an emotional juncture

of individual times. Stories provide a punctuating linguistic form for an emotionally constituted time, not altogether separated from clock-like, narrative, and reconstructed times. Poems fill out a similar complex common time with words, understood and heard. Each of these arts creates a new time having a distinctive pace and distinctive units. That time exhibits the texture and significance of the existing time which underlies daily time. That existing time can be fully enjoyed only by participants in the temporal arts.

The dynamics of the world of common sense is a miscellany of centres of force. These centres express the power of existence itself. The dynamic arts create new forces representing that existing power. Music creates an assertive force, insisting on itself everywhere; the theatre creates a maturating force which comes to expression in a series of interlocked moments, incidents, and characters; the dance creates a self-maintaining force, revealed in a set of transitory movements and rests. Each of the created forces has a characteristic career, and exhibits the texture and significance of the power of existence. This power is single, controlling, expansive, effective, and cosmic; it can be fully enjoyed only by participants in the dynamic arts.

Most of us are more appreciative of the dynamic arts than we are of the spatial or the temporal arts. Created ongoings are apparently more readily participated in than are created spaces and times. Music, theatre, and dance seem to have a great immediate appeal, and at the same time are accepted as nothing more than arts. All of us have a genuine interest in drama, quickly catch the spirit of a genuine dance, and feel the power of music. All of us seem to know quite early that these arts are to be enjoyed for themselves, and all of us seem able to discern what it is that they portray.

Techniques, discipline, and a willingness to attend and study may lead to joy and insight, but they sometimes make the achievement of an art improbable. The intrusion of critical canons, the great innovations which have caught men by surprise, and the teaching, particularly the teaching of accepted techniques, have produced men who have less joy and insight in these arts than others have. The ordinary man is not subtle; he readily accepts shoddy substitutes; he is inattentive, missing exciting variations; he makes judgments which are sentimental

and prejudiced. But he is ready to enjoy what is vital, particularly if it is able to reach to him and pull him along.

The innocence of ordinary men is precious. Training and study, attention and devotion ought not to be allowed to extinguish it. They should instead serve to protect it from corruption and to make it quicken an interest in the subleties which the arts in fact contain. To-day all men have an opportunity, as they never had before, to make good music part of their lives and thereby master existence in a most relevant vital form. I refer not merely to the availability of records of high fidelity, but to the fact that great composers like Stravinsky seem as readily appreciated by men with little as well as by men with a great deal of musical knowledge and experience. He has provided scores for conductors who have then produced a music so different from the music of the past as to permit newcomers to stand somewhere near the others in a common listener's space. This is a great epoch for any man who would like to enter quickly and to live for a while in the world of music.

Music, perhaps alone of all the arts, both makes a great immediate appeal to unsophisticated men, and gains in worth the more technically proficient and knowledgeable one is. This does not make music an art greater than any other; it merely underscores one of its peculiar features—the ready appeal most of its works make both to cultivated and uncultivated tastes. Music is on a footing with all the other major arts. Like them, it produces a substance which stands over against all others. Its work is as excellent and as revelatory as theirs. They do not aspire to be like it, any more than it aspires to be like them.

Music is the art of creating a structured audible becoming. It is to be contrasted with musicry, the art of structuring an emotionally sustained common time, usually in the guise of musical compositions. Musicry contains no sounds. But when one speaks of music, a reference to sounds is inescapable. Where music takes account of musicry, it treats it as a script. The musical composition is not then filled in by the music, put in a form which will enable others to share in it, but is made subservient to the requirements of the music.

Music involves problems, techniques, values, and outcomes not characteristic of musicry. It is futile therefore to ask a performer to be

faithful to a composition. Were he really faithful, he would have nothing to play. Not only does no composition contain sounds, but none even tells just how loud or soft, just how long or short, just how interlocked or separated the sounds must be. "If one just plays the music as it is written," said Wu Ch'en, "one will not be able to express the sentiments of the composer." A work of musicry guides, directs, instructs, illuminates, but in the end gives way before the music which is performed.

Musicry deals solely with time. Space is utilized in its scores, but this is as irrelevant to the composition as the space over which a minute hand moves is to the time that hand is intended to punctuate. Music occupies a volume; it is spatial as well as temporal. But it is more as well. It is expansive, insistent, a sheer becoming in the shape of sound, produced by man and answering to a primitive aboriginal striving force effective everywhere. Not as noiseless as Schopenhauer's will, better structured than Bergson's *élan vital*, more complex than Whitehead's causal efficacy, it relates musician and listener, carving out its own place where it can be enjoyed.

Music is a controlled audible force creatively produced. It may make use of sounds produced by various daily objects; it may also use sounds which are produced by acting on various instruments; and it may use sounds produced by man. Sounds are peculiarly suited to convey the dynamics of existence because they are at once *detachable, voluminous, insistent, directional, self-identical, interpenetrative,* and *interrelatable.*

DETACHABILITY: The tones of a work of music are distinct from any heard outside, even when produced in the same way. If one introduced a street sound into a musical piece, one would radically transform that sound. It has been said that Beethoven's *Pastoral Symphony* imitates the songs of birds, his *Battle Symphony*, the sound of cannon. Mendelssohn's *Overture to a Midsummer's Night's Dream* is said to include in it the braying of an ass. We are told that the bleating of lambs can be heard in Richard Strauss's *Don Quixote*. There are pieces which in their titles seem to proclaim that they will reproduce the humming of bees, the sounds of waves, the tumult of the circus, and so on. And today we can tape the sounds of winds, automobiles, and market, and make

the tape part of a work of music. We can produce sounds by means of machines; we can select out of a large collection of noises bits to be spliced and rearranged. These facts do not change, but rather emphasize the truth that sounds in music are different from what they are apart from it. Even when it is the case that sound for sound the two could not be told apart, a sound in music is other than a sound outside. It has different affiliations, different functions, and reveals a different side of reality. We blur this truth when we remark that the music must have a certain quality if it is to serve in a funeral, a march, a modern dance, and so on, for we then suppose that the music is adjectival to a world outside. The distinctive nature which a piece of music has might promote some extraneous purpose, but this fact would tell us nothing about the music as a work of art. When music is made to function as part of a nonartistic whole, or is a part of some other art, it is no longer treated as a distinctive art, but as a piece of craftsmanship, or as a constituent of a larger art in which its nature is transformed.

Colors, touches, and tastes, like the sounds we hear, are detachable from the daily world. Smells, in contrast, seem to be nondetachable. We do, to be sure, encounter smells as at once external to us and apart from any object. But they decorate the spatial region relating us and other things. No art of smells will be possible until one is able to hold them off over against the spatial region they normally qualify, and then is able to create and interrelate them to constitute a self-sufficient substance.

Tastes, sounds and colors are detachable not only from the daily world, but from the things encountered there. Tastes, though, are not separable from things altogether. We enjoy tastes within ourselves, but as adjectival to some object or other. They terminate in qualities adhering to objects within us, as surely as touch terminates in qualities adhering to objects outside us.

Sounds and colors are peculiar in being detachable both from the world of everyday and from all objects, internal or external. Sounds, to be sure, decorate a region between us and their point of origin. But they can be separated from this region. When so separated, they, together with newly created sounds, become inseparable from a new region then and there created. Colors, too, are inseparable from a

region they help constitute. But both old and new colors are carried by such palpable things as paints and canvas. The sounds and colors used in the arts, thus, while detachable from the external world and all objects, internal or external, are detachable in different ways. The sounds are carried entirely by the new extended region they help create, while the colors are carried not only by the space they help create, but by paints and canvas as well. Since one can attend to the colors of a painting only if one ignores the carrying paints and canvas, one enters the world of painting only after taking two steps; only a single step is needed to take us into the world of music.

Sound and color differ in another important respect. The one is located, the other is not. "I encounter the color as something that is *without*," writes Zuckerkandl, "the tone as something that *comes from without*." Sounds move to and around the listener; he is at its center, no matter where he sits. They are detachable not only from the external world, or from things, but from particular places. The only relevant "wheres" for a work of music are those which it itself provides. Sounds are free as no other qualities are.

VOLUMINOSITY: A sound, in and outside music, is voluminous in and of itself. Its range and limits are not ascertainable in any other way than by being lived through. Colors are voluminous too, but only as carried by things or when creatively used by a painter. The voluminosity they possess in a painting is a new feature of them; but sounds are voluminous apart from the musician, though through his efforts they become voluminous in a new way.

We speak sometimes as though an orchestra was producing music at a distance and we were passively waiting for it to reach us. But what we do then is to allow a theory of acoustics to interfere with what we actually experience. The orchestra does produce music, but the music does not exist except so far as the sounds actually transform the concert hall into a substantial dynamic sounding whole, encompassing us and orchestra. We have to wait until this happens, but this means only that there is a time lapse between what must be done by musicians and the enjoyed work of art they make possible. Zukerkandl writes, "No tone occupies more space than any other tone; every tone occupies the same space, i.e., all space. It is true that high tones sound *narrower*

than deep tones; shall we say that space as a whole contracts in high tones, expands in low tones? But then, on the other hand, high tones seem to come from far away, low tones from nearer, so that one might speak of a greater transparency, rarefaction of space, in high than in low tones." ". . . space is differently alive in high and low tones . . . these different modes of spatial aliveness are related to the spatial qualities 'above' and 'below.' " By "space" Zuckerkandl seems to be referring to a forceful voluminosity of which both space and time are but facets; what he says is therefore most pertinent. He makes evident that the pitches not only stand in relationship to one another as above and below, but that a pitch which is above comes from afar while the ones below move a somewhat shorter distance. Tones arrive from different places on different levels to make a volume in which different parts move at different rates and over different routes.

INSISTENCE: Smells are insistent, and so are sounds. Occasionally our vision and touch—more rarely our tastes—are insistently intruded on. But it is smells and sounds that make irresistible demands. They force us to submit to them. Smells, though, are rather atomic; they do not refer to one another. Sounds insist not only on their own natures but form links, determining our expectancies. They make patterns which we are compelled to follow. They insist on making us pursue a logic which they themselves constitute. In accepting a sound as part of music, the listener expectantly rushes beyond it to the place where another allowable subsequent tone is to occur. His expectation grounds the tolerance he shows towards what might be allowed to be subsequent in that particular work.

DIRECTIONALITY: Zuckerkandl remarks: ". . . the ear knows space only as that which *comes from* without, as that which is directed toward me, streams toward me, and into me, as that which is given in no other way than as a boundless indivisible oneness, in which nothing can be divided and nothing measured—as placeless flowing space." And so far as it is one, in it "there is no distinction of high and low; all tones are heard as coming from the same place, from all places, from everywhere." This last assertion is not incompatible with the assertion that different pitches come from different distances, for each occupies the

whole volume, but with a centre of gravity at a distinctive place within this.

A tone, in short, has an inherent directionality. It is not merely that from which or towards which one has moved; a tone in and by itself actually moves away and towards. It does more: it moves above and below, forward and backward by itself, apart from the efforts of the listener to attend to it and its accompaniments. A single tone is always first heard as moving on, away from and towards because it has a life of its own, with vectors radiating out in all directions, over some of which it now is in fact moving.

If a tone remains constant it soon overruns the limits of its own vectors to become something not listened to but suffered. We then wait for it to stop. A tone must change within a certain period and in a certain direction, or we will find ourselves lagging behind, no longer having it as a heard tone. Accompanied by or followed by another tone its vector is challenged, intensified, altered, to help determine a vector for the pattern of the two tones. If the root of a chord is one which had a predecessor its vector is somewhat different from what it would have been had it been sounded alone; it is this fact which makes it impossible to determine in advance just what other tones a given tone does in fact allow. There is a vaguely defined gap between a given tone and what the listener thereupon expects. When his expectation reaches to the limit of the musical work, he bounds it. Since the satisfaction of his expectation usually grounds still another expectation, the boundary of his music is not only loose, but movable. A pattern of tones, as surely as a single tone, constitutes a distinctive directionality which is to be creatively pursued.

IDENTITY: Tones of the same pitch and timbre may differ in loudness. One can strike the piano key hard or gently. No one can ever really be told how hard he should hit, though indications can be given that at this place or that the tone should be loud or soft, or louder or softer. Nor is anyone ever really told what the duration of a tone should be, though the notes are written so as to indicate their comparative durations. A piece of music is a single continuous whole, but the notes, no matter how many written links there be put beneath them, are always

distinct. How soon a note should be sounded after some other is indicated in the metre. But only an amateur would look to the metre to tell him when to make a sound.

Each tone has an identity on which it insists. The same note struck by a piano and a violin have different timbres. One is round and soft, the other sharp and brittle. Though the composer, as he sits down to write, does not hear these, he does know what they are like and how they can support and conflict with one another. He has to pitch them differently at times to make them work best in harmony.

A chord is a unified combination of tones. Single and undivided, it fills the whole audible world within a loosely fitting frame. Each of its tones maintains itself concurrently with the others. Each has its appropriate individual volume, a distinctive height, and a tensional relation to others. Each also has a depth; each tone moves at its own pace and over its own characteristic distance to make the chord a set of layers in which narrower and broader movements from different distances occur.

INTERPENETRATION: Though each tone maintains its integrity, all occupy the same place. A color has no similar tolerance for other colors. If we had a bit of red in a spot we could not put green there too, except by radically altering one or both of the colors. There can be no blue or green in its own right where red is, though, to be sure, a neighboring green may bleed into the red, or the red may be one through which a green might peer. But a tone tolerates the presence of other tones when and where it is. Though each is voluminous and self-identical, though each intensifies and is intensified, opposed by and opposes others, each still allows room for all the rest.

Music embraces a plurality of volumes all in the same place. When and as the tones maintain themselves they act on one another, and when they do they produce a new unity differing in color, and sometimes in volume. By filling up the volumes of one another they make a single volume, having its own timbre, pitch, and loudness. There is cacophony, noise, when the interpenetration goes too far, or when the volumes are not in consonance. Though there are well-known combinations of sounds which have been found to support one another, as e.g., the root and third of a common chord, there are perhaps none which do so in every

context. And there are perhaps no combinations of tones which clash in every context.

INTERRELATION: Susanne Langer has justly remarked that few of us have difficulty in distinguishing the pitches, timbres, durations, and loudness of the tones we hear. Difficulty arises only when it comes to tracing out the repercussions which they have on one another, in grasping the relations and tensions between them, and in appreciating the nature of the whole they constitute. It is not desirable that the several tones be distinguished; it is not even necessary to see how they affect one another. What is necessary is that the resultant of their interplay be lived with.

In music various voluminous tones are interrelated. This demands that an account be taken of pitches, the heights at which the tones occur. It is to be noted that while we can by a deliberate and mechanical manipulation of the rate (or amplitude or complexity) of vibrations produce sounds of a definite, predictable pitch (or loudness or timbre), this fact is irrelevant to the nature of the music that is heard. It is interesting, though, that while our musical notation seems somewhat arbitrary and is the product of unreasoned accretions over the years, it expresses quite well the vertical relation that pitches have to one another. The musical scale shows where different pitches are to be placed. That pitch which is taken as the key marks the point from which one moves and to which one returns, defining all the other pitches as pitches which both move towards and from the key.

Every art, of course, presents items in interrelation. But only in music do the interrelated items have a palpable insistent value to which we ought to attend. Each tone allows itself to be experienced, even though its primary role is to be caught within a single continuum of substantial sound. One can, of course, attend to the walls of a building, note this or that feature or interval in a sculpture, remark on particular colors or designs in a painting; one can pay attention to the notes in a musical composition, particular incidents in a story, or certain combinations of words in poetry; one might be absorbed in a dramatic occurrence or in a single dance movement. These items are parts of works of art only so far as they are interrelated with others inside the works; to isolate the items is to dislocate them from their proper set-

tings. The qualities they have as distinct items are often subdued in the course of that interrelating. The tones of a piece of music also are interrelated items. But each tone has its distinctive pitch and timbre which is usually reinforced rather than subdued by other tones.

Different tones qualify the same area ; each maintains its own nature, indeed, insists upon it, at the very same time that it helps constitute a complex, qualified volume. Somewhat in the way in which architecture synthesizes common and created spaces to make a new architectural space, and story synthesizes common and created language to make a new language of story, music synthesizes a plurality of tones to make a single, dynamic, voluminous musical whole. But music does not, as these other arts do, combine what is created with what is not, for as was previously observed, even when music makes use of familiar sounds, it deals with them as part of a single creation in which they have roles similar to those exercised by freshly created tones.

The becoming that music creates, by taking account of the foregoing characteristics of sounds, moves in three ways simultaneously. The tones which occur together, as in a chord, interpenetrate at different rates and with different degrees of force to yield a process of becoming having multiple heights and depths. The tones which occur in sequence, as in a melody, move at different rates and overlap to some degree to yield a process of becoming which is restless, tensional, with innumerable endings and beginnings throughout. Both forms of becoming move towards the listener with an insistence and appeal which makes him subjugate his own process of vital becoming to that of music.

In arts other than music, the spectator's nature, interests, desires, and temperament contribute a great deal to the determination of what the appreciated result will be. Musical works, of course, also depend for their appreciation on the nature, training, concern and alertness of those who hear them. But music is able to overwhelm the listener and force him to follow its contours rather than his own ; in the other arts, the personal equation has a more conspicuous role.

The emotions which music provokes are, more than in any other art, a product of the operation of the art on the spectator. Because music subjugates the listener, the provoked emotional response is singularly relevant to it. In compensation, music often prompts the listener to

abandon his awareness of it for reveries and sentiments which, while paced by the music, have careers of their own ; when men deal with other types of art, largely because they must initially show a greater antecedent willingness to participate, they tend to stay with the works and follow the paths that can be discerned within them. But the difference between music and the other arts in this regard seems to be only one of degree.

Despite its insistence, each tone allows other tones to make their presence felt. Tones, despite their detachability from everything else, occupy an extended region ; despite their volumes, they do not displace any objects. Despite their directionalities, tones do not have a geometry ; despite their self-identities they interpenetrate ; despite their interpenetration, they do not necessarily give up anything of what they themselves are ; and despite their interrelationship, they have distinctive values of their own. To say that tones are insistent, detachable, voluminous, directional, self-identical, interpenetrative and interrelated is but to say that they are active forces, together constituting a new world.

Music offers us a substantial, vibrant volume through which we can live. In it we experience a forward thrust guiding an expectation of what is to come. We also experience a backward thrust through which every part is reassessed as more or less important for the whole ; a structure, a patterning, a rule of causality which governs the relation of part to part ; and an eventfulness, a sheer ongoing, a freedom, a coming to be, cut off from all else. The past is operative in it now, moving through it as a cause ; the future is operative in it now, moving through it as a plan ; a pattern is operative in it now, moving through it as a divider ; the present is operative in it now, a finite stretch internally defined. In music part is related to part by a freely exercised, structurally confined, persistently assessed causality which relates distant as well as nearby parts. Making use of the rhythms, myths, and measures that musicry might exhibit, repeating musicry's bleeding, modulating and the rest, it differs from musicry by virtue of its sound. That sound has a vitality and a texture which answers to a phase of existence beyond the capacity of anything not heard. It exposes existence as a vital power, promising good or ill to man.

The substance that man creates in the guise of music is dynamic. Not only does it have formal properties of interest to science, sensible qualities evident to perception, values open to a sense of importance, and an event-like aspect, also it is a self-sufficient unity. The substance which is music is an irreducible becoming within which one can isolate structures, qualities, value alignments, and a sheer ongoing. When that music is accepted as self-sufficient, as something with which we can live for a while, it no longer has the role of a mere substance standing over against others, but becomes in addition a representative of the dynamics of existence.

The dynamic whole that is music is a substance produced when the musician creatively uses the existence within him to organize forceful sounds. These permeate the physical and spiritual distance between the musician and audience. Each of the sounds has a distinctive power. None is a part of a work of music until it has been creatively united to others by a musician, usually under the guidance of a musical composition. This creative union involves the use of energy ; it is produced by making use of one special form of the dynamics of existence.

Despite the fact that music constitutes a self-sufficient world, it does not preclude the presence of language or gesture. The language and gesture may, despite their occupancy of the same volume, be independent of it in structure and value. They are then, together with the music, components in a more complex art such as the opera or ballet. But they can be made to permeate and to be permeated by the music, as in Greek drama or as in the modern dance.

At first glance it seems odd that a solid work, with an insistent character such as music has, should allow a place for something as insistent as language. It would seem reasonable to say that the silences, but not the sounds of the music allow room for the words of a play. So far as the words spoken in a play are together with the sounds of music, they would seem to be absorbed and qualified by the music, or to be so over against the music as to require synthesis with it in some other art. One of these consequences would be inescapable if the play did not have a power of its own. Music can function as a background and guide for a play without absorbing or qualifying it. And since the silences in a musical piece are heavy, solid, no more and no less permeable or per-

meating than the tones, whatever room they leave for the play is left by the tones as well. One may, of course, be unable to hear the words because of the music. When this occurs, the music takes us away from the play in somewhat the same way that a thunderclap or an outside disturbance might.

Music is a distinct art, forcefully occupying a volume, and forcefully making men attend to it. Other occupants within the volume which it forcefully occupies are either correlatives of it, as in opera; are subordinate to it, as in song; subordinate it, as do plays having a musical accompaniment; or are intertwined with it, as in Greek drama. Like architecture which makes room for sculpture, and musical composition which creates a time within which stories and poetry can occur, music fills up a volume in which there can be room for both plays and dance. Indeed, if account be taken merely of its rhythms, and its mastery of volumes, one can say of it that it provides the necessary field in which both drama and dance occur.

II. THE THEATRE

A THEATRE is a building in which plays are performed. *The* theatre is a world of theatrical performances. Directors and actors speak of themselves as "in the theatre" even when they are out of work; their minds, their interests, and their lives gravitate about performances. They know that they are part of the theatre even though they are not then and there actively participating in it. When stage hands speak of "the theatre" they refer to the building in which they work. Directors and actors also speak in the same way occasionally; they may ask one to meet them at the theatre or after it. Ordinary men use the term "the theatre" a little more consistently, since they less often use it to refer to a theatre. When they say they are going to the theatre, they usually mean that they are going to see a performed play, in which for a while they intend to lose themselves. But ordinary men do not see so clearly what it is like to be *in* the theatre. If they did, they would be more punctual and appreciative, and less noisy when they enter into a theatre to be part, for a while, of the theatre.

The theatre never takes place in a theatre. It is only placed there, publicly located there, so that one can approach it, know where and when it is that one must change one's status from that of a common-sense man to that of a member of an audience. The theatre is a realm of performed plays; it is a dynamic world, audible, affective, revelatory. There is no physical relation, no geometrical connection between its space and the space of a theatre. To go from one to the other one must change one's attitude, not one's position.

The space, time, and movements of the theatre are produced through the interplay of script, actors, and audience. It is a newly created, a well-bounded substantial world, exhibiting the kind of vigor, crosscurrents, urgency, and ongoing which is characteristic of ex-

istence in its deepest recesses. It has more stable and familiar points, as well as a sharper climactic focus than music; it allows the makers of it, as dancing does not, to hold themselves apart from it while they are in it, and thus allows them to see just what it is they are producing.

A single theatrical performance is an instance, and can be taken as representative of, the theatre. I shall refer to it indifferently as a performance, a play, or the theatre. Both historically and analytically it presupposes music, occurring as it does inside that forceful, voluminous, ongoing substance, reaching to and engulfing the listener, which was won for us by music. To enter the theatre, we must not only go to a theatre, and then ignore it, but must accept the dimensions of a world produced by music. Music provides the dynamic area which a play fills out. Even where there is no musical accompaniment, the theatre utilizes an area that music provides. It is music that has taught men to be appreciative of certain rhythms, to be alert to certain myths, to be aware of the nature of existence, its power, texture, and import for man. Not all music, of course, provides the proper volume for the theatre. The music may be too intrusive. At the dawn of the theatre, music (which was then not separated from the dance) forged a reality which was punctuated by the characters and the plot that the theatre provided. Today occasional use is made of musical accompaniments, particularly in connection with poetic plays and musical comedies. But in the former the music, and in the latter the acting, are not really integral, as they apparently were in the days of the Greeks.

The theatre subdivides the world of music at the same time that it reverses the direction which music takes towards the listener. The music exists for the listener, reaching to him from a distance. He awaits it, is engulfed by it, is carried by it. He may be and ought to be lost in it, but only as that which comes to him from a distance. The theatre, in contrast, does not reach out to the spectator. He must move into it. It exists only for a man who has abrogated the distance from seat to performance. It makes no difference to his role as spectator whether he sits in the second balcony or on the stage, for he sees a performance only so far as he has gone to it. Both music and the theatre require

the spectator to give himself to it, the one where he is, the other where it is. It is a mistake to suppose then that there is a fourth wall through which a spectator looks. He is that fourth wall, and not until he appears is there a performance.

As a rule, a performance makes use of a written play. The play that is performed is not that written play. The written play is just a script, a story which, though constituting substantial time, lacks the force and the body of a substantial becoming. There are great stories which do not make good theatre. It is doubtful that the Crucifixion could be given a successful theatrical rendering; its story is overwhelmingly impressive without further dramatization. Also, a good story might be badly acted; it would then be poor theatre in fact, though perhaps not in principle. High school students make bad theatre out of good Shakespearean plays. On the other hand, good theatre might be provided for a mediocre play. Thornton Wilder's revised *Matchmaker* is a trivial play; acted by Ruth Gordon it became great theatre. MacLeish's *J. B.* offers a fair script, made by an outstanding director into a passable play. Indeed, if MacLeish had prepared a better script it might not have been actable. Poets, as a matter of fact, rarely succeed in the theatre; they not only fail to know what action is like, but they overcharge their words with overtones which prelude their effective use in dramatic interchange. Goethe, Shelley, Browning, Eliot all tried to write for the theatre, but all failed quite badly. There are, of course, exceptions. Shakespeare fills his usual role of defying all generalizations. The Greek dramatists and Schiller are also exceptions. But the assertion, I think, remains true on the whole.

A play can be dealt with in at least two distinct ways. Treated as a story it is to be read in one voice and manner; performed in the theatre it demands another voice and manner. Each yields a complete work of art. The one cannot be understood without an environment; the other cannot be produced without actor and audience. An environment, given by the usual values of words and statements, is one through which a reader can approach a story; an audience is already at the play. As a fourth wall, it keeps in dynamic accord with what takes place. Clayton Hamilton, I think, points to the same con-

clusion when he says, "Every play is a dramatization of a story which covers a larger canvas than the play itself."

Reading a story aloud makes no appreciable difference to it; the reading is but the re-presentation of the story. An ordinary audible reading differs from a silent one somewhat as a reading with glasses differs from a reading without glasses, or an audible reading in which a good deal of attention is given to enunciation differs from one where there is little. One may, of course, give a story a dramatic reading, but then one will treat it as a script for a performance. Like any other type of theatrical performance, the dramatic reading will add new content to the script. It will treat the script as a guide or outline to be filled out creatively by transitional situations, directive gestures, and interacting people.

The playwright tells a story, giving major places where vivification and thereby alteration can take place; the director looks at the play as a whole, seeing how the different parts should fit together and how they will affect the audience. "After the speech has been understood and the feelings to which it corresponds conceived by the actor," says H. C. F. Jenkins, "comes a task of ineffable difficulty—that of finding tones, look, and action which shall represent these feelings. The author gives an outline, which the actor must fill up with color, light and shade, so as to show a concrete fact." It is the actor, as Jenkins sees, not the playwright and not the director who defines the essential difference between story and theatre.

A performance needs actors. Their task is a special one, quite distinct from that of the musical performer or the dancer. The musical performer stands outside his own music as a listener; he makes it have a being distinct from himself, though, to be sure, one which is to satisfy him as well as others. The dancer, in contrast, is in the dance. His every move is himself transformed; he becomes as pure an art object as a man can be. The actor stands in between these two. Like the musician he is not entirely caught inside what he produces; like the dancer he is nevertheless an integral part of the work he makes be. In his relation to other actors he is like the dancer; in his relation to the audience he is like the musician. He interplays with actors inside

the play, and makes himself one with the audience by assuming a position at the fourth wall from which he can look at what is happening inside.

The actor assumes a role. The statement takes us right into the heart of a controversy begun by Diderot and carried on to this day. Diderot held that the actor, even in the most passionate of roles, must remain calm and detached; Stanislavsky has been interpreted as holding the opposite thesis and maintaining that the actor must become identical with the being he portrays. I do not think that Stanislavsky has been correctly interpreted, but his disciples do seem to speak at times as though this were his view.

The brilliant Coquelin seems to be on Diderot's side. ". . . one can only be a great actor on condition of a complete self-mastery and an ability to express feelings which are not experienced, which may never be experienced, which from the very nature of things never can be experienced." "The actor is within his creation . . . makes up his personage . . . borrows from his author . . . from a stage tradition . . . from nature . . . in short he sets himself a task. His task once set, he has his part . . . it does not belong to him, but he inhabits its body, is fairly it." ". . . the true actor is always ready for action. He can take up his part, no matter when. . . . He need not wait until he experiences these emotions himself . . ." Indeed, when the actor Talma "learned of the death of his father, he uttered a piercing cry; so piercing, so heart-felt that the artist, always on the alert in the man, instantly took note of it, and decided to make use of it upon the stage, later on." Yet Coquelin has also said that "the actor is his own material. To exhibit a thought, an image, a human portrait, he works upon himself. He is his own piano, he strikes his own strings, he molds himself like wet clay, he paints himself." And again, "The actor creates . . . there is always a considerable distance between the type dreamed of and the type actually living and breathing; because it is not enough to create a soul—a body must be provided for it as well."

The no less brilliant Stanislavsky says "an actor must put himself into the given circumstances. You must say to yourself, 'What would I do *if* what happens to this character, happened to me?' . . . Find

all the reasons and justifications for the character's actions, and then go on from there without thinking where your personal action ends and the character's begins. His actions and yours will fuse automatically if you have done the preceding work . . ." ". . . ideas, thoughts and events of the play must not only be perfectly understood by the actor but also filled with emotional content of definite power. I have been telling you all along that every feeling is the result of the actor's thoughts and actions in the given circumstances. . . . Stepanova [an actress] you must be terribly frightened when Famusov finds you with Molchalim in your room early in the morning." "The young actors are shy of *living* their roles on the stage."

I think there is no genuine disagreement between Diderot or Coquelin, on one side, and Stanislavsky, Lee Strasberg, or other practitioners of The Stanislavsky method, on the other. Stanislavsky is trying to get his young charges to act, to make them fill out their roles, to take these seriously as demanding all their attention, energy, and creative power. He knows as surely as Coquelin does that "the actor should remain a master of himself." He doesn't want an actor dressed like Othello to strangle another actor called Desdemona. He wants the actor to take the *role* of an Othello; he doesn't want him to *be* Othello. The actor is to use real passions to get himself involved, caught up in a character; he is not to allow himself to act as though *he* were a different man even when it is another real individual that he must try to present.

Let an actor be asked to say, "Please sit down." * This must be said in some tone or other, and accompanied perhaps by some gesture. It precedes or follows other statements. There is a situation in which it occurs and which it should serve to clarify, focus or further. It should contribute something to the development of the plot, to the drive towards the resolution of the tensions now present. Were the actors

* Early in my explorations into the nature of acting, I asked Janice Rule to teach me how to say, "Mrs. Gundelfinger, will you sit down?" I thought I had only to master a simple problem of enunciation. But she at once turned to me and asked, "Who is Mrs. Gundelfinger? Do you like her? Is she tired? Is it a warm day or a cold one? Do you want to make a long speech to her? Which chair should she sit on? etc., etc." I am grateful to her for my first significant insight into the complex nature of acting.

in real life to be in the situation expressed in the play, if they had gone through the situation which had preceded it, if they had to go through the situation which will follow it, and if they had the characters which they had already displayed, one actor would have to say to the other, "Please sit down" at that juncture, and he would have to say it in a certain way, showing that it had just the past it did, and that it is rightly followed by what comes after.

The actor's role is a conditional, stated categorically, interlocking with other similar conditionals which are provided by other roles and by the ways in which the roles interplay. This "*if* (. . . the magic *if*)" Stanislavsky called it. Like every conditional the role serves to articulate a state of affairs, a nature or a power, by showing how it is manifested in a plurality of ways or contexts. In ordinary life we sometimes name the state of affairs, nature or power, and then go on to show how it is to be explicated. "The man's dog" names a state of affairs which may or may not have any answering fact. To explicate this state of affairs, we assume a condition, say, "If he were to confront it," and then state the kind of consequents which would ensue on that condition if "the man's dog" named a state of affairs which answered to a fact. "If he were to confront it, it would wag its tail"; "if he were to confront it, he would see his name on its collar"; "if he were to confront it, it would lick his hand" in different ways explicate the supposed state of affairs "the man's dog." On that very same state of affairs, one could base another array of conditionals: "If he were to command it, it would obey him; if I were to hit it, it would bite me; if he were to hit it, it would cower; if the man and I were to part, it would follow him," etc. This array explicates the very same state of affairs, "the man's dog," as the previous array did, but each member of it relates a different condition to its appropriate distinctive consequent.

The full meaning of "the man's dog," as that which can be manifested in a plurality of particular situations, is given by the totality of possible conditions and their consequents. Since a dog is not only a being in and of itself but is also a specialized case of existence, each union of antecedent and consequent will explicate the nature of existence in a specialized form. The totality of all possible conditions

with their consequents evidently explicates the whole of manifestable existence. Whether or not the set of conditionals which serves to explicate "the man's dog" relates to an actual or imagined state of affairs, it always explicates part of the meaning of existence.

In a play and in a story, antecedents are presented and consequents drawn. Usually neither plays nor stories name the actual or imagined objects or situations which are to be explicated. They merely present us with the antecedents and consequents. In a narrative we usually assume that what these explicate is a familiar state of affairs. In a dialogue, we instead usually assume that what is to be explicated is a qualified form of a familiar state of affairs. If a narration and a dialogue are to explicate the same object or situation, they must then provide different consequents for the same antecedents.

A storyteller might say, "When the boy spoke to the dog, it bit him. When he patted the dog, it growled. When the man spoke to the dog, it wagged its tail. When he patted the dog, it licked his hand." His narration then explicates the fact that the dog belongs not to the boy but to the man. The combination of antecedents and consequents explicates not "the boy's dog," but "the man's dog." The first and second assertions tell us that the dog does not belong to the boy; the third and fourth tell us that the dog belongs to the man.

If the storyteller had presented a dialogue he would have sought to alter the normal supposition we make regarding what is explicated by a union of these antecedents, and consequents. As a rule, too, his antecedents would be expressed by one speaker, and its consequents exhibited in the form of some response by another:

"This is my dog."

"I see; why then, when you speak to it, does it bite you?"

"I tell you, it's my dog."

"I believe you; but tell me why does it growl when you pat it?"

This dialogue may lead one to suppose that the dog does not belong to the boy; but it allows one also to conclude that there might be something wrong with the boy or the dog. We cannot decide amongst these alternatives, except by continuing with our story.

A narration in a story, then, has a logic distinct from that of a

dialogue. A narration articulates something in each assertion, but a dialogue articulates something not yet focussed on. A narration in its subsequent assertions clarifies what had been initially isolated; a dialogue in its subsequent exchanges enables us to further demarcate an area which had been opened up in the initial exchanges. To write "This is the man's dog" in a narration is to assert something; to put it in a dialogue is to alert someone. In the narration I ask you to take for granted that the dog belongs to the man. In the dialogue I ask you to be aware of a state of affairs of which the dog may not even be a part. If the preceding dialogue were to end with "It is the man's dog" we would conclude that the boy is mistaken, confused, or lying.

A narration looks at a definite state of affairs from one position; a dialogue offers a number of positions by means of which we are enabled to make definite an indefinite state of affairs. A dialogue can, of course, be given a narrative guise; the narrative will then be multi-toned, presented in a plurality of styles. A narrative can be stated in a dialogue form; the dialogue will then be informative, didactic, presented from one point of view. The look of the page, punctuation, and similar devices never suffice to distinguish the two forms. Their distinction is a function of the knowledge as to whether or not one is assuming a fixed distance from a definite situation or object, or is taking up different positions demanding distinct antecedents at different distances from some gradually demarcated situation or object.

The logic of a play is distinct both from the logic of a narrative and the logic of a dialogue. Like a dialogue it offers multiple points of view, and often through the agencies of different verbal responses on the part of different men. But through gesture and act the play, like a narration, focusses immediately on a state of affairs. Like a narration, the play at each step deals with some definite topic; like a dialogue it moves on in order to determine that topic properly. The play, too, is concerned with explicating characters. It will not therefore leave open as many alternatives as a story's dialogue will, even apart from all gesture and incident. If the foregoing interchange were part of a theatrical performance, it would serve to make evident that the boy is so strange that his dog acts strangely towards

him. Where the given dialogue, when part of a story, explicates "not the boy's dog, or a peculiar boy, or a peculiar dog," the same dialogue in a play would explicate "a peculiar boy with his dog." We would not, in the play, question the boy's ownership of the dog, nor would we suppose that the dog was strange. Had the dialogue ended with "This is the man's dog," but been part of a play, we would have supposed that the boy was confused or that his interrogator was trying to confuse him. If it had been the playwright's intention to make one aware that the dog did not belong to the boy he would have offered a different dialogue:

> "This is my dog."
> "But Mr. Harris says it is his."
> "I tell you, it's my dog."
> "But don't you see, it has Mr. Harris' name on its collar."

If he had wanted to show that the boy was lying about a normal dog, the dialogue would have had to be quite different and perhaps more extended. It would have to follow given antecedents with those consequents which are relevant only if the boy is lying. The preceding dialogue, which already informs us that the dog does not belong to the boy could, for example, continue:

> "I put that collar on."
> "How could you get a collar with Mr. Harris' name on it?"
> "His name wasn't on it just a minute ago."

In another setting, say one of fantasy or mystery, some other supposition would be made; but in the ordinary presentation of such a dialogue on the stage, the supposition would be legitimate that the boy is lying. The rest of the play would tell us why, or would lead us to new situations in which his lying would prove to be a vital factor.

We seek to learn something about the boy and not about the dog. Consequently, when accepting the assertions as true we eliminate part of the indeterminateness which a story would allow. Had we sought to know something about the dog in a play, the interchange would have had to be different:

"This is my dog."
"I know; but it ought not to bite you when you speak to it."
"It's not really biting."
"But it does growl when you pat it."

This tells us that the dog is strange. The dialogue in the story, like an alternation of this interchange and the previous one, allows either the boy or the dog to be strange. But it also allows one to suppose that the dog does not belong to the boy. Either exchange in the play, in contrast, requires one to suppose that what is being explicated is that the dog belongs to the boy, the one exchange pointing up the strangeness of the boy and the other the strangeness of the dog.

A play discourses about some definite existence; a story allows one to explicate the existence of something or other. The difference is due to the fact that whereas the story progressively specifies a common time, the theatre is concerned, at every stage of its development, with portraying becoming, though only as this comes to expression through particular channels. From the very beginning of a theatrical performance there is an explication of the nature of characters, whereas in the story there is only a setting provided, out of which characters are eventually to emerge. The theatrical performance progresses towards an awareness of the existence with which story begins; the story progresses towards an awareness of the reality of individuals with which the theatrical performance begins. The progression in each case adds depth and richness to what is supposed in the other. If we are to know what man and existence both are, we must attend to stories as well as to plays. But only a few—a Shakespeare or a Molière—can write a dialogue which can be used both in a play and in a story, and in both places reveal what temporal dynamic existence and time-bound vital man are like.

In a play every one of the assertions in the initial dialogue could be known to be false, as is shown by the added observations:

"This is my dog." [It is not; it belongs to the management.]
"I see." [He really doesn't see, as his sneer and shrug show.]
"Why then does it bite you?" [It doesn't bite him; if it did he would sue the management.]

"I tell you, it's my dog." [It is not his dog, nor does he think it is.]

"I believe you." [The look of incredulity which accompanies his remark makes evident that he does not believe him.]

"But tell me why does it growl when you pat it?" [It doesn't really growl; some stage hand is making the noise; the dog is too unreliable to use for this purpose.]

This combination of assertions and bracketed remarks does not occur in the play. Except where they serve to indicate gestures and tones for actors, the remarks are not relevant to the play at all. They can be made part of a story, though, telling us about existence as at once utilizable in a play and as occurring outside it. Brought inside the play, in the form of asides, they help constitute a humorous play about a deluded boy.

In a story one could endow the dog with the powers of speech, make it into something like a man; or more subtly, it could be kept from speaking and have its nature explicated by a narration of incidents. In either way it could become a central figure. This it can also become in the play. What it cannot do there is to assume a role. The dog is nothing but a prop. In response to applause it may become exhilarated, but its response is still only a response to praise and not, as the actor's is, to appreciation. It can be made to walk like a man, to run through someone's legs, to retrieve on cue, to blow on an instrument, and the rest. It will then do a job. And it may do this splendidly. But its job will be only that of enabling a play to be acted. Made into a central figure in the play, it would demand a change in dialogue, gestures, and movements on the part of the actors; but no matter what it or they did, it would still be only a prop. This too is the function which a child actor performs even when it has a rather large part.

Strictly speaking, actors engaged in our little dialogue would not yet be in a play, even a minuscule one. A play explicates *all* the characters, but our initial interchange tells us nothing about the narrator. Each character in the play should be revealed, the narrator as well as the boy, by what is said, done and undergone. Each, through his interplay with the others, should reveal something about those others.

All of them together should explicate something not to be found in any of them. The entire play offers one single explication, and the characters in it are focal points, sources, and termini of what happens there, whose explication should be incidental to the one explication of the play. "Constantly check all the actions, thoughts, and feelings of your actors," said Stanislavsky, "with their over-all problem—the idea of the play."

A play contains no hidden, no unexplored powers or natures. It is just what it appears to be. We do not look outside it; we give ourselves up to it. We do not contrast its assertions with those made about the everyday world of fact. We know it is not the world of everyday, but we also know it is no fiction, no semblance, no mere make-believe. We are affected by it, cheered or sobered by it. We learn much from it. Just attending to semblances or fictions would not have this effect. We do know that the play is not fact; we do know that the actors have assumed roles; we do know that some of the things they say or do may not be possible elsewhere. Yet, for all that we may come to know that this or that play is truthful, discerning through its aid the nature of existence in its bearing on men's lives.

A play exhibits existence as that which is being manifested through diverse but concordant and supportive characters, actions, and incidents. By holding the play off from the world about and living through it for a time as self-sufficing, we are enabled to grasp existence as a humanly pertinent, vital becoming. The meaning of this existence is given by the entire play; its texture is exhibited by the plot, the props, the actors—and the audience.

The audience is essential to a play. "The word 'play,'" said Sarcey, "carries with it the idea of an audience." To this one can add William Gillette's observation that "a play is worthless that is unable to provide itself with people to play *to*." These remarks could be interpreted as supporting Molière's "There is no other rule of the theatre than that of pleasing the public." If this means that one must attend to the demands or tastes of an audience, and must change the story or the mode of acting to suit them in the face even of the requirements of the play, it surely is mistaken. Presumably, Molière intended to stress the fact that a play is addressed to an audience. That audience may

consist of only one man, who then, as Sarcey remarked, represents the multitude.

The audience does not act in the play, it does not help explicate any character or the existence which is being manifested through the characters and the plot. (When an actor addresses an audience, with an aside or even when he sits with it, he is still apart from it. He is in the play addressing or joining, not that particular audience, but a play-audience, conceived of as looking at the rest of the play.) There can of course be an audience participation, but this turns the spectators either into props, or into actors who in turn need an audience of their own. The audience, though, helps constitute the play, changing the quality of the play on different days. The actors, because they confront different audiences, consequently learn over the course of a run something about the complexity of the texture of existence which they otherwise could not have known. One of the great satisfactions and rewards of the actor is that he gets, through the help of the audience, a feeling for the multiple nuances of existence.

Strictly speaking, there is no acting of a play in rehearsal, for a rehearsal has no audience. A stage hand might watch it; the director and sometimes the author and producer do. But none of them provides the play with its needed audience. The stage hand is not noticed, whereas the others, where they are not trying to anticipate the comments of critics, are trying to project themselves into the position of members of an audience. They are not members of an audience but men who are trying to act as though they were and also were critics. Rehearsals are occasions for readjustments, for the mastery of techniques; they are periods during which actors can learn the strength and limits of their parts. Stanislavsky even urged his actors to overact somewhat in rehearsal. By overacting, actors have "learned how far characters would go if they were not restrained by the conditions of time, by the surroundings, by the line within which the character grows, and by an artistic sense of proportion." The overacting is a way of allowing for new circumstances which will enable one to see from a new angle what is being explicated in the play. It offers a new array of antecedents and consequents for the same reality that the acting exhibits.

There are many themes in a play, recognizable items which are repeated and developed throughout. They may have the form of gesture, speech, incident, or other readily recognizable factors that can recur in scene after scene, act after act, throughout the play. These themes have a grain, to which the audience contributes some part, though it is primarily an outcome of the manner in which the actors speak and move.

The play, to be more than a series of episodes, must provide agencies for carrying actors and audience from point to point. This is partly done by speeches which demand a response; partly too by the persistence and re-use of props; partly too by portraying the consequences of actions. We, the audience, push ahead on our own, affecting subsequent events by what we now understand, thereby introducing changes in the themes. But the play itself has its themes in interplay; they bleed into one another, affect one another. At the end, the beginning has become clarified, and its meaning absorbed.

E. Legouve amusingly remarks, "A play is a railway journey by an express train—forty miles an hour, and from time to time ten minutes' stops for the intermissions; and if the locomotive ceases rushing and hissing, you hiss." The intermissions, though, are not really part of the play; they are but devices enabling the audience and sometimes the actors to rest. Usually the act after the intermission begins with a speech or incident supposed to occur at some interval after the last speech or incident of the previous act. But this need not be; the play can continue where it had left off. Whether this be the case or not, the intermission does not interrupt the play as a work of art, but only as an occurrence inside a public common-sense time. There are, however, real rests, genuine spacings inside a play. Silences, pauses, periods of waiting: these "negative" spaces are palpable and sometimes the most exciting parts of a play. Minor parts, minor positions can also provide spacing for those in the forefront, or between major incident and major incident. All are integral to the play, and freshly, creatively, produced in it.

Most practitioners in the theatre seem to agree that the most important features of a play are the created tensions, and their resolutions in crises and eventually in a major climax. W. Archer: "A great

part of the secret of dramatic architecture lies in the one word, tension; to engender, maintain, suspend, heighten, and resolve a state of tension . . . The drama may be called the art of crises." Henry Arthur Jones: A play is "a succession of conflicts impending and conflicts raging, carried on in ascending and accelerated climaxes from beginning to the end of a connected scheme." Lawson: ". . . the characteristic progression of an action—exposition, rise, clash, and climax." And "heightening of the tension as each cycle approaches its climax is accomplished by *increasing the emotional load;* this can be done by emphasizing the importance of what is happening, by underlining fear, courage, anger, hysteria, hope." He concludes that "the climax furnishes us with a test by which we can analyze the action *backward.*" "The climax . . . is the most meaningful moment, and therefore the moment of most intense strain."

The climax is prepared for throughout the play; and after it is over it is looked back to as the place where basic realignments took place, where another facet of existence had become exposed. The play does not end at the climax because there is a need to make evident what it is that has been uncovered. The end of the play is reached when that need is satisfied. One must avoid a flattening anticlimax,* i.e. a sudden descent in value or importance; at the same time one must avoid starting another thematic development towards another climax. The gap between climax and end is the hardest to fill. Success involves the exercise of a power to omit and a power to close.

There are many themes in a play, some coming to the fore in one place, some at others. The development of these themes together yields a work having structural complexity and spanning an harmonious unity. In it some ideal meaning is given a sensuous form. That meaning, like all those used in the arts, expresses a value. The meaning is specified, often humanized, and referred to by an idea remarking on

* There are isolated anticlimactic expressions as well as contextual ones, but sometimes no agreement seems possible on just what would be good instances. There is, for example, a difference of opinion in Cambridge and in New Haven on the nature of the expression "For God, for Country, and for Yale." One says that it is a genuine anticlimax, the other takes it to be strikingly climactic. Both agree, though, that "New York, New Haven, and Hartford Railroad" ends in a definite anticlimax. Here they are supported by the students from Smith.

a humanly important beginning, turning point, or end, or some combination of these. The play is an idea-mediated, textured, sensuously enjoyed meaning carried along the course of a self-sufficient, vital process, and iconizing existence, benign or ominous. A playwright rarely has the meaning clearly in mind to begin with. One of the functions of the director is to identify it, and then to see to it that the actors become more and more aware of it as an essential component of the play. In the course of the play both they and the audience come to live with it.

The words of a play are caught almost wholly inside the play. They are in this respect different from the words used in a story, and, to a lesser degree, from those used in a poem. One cannot enjoy a story or a poem written in a language one does not understand. But plays can be enjoyed to some extent by men who do not understand a word that is spoken. What the conventional associations of words do for them in the story or poem, is done for them not only by the acted incidents but by the conventional associations of the tones, gestures, grimaces, actions and props in the play. Dramatic readings, since they make use of these associations, are, as the theatre well knows, not stories made audible but plays performed. Their production requires the solution of the same kind of problems that beset all acting. Many of those who do read dramatically, incidentally, do not literally read, having memorized the script as thoroughly as actors usually do. On the other hand, it is possible to wave one's arms, gesticulate, change tone, and so on, and yet in no way approach a dramatic performance. An effective teacher is not an actor in any sense, for he does not function as an integral part of a created world, to be accepted as substantial and self-sufficient.

Since the conventional associations of actions, etc., and the spoken words are somewhat independent, what is conveyed through the help of the associations is usually something quite different from what is conveyed by means of the words alone. One man says "no" to another. The two are related in the play by a negation. When the "no" is dramatized it immediately reveals to all that one of the men is holding himself over against the other. It tells us something else as well. A "no" pounded on the table, sighed shyly, or shaped into a barricade

in a play makes us acutely aware that it is existence as well as another man which is being defied. By living through the "no" dramatically produced, we thereby not only learn to face existence on our own terms, but to know what it is like apart from the play.

Aristotle has taught all that by means of the play the emotions are purged. He concentrated on tragedy (his work on comedy having apparently been lost) and therefore spoke of the purging of the emotions of pity and terror. His insight deserves extension. What he said of tragedy is a special case of what can be said of every type of play, and indeed of every art. There is a purging of emotions, sad and joyous, quiet and violent, in sculpture and painting, in music and dance, in poetry and architecture. All these offer controlled contexts in which emotions can be spent, freed from the rasping, debilitating, disorganized effects they have in daily life. All of them turn raw emotion into refined emotion. All replace an outburst into the world— which may as readily injure as help one, may as readily miss its object as reach it—by a structured expression which is made into part of a substantial work revealing man's destiny.

Not only are the emotions of spectators purged; the artists' emotions are purged as well. For both spectators and artists the act of entering the world of art is the act of subjecting emotions to restraint. By living with the art, the restrained emotions are expressed in a controlled way. The outcome of a purging is a changed attitude towards the universe, an insight into its nature and cut; for a while at least it makes one sensitive to the good and evil that existence contains. Sometimes we win such an insight through a direct struggle. When we do, the effects are longer-lasting than those produced by art. But they are usually also somewhat cataclysmic, shaking us to our foundations. More often than not, too, a direct struggle is not well guided and is without good issue. The emotions elicited by things help us adjust ourselves to them and what lies beyond, but only in a rough way; the emotions elicited by and used in the arts both help us to make the arts be, and help us to have our lives and values enhanced. Though art does not affect us as deeply as life, it does affect us in a more successful and satisfying way. Art, however, is not therapy; it is not to be engaged in in order to refine the emotions. The emotions are

refined only in the course of an act in which the work of art maintains itself as a world, while making evident the bearing which the ultimately real has on human life.

Actors utilize their emotions to fill out the structure of a play, to carry it from point to point; the members of the audience provide it with an emotionally sustained wall. The one lives inside a vitalized ongoing, the other offers this a boundary. The actors are in the play, the audience only at it. Since actors also incidentally assume the position of an audience, they purge, not one, but two sets of emotions. One set is purged in the process of acting, the other in the process of making the work stand away from prosaic day, giving it body, a substantial being of its own. The latter process is undergone when the actor acknowledges the roles of others; it is then that he looks at them in the spirit in which the audience faces all. Let an actor take the part of a father and another the role of son. The two together might interplay with one another to constitute a play. The "audience-status" of each actor rides on the back of this interplay; it is nothing more or less than his comprehension of what it is that the other is doing. Since actors grasp what the roles of others are when and as they dynamically live out their own roles, they are able to purge themselves, audience-wise, when and as they purge themselves actorwise.

There was a time when the audience made its pleasures and dissatisfactions clearly known throughout the performance and unmistakably afterwards. Men were aroused to shout, to fight, to scream. Audiences today are usually better mannered; they do not jeer or yell except on rare occasions. They do not move into the actors' world as readily as they once did. But plays are made and broken by audiences today as they always have been. In addition they are made and broken by theatre groups, who buy out or refuse to buy out houses, by theatre brokers who buy or refuse to buy seats before the play has found its audience, and by critics who, in a hurried hour between curtain and deadline, lend the play a helping hand or deal it a staggering blow. These are unfortunate developments. Though the audience has a right to be considered, since it is a constituent of the play, the others are outside the theatre's province. They stand at a distance, helping or hindering a ready entrance into it. This is an important function, but

it ought not to be allowed to obscure the fact that it is not integral to the art of the theatre.

Actors of one generation seem to another to rant or to underact; actors in one nation seem to those in another not to act properly. Plays have changed in length, topic, language over the centuries. But none of these facts seems to be of much significance. The theatre is perhaps the most constant of the arts. This is in part due to the fact that actors live inside a tradition, and in part because audiences, though they change daily and have different prejudices and tolerances in different periods and places, are in root always the same. The theatre is a world, one side of which is constituted not so much by men as by mankind.

12. THE DANCE

THERE seem to be at least a half dozen prevalent interpretations of the nature of the dance. It has been called an accompaniment of music, a type of acting, a series of gestures or pantomimes, a set of pictures or paintings, a way of discharging surplus energy, and a form of self-expression. Every one of these interpretations can be given an illustration in some dance. But none, I think, does full justice to the richness of the art.

One may, as Cage and Cunningham have shown, create music together with the dance. If the two are really co-created they will constitute a new compound art. As a rule, though, each, at different moments, serves as a script or guide for some development in the other, and at the end the music is made to give way and become subordinate to the dance. A dance is usually preceded by a period of music; and where it is not, there is a reference to music in the preliminary swayings, gestures, and movements. The music here is at the service of the dance, played in advance only to enable one to place himself inside a created, controlled, pulsating world. The fact is all the more remarkable since men enter into the dance to a degree they do not enter into any other art. Only in the theatre and in music do they also move into the art in the flesh as well as in the spirit. But in the theatre they do it only by dividing themselves into roles and bearers of these roles, and in music they do it only as agents of sound. The dancer, in contrast, gives himself to the dance.

Only some kinds of music, Doris Humphrey says, are "suitable for dance—melodic, rhythmic, and dramatic" which are "most closely allied to the human body and personality; melody through its original source in the breath and the voice; metric rhythm, through the change of weight of the feet and the pulse; dramatic sound, through the enormous range of emotion, always accompanied by a physical re-

action." I know of no more sensitive, philosophical, and persuasive writer on the dance than Doris Humphrey. But here I think she is less perceptive than she usually is. There is no music that might not be used to accompany a dance. Some works of music are insistent, some are limited in range, some are distractive. But all mark out areas in which a dancer can function. To deny to some work of music a possible function for some dance is to delimit the possibilities of dance unnecessarily.

It is also true that dance is independent of music. Dance has its own space, time, and form of development. A dance need not, in fact, be accompanied by music at all. Mary Wigman, who originally danced to music, says, "Each dance is unique and free, a separate organism whose form is self-determined." "My dances flow from certain states of being, different stages of vitality which realize in me a varying play of emotion . . ." "I find my dance parting company from the music." This does not mean that the music does not have a most important presuppositional role. Like the play, the dance is performed within an area which is won for us by music.

As is often the case in the classical ballet, the dance can serve to tell a story. Intentions and designs are high-lighted by gesture, and the whole is then presented as a kind of silent play with a background of music. But the dance is not, even here, an accompaniment or form of acting. The actor supplements his words by his movements. Were the dancer to speak he would accompany his movements by his words. The movements of the one add tone and volume to the words; the movements of the other have sufficient tone and volume of their own and therefore need no words. The actor's words precipitate actions; the words of the dancer would summarize actions or translate them into another medium. That we attend to the actor's words and to the leaps and pirouettes of the dancer is not therefore an irrelevant fact about them. It is true, of course, that one can enjoy a play even though one does not understand the words, but that is because the incidents which the words require are interesting in themselves. The movements of the dancer do not require words at all; they suffice to make a work of art be.

Is the dance a series of pantomimes? The idea is so shocking to

some that they go to the extreme of denying that pantomime could ever be an art. Isadora Duncan, before the days of Charles Chaplin and Marcel Merceau, had perhaps some little justification for saying "pantomime to me has never seemed an art," but it is hard to understand why at this late date Susanne Langer feels she must echo Duncan and say, "I also consider pantomime not a kind of art at all." Pantomime is a form of acting, though one which does not use words. For the pantomimist the gestures, like the movements of the dancer, have sufficient volume and tone of their own to make a work of art be. But he, unlike the dancer, assumes a role, acts out a part. The gestures of the dancer in contrast are part of the dancer's movement; the slope of his shoulders, his shrugs, his looks of surprise and despair, his preparations for arrival and departure, and all the rest, serve only to set limits to the movement and perhaps to cue the audience, helping it, in the light of familiar occurrences, to find its way through the dance.

Doris Humphrey observes: "The normal handshake lasts a second or two. By prolonging this through timing or repetition, we are immediately in the area of dance and not mime." She does not here intend to say, I think, that we can, by these devices, convert a pantomime into a dance. As was just observed, pantomime is a form of acting; no elaboration of the art of acting, by any device, turns it into a dance. In any case by prolonging a pantomime we do nothing more than make it a prolonged pantomime. Pantomime is a temporal art; dancing is a dynamic one. Spectators are merely at the former, but participate in the latter. Pantomime is dramatic, a role-taking art, in which energy is sluiced through limited channels so as to provide a sequence of incidents which reveal the nature of existent time as mediated by men; the dance, in contrast, is a world in which the individual becomes one with the dance, pouring his energy into a single whole of energy which thereby iconizes, with hardly any mediation, the nature of an existential becoming.

Nor is the dance a series of pictures or paintings. This would make it primarily a set of stills, and leave motion the task of taking us from one still to the other. Even if one were to attend to a design at its best—complex, involved, with a plurality of tensions, and multiple

relations connecting every part—one would not yet face a kind of painting, for one would not yet have created a multi-dimensional space. Moreover, a dance without movement is no dance at all. "Arrest the dancer anywhere on the stage—his condition is flux," Merle Marsicano forcefully remarks. He who attends primarily to the designs which the dancers make possible therefore makes an error somewhat similar to that which would result if one ignored the rhythm of a piece of music to concentrate on its metre. Any design that a dance may exhibit is usually of minor importance. And where it is of major interest it is still subordinate to the dance. The dance is appreciated not by those who note how the dancers are placed from moment to moment, but by those who see how they move in, to, and from their places, who are aware that something is being produced by the movement.

Nor can the dance be correctly viewed as an exercise in the free discharge of surplus energy or emotional excitement. It does, to be sure, involve an expression and a refinement of the emotions. What is produced in the dance must be held off over against the world; it must be emotionally sustained. Since this is what happens in every art, emotional expression will not suffice to differentiate the dance from other arts. For a similar reason the dance cannot be treated as a form of self-expression. Every art allows for some self-expression. Each also goes beyond this. Each, following out its own peculiar internal rationale, creates a distinctive icon of existence, and makes evident something of existence's texture. Dance, in its own distinctive way, does this as effectively as the other arts do.

The dance appears to be one of the oldest of the arts. Of course, there has been a kind of architecture as far back as one can go, but this seems to have been pursued as a craft rather than as an art. The art of the dance seems to have preceded every other art, with the possible exception of story. But then, in contrast with story, it is participated in by much greater numbers. The dance is also the most widespread of the arts. There appear to be societies where there are no sculptors, painters, composers, poets or actors. No society, though, seems to be without dance, music or story of some kind. But history and anthropology make plausible the contention that music and story are originally parts of the dance, or prepared a place for it. The separate

pursuit of music and story as arts seems to come late in history and to be characteristic of only highly developed cultures.

In the dance the human body is at its freest and fullest, in closest harmony with the vitality of existence. The dance has no need to tell a story, to communicate, to do anything but make a work of art be. It escapes the separateness, the rigidities, the sharp breaks of the theatre, and the intangibility and distances of music. It fills up, gives body to an energetic, voluminous ongoing, thereby contrasting with music which merely presents such an ongoing, and with the theatre which punctuates it. Music strives towards continuity; the theatre insists on various pivotal characters and incidents; but in the dance the pivots are continuous with the movement. Acting is a dancing in restrained and awkward movements under the guidance and pressure of discourse; music is a dancing in which the performers are tones.

Dancing as an art has two basic forms: the classical and the free. The latter is the older. Though there are fixed forms in primitive dancing, it is also true that it is more open, less contrived than the classical. The classical is today exhibited in the ballet, the free in the modern dance. The differences between these are less interesting or important than their similarities. They differ perhaps somewhat as traditional differs from modern painting. The current movement in both painting and dance emphasizes its revolt against the older generation by claiming to be an entirely new adventure. But in both old and new forms dancers make use of similar instruments, their bodies, and for the same ends, the production of a new dynamic world.

This view is explicitly rejected by John Martin. He says that the modern dance "has actually arisen in fulfillment of the ideals of the romantic movement. It has set itself against the artifice of the ballet, making its chief aim the expression of an inner compulsion; but it has also seen the necessity for vital forms for this expression, and indeed has realized the aesthetic value of form in and for itself as an adjunct to this expression. In carrying out this purpose, it has thrown aside everything that has gone before, and started all over again from the beginning." His point seems well taken, particularly when one recalls that Noverre said, "A ballet is . . . a series of pictures connected one with the other by the plot which provides the theme of the ballet;

the stage is . . . the canvas, the choice of the music, scenery and costumes are his colors; the composer is the painter." "A ballet is either the likeness of a finished painting or the original." It is, of course, also true that in the modern dance, in contrast with the classical, there is more freedom of movement, a greater readiness to experiment and improvise, a greater willingness to accommodate the dance to new rhythms, and a greater desire to make use of new types of decor and music. But both are forms of dance, and dance has a single essence. When Doris Humphrey, who is certainly a modern dancer, and who thinks of her movements as essentially experiments in unbalance, or attempts to organize tensions into a unified whole, says all "movements can be considered to be a . . . deliberate unbalance in order to progress, and a restoration of equilibrium for self-protection" she speaks for both the classical and modern dancers. There is one dance, and it has many different guises.

Energy is employed in all motions, in the arts and outside them. But the dance employs energy in a distinctive way, for a distinctive purpose. It comprises all forms of movement—swinging, walking, running, jumping, falling, challenging and maintaining equilibrium, bending, holding and letting go, rising and falling. "Sometimes," says Merle Marsicano, "I feel that I am descending below the level of the floor, and at times I feel suspended in strata above me. The feel of the floor, its primary attraction, need not occur under my feet alone. The space about me, as I will it to do so, can possess the same tangible resistance." It also includes rests. Doris Humphrey wittily remarks, "Many a time I have used the reverse of the old admonition to my students and said, 'Don't just do something, stand there!' "

There are some who speak of the dance as primarily an exhibition of man's attempt to defy or deny gravity. They point to the fact that the dancer stands on his toes, leaps with grace, seeks in multiple ways to convey an impression of being without weight. There are others who say, instead, that dance is an art which seeks to accommodate, utilize, exploit the fact of gravitation. The one group attends primarily to the classical dance, the other to the modern dance. They are not radically opposed. The one contrasts the movements inside with those which occur outside the dance; the other contrasts the product of

the dance with the raw material which was provided for it. What is outside the dance is to be put aside, but the raw material which is gravitation cannot be denied or defied.

The dance is not an exhibition of a futile effort to make one believe that gravitation does not exist, or that it can be cancelled out. It transforms the raw power of gravitation and makes it operate in new channels. The dance seeks to master, to make use of, to possess gravity in a new setting. The man who makes the dance is in the dance; he gives to the art not only his emotions, muscles, words, sounds, attention, but himself. When the dancer stands on his toes or leaps, he moves in a new world according to a new logic. He rises and falls subject to the very laws, of course, that govern every man in and outside the dance. But his rises and falls in the dance are not rises and falls against or with gravitational pulls, but with and against other rises and falls. The gravitational pull is an integral part of the dancer's movement, having distinctive relations to other movements in that dance.

The dancer not only stands on his toes or leaps, but twirls about, is thrown, caught, and carried, lies down, twists; he can move heavily, slowly, take short strides, crawl, be dragged, pulled, crushed, brought suddenly down to the ground. There is no more yielding to gravitation in these last acts than there is a defiance of gravitation in the first ones. In all of them the dancer is using his body to help constitute a realm of becoming. When he moves with heavy step, crawls or falls to the ground, he moves with just as much freedom and aesthetic purpose and result as he does when he jumps with apparent effortlessness, glides with ease, or moves weightlessly.

The gestures of the dancer are continuations, through his limbs, of the movements carried on by his body. Doris Humphrey divides them into four categories: "social, functional, ritual, and emotional," illustrated by a handshake, the combing of one's hair, bowing, and the expression of grief by putting one's hands before one's eyes or face. The form these have in common experience, she remarks, must be considerably altered before they can become part of a dance. She suggests that this is to be done by changing the initial rhythms, stresses, timing, design, thematic meanings and emotional values. Her four categories are in consonance with the divisions made throughout

this and the previous book. The agencies which she suggests for moving from common experience to the dance are, I think, comparable to rules of prosody, perspective and the like. They are helpful guides which students can use to move more effectively within the realm of art. But they presuppose that one has already entered that realm, that one has already turned away from the world of common experience and engaged in an effort to create a new world with its own logic, demands, and values. The most familiar gesture may be made within the context of a dance; the rest of the context will give it a new role, alter it radically, change its value, and this without requiring it to vary in stress or timing.

The gestures of the dancer are movements, parts of the dance itself, telling no story, conveying no meaning, saying nothing on their own. They are not to be identified with symbols or with silent words. It is true of course that almost every dance contains gestures which underscore some intent or meaning, and which remind one of the gestures and acts that take place outside the dance. Two dancers embrace; they are evidently lovers. One leaves and the other assumes a sad look, he takes shorter and shorter leaps, his shoulders droop, his legs bend, he moves more and more slowly. He is evidently in despair; his gestures make that fact evident. But the gestures are not needed for such a purpose; without the sad look or the drooping of the shoulders, the dancer might produce somewhat the same effect by longer leaps, different bends and other movements. And in any case when gestures of the most familiar sort are used, they serve not as symbols or signals but as cues which enable the audience to find its way about in the dance. A dance without cues would be like nonobjectivist painting; it would be just as much a work of art as one which had such cues, but it would have only a limited audience.

The dancer does not always move. As was observed before he sometimes rests. But when he rests, he dances. He then makes controlled use of energy and points to the movement through which he had gone as well as to the movement through which he is about to go. A rest for the dancer is a pivotal point, tensional, directional, vital. As Merce Cunningham has observed, standing still involves as much space and time as movement does. He also said, "Anything can happen in any

sequence of movement, and any length of stillness can take place." It is not true of course that "*any length* of stillness can take place," but it is surely true that the length cannot be prescribed in advance. The time of rest is a tensional time, demanding a movement after a while; it is accumulative, calling for an end, just as surely as a movement does.

Although a dance can be put on the same platform where a play has been performed, it will use a completely different stage from that used in the play. "The natural meanings of stage space," Doris Humphrey observed, "are unique in the dance." The dancer starts with a stage subdivided into various positions and then proceeds to vitalize them all simultaneously, though with a primary stress on limited portions of it. The actor in contrast starts with a plot and then vitalizes some region within the single undivided area required by that plot. The actor creates a place in a single whole prescribed by the idea of the play; the dancer creates a whole from a position prescribed by the idea of the dance. Every movement of the dancer covers the entire dancing space. Each is affiliated with whatever other movements and rests there be. If the dancer is alone he dances not only where his body is, but in the entire dancing space. Like the sounds of music, the movements and rests of the dancer are voluminous; if there are a number of dancers, each occupies a different dimension of the same single volume. The world of the dance is endlessly complex; in it every movement goes at once backwards and forwards, up and down, sideways and irregularly, to fill the entire dancing space.

The actor is a man who assumes a role; he is somehow two men in one. The audience of the theatre, on the other hand, gives up the side of itself which had a being apart from the theatre in order to function as a fourth wall. In the dance the two positions are almost reversed. The dancer is in the dance. He does not assume a role; he gives himself without reserve. But the audience, though it also acts as a wall or limit of the dancing space, functions at the same time as the environment for the dance. That environment is not the world of nature, but an artifactual area inside of which the dance takes place. The audience adopts the rhythm given by the music (if any) at the same time that it helps constitute a dance area where the dance vitally fills out that rhythm. The audience is where the accompanying music arrives, at the

same time that it is where the actual dancing takes place. It can be in both places because the rhythms it exhibits in the former capacity are those which are filled out by the dancing in the latter.

Dancers, like musicians and actors, express themselves dynamically to produce an icon of a vital, all-encompassing process of becoming. The musicians iconize that becoming by means of sounds; actors iconize it by means of interrelated, dynamic roles; dancers iconize it by turning themselves into representatives of it. The icon that the musicians provide reaches out to include the listener; it absorbs the audience as well as the musician in the role of listener. The icon that the actors provide is sustained by the audience; it is bounded by the audience and by the actors as they take cognizance of one another's roles. The icon that the dancers provide is themselves as dancing; the audience can become part of it only by dancing in spirit or in fact.

The simplest themes of a dance are movements which achieve maximum luminosity when performed with ease and grace. Each of these has a grain produced by the quality of the dancer's body, the force of gravitation, the resistance provided by other dancers and movements, and the audience. The theme is carried by the audience from place to place and time to time, and thereby made to change in value. The movements of the dancer interpenetrate the movements which he thereafter, and which others then and later produce. The dance is therefore never a mere sequence of movements and rests. It is a single whole within which themes and movements can be distinguished but are not to be isolated. The dance is molded from the start as a single organically interconnected unity.

The dance contains both negative and positive components. Since there is no unoccupied space or time in it, since its rests and stillnesses are themselves tensional and dynamic, its positive and negative components evidently differ only in degree. Most compendiously, there is only domination or foreground, and recessiveness or background, and these not sharply distinguished. Some movement or rest is for a time to the front and then only so far as it dominates and guides; what is then most recessive serves to space it, to relate it to whatever else there be.

Both the dominant and recessive movements and rests occupy the entire dance volume; each is affiliated in multiple ways with every other;

each mediates and is mediated by the rest. Those who concentrate exclusively on the main dancers or on outstanding motions and rests will see the entire world of the dance, but they will not see all the relations that occur in it. They will miss the fact that recessive movements and rests not only have an intrinsic value of their own, but are affected and affect the dominant. The world of the dance is a solid world in which the slightest of elements is an integral component, relating and related, functioning as a background only in relation to what has been accepted as foreground.

A theme is developed throughout the dance; in successive appearances it is modified, inverted, changed in pace and place. Some occurrences are pivotal, others minor; and though the dance is not a piece of theatre, there is a climactic point, a place where the theme comes to conspicuous expression and towards which and from which other instances of the theme are directed or initiated. There is, of course, more than one theme. But all the themes must be interlocked to yield a single complex theme. As this is developed, different subordinate themes become conspicuous at different times.

A theme pursued throughout a dance provides it with a structure. A plurality of themes yields a structure which weaves in and out throughout the dance, to produce the analogue of a series of incidents locked in a plot. But the dance has no plot. Precisely because it has no dramatic story to tell, the dance can easily be misconstrued as presenting nothing but a set of structures. There is more to the dance than this. It has a meaning imbedded in it. If the themes and structures are harmonized, the meaning can permeate every part of the dance to make it excellent, beautiful. The meaning imbedded in a dance all too frequently has been spoken of as being essentially religious in import. Only such a meaning, it is felt, is old, broad, and vague enough to be relevant to the origin, function, and appeal of dance. But this is to overlook the role of myths. Like every other art, the dance makes evident the nature of a myth. This is a cultural idea referring to and making relevant an objective meaningful ideal. It celebrates the meaning of a beginning, a middle or an end. When entertained and embodied in a dance, it has a form which is even more amorphous than that utilized in music or the theatre, in good part because the dance is

freer in its metrics and looser in its design. The steady beat of music requires and presupposes divisions in some expressed idea; the demands of a plot require and presuppose some articulation and considerable particularization; but the dance tries to do nothing more than convey the unitary meaning of a beginning, middle, or end.

Because of the comparative generality of the meaning with which it is concerned, the dance is primarily rhythmic. Even the steady drumming or the repetitive shouts accompanying primitive dancers provide not beats but accents for or in the dance. Drum beats can be thought of as marking out a time, but a dance—even where it offers a repetition of the same movement from moment to moment—is an accumulative affair in which what comes after is changed by what had been. Repetitions in music are also accumulative. But it is precisely from this accumulation that one attempts to abstract when the music is used to provide beats which are to be made into accents placed on particular dance movements or rests.

A musical accompaniment that is not repetitive, in which there is an attempt to exhibit the very same rhythm that is being exhibited in the dance, serves primarily to give the dance a more specific content than the dance would by itself possess. But then the music must itself be incorporated in the dance as an essential but subordinate part. A still richer content could be obtained by having the dance incorporate some theatrical incident or story. This will not turn the dance into a theatrical performance, nor force dancers to assume the roles of actors. Indeed, many features of a dance may be produced by non-dancers. This is what happens when the dancing catches within its scope some act, such as circumcision or sacrifice, engaged in by non-dancers. These nondancers and their activities are then in the world which the dancers define, adding features to the dance.

It is in connection with the subordinated music and theatre that the choreographer and dancer are called upon to exercise considerable powers of omission. Ordinary music or theatre is too self-enclosed to suit the needs of the dance; a good deal must be omitted before they are capable of being used in a dance. Or where the music or theatre is forged together with the dance, one must restrain the temptation to have the music or the play be full-fledged, self-sufficient. At some point

too the choreographer and his dancers must call a halt in the endless effort to make a perfect work. As a result the dance, music, and theatre will not be altogether well integrated one with the other, and will not either severally or together make a perfect whole. But in this respect they will not be unlike other arts. All artists stop and ought to stop before perfection is attained, for beyond a certain point they are bound to substitute technique or artiness for genuine creative work.

The dance must be charged with emotion constantly in the effort to give it substance enough to push all else aside. It then constitutes a world of its own which satisfies because it contains within itself the texture and nature of a most relevant ultimate reality. The texture is given by the bodies of the dancers in interplay with one another, the audience, and gravity; the nature is given in the process of the dance itself. By living through the dance one lives through a course of vital becoming, a reality whose being consists in its coming to be. The dance teaches us what the import of a world of process is. We learn from it that existence is at once relentless and supple, insistent and persistent, ruthless and vitalizing, that it forges, over an uncharted path, a world big with the promise of good and ill.

Were Hegel right, that the highest art is one in which there is a perfect conformity of form and matter, the dance, in addition to being one of the oldest and most widespread, would also be the most perfect of arts. This theory of Hegel's is, I think, mistaken. Although the virtues of the dance are great and distinctive, they do not suffice to make it an art superior to the other major arts. Music makes a world which we can remember; the theatre punctuates a world which we can understand. In the dance man touches the depths of reality more profoundly, but what he thereby grasps he can hardly remember or understand. And because the dance involves a whole man who, apart from the dance, has a volume, a mode of becoming, a public space and a temporal life, it is hard to accept and to remain with as an art. It demands a great and continuous effort on the part of the dancer; and on the part of the audience to hold the dance away from the world of everyday.

The dance as a fine art is of comparatively recent origin. And in America it has only in the last decades won an interest from more

than a few. But recently, because of the work of such distinguished choreographers as DeMille, Balanchine and Robbins, more and more people have begun to see that the dance is an art. Balanchine is tempted at times to put in little tricks which he assumes will help maintain the interest of the audience; Robbins is somewhat impressed with grandiose theatrical affects; DeMille seems overanxious to produce an indigenous form of dance. But these are minor and remedial faults. The important thing is that they have made the dance an art for many. Because of them, there will be a greater and greater acceptance of the Martha Grahams and Merce Cunninghams. We seem to be on the verge of a new era in the dance.

13. SOME COMPOUND ARTS

HUNDREDS of possible combinations can be made from our initial set of arts. Only some of these have been explored by artists. Arp combines sculpture and painting; Joyce combines musicry and story; minstrels combined story and music; the Homeric molpe combines poetry and dance (or according to some interpreters, story, music and dance); the opera combines music and the theatre; and Gabo and Pevsner have spoken of themselves as producing a new art which embraces architecture, sculpture and painting. These combinations are usually brought about by subordinating one or more arts to some dominant one. In the opera the theatre is clearly a subordinated element. Ideally, though, it should be possible to give equal weight to all the constitutive arts. But whether one does this or not, the result will be either a thicker portrayal of existence, or an intensification of some dimension of it. In the molpe, time and becoming are made to supplement one another, thereby enabling one to grasp the nature of existence as more than either. Photography, documentaries, and movies are arts in which space, time, and the process of becoming achieve intensification through a use of a number of arts.

The photographer approaches the world with an aesthetic eye. He is alert to its lights and shadows, its interrelations, its multiple structures, and its spatial configurations. He is ready to attend to the way in which light opposes and merges into darkness, color bleeds into and alters color, shape contrasts with and passes into shape, and background stands over against and is continuous with the foreground. He is prepared to follow the development of a theme throughout a situation, to attend to the way in which what is here affects what is there.

This approach of his is not characteristic of the painter or the sculptor. These have little and sometimes even no appreciation of the

aesthetic values of experience. And when they do have such appreciation it is rarely relevant to their purposes. Their characteristic work begins when they leave that experience behind to manipulate stone and paint, chisel and brush. The world beyond is for them often a hindrance or temptation, and sometimes a reminder or stimulus. But for the photographer it is essential, precisely that on which he concentrates as the locus of the aesthetic values he cherishes and wishes to preserve and enhance.

The photographer begins by trying to increase the values he first discerned. He shifts his position, changes the lighting, adds and subtracts props and objects. The result is a new aesthetic experience. If he is realistically inclined he keeps these alterations to a minimum. The realist does not believe he can improve on nature; he thinks it desirable to capture, not to add to what nature provides. If the photographer is an experimentalist he maximizes changes in the aesthetic situation. He does not deny that the initial experience might yield a satisfaction greater than that which he now elicits, but he is interested in exploring possibilities, seeing just what can be done. The studio photographer is different from both. He alters the situation by means of a number of well-tested devices. He knows he could be more realistic and he knows that he could be less. But as a rule he keeps within stable limits to satisfy those for whom he works. Most photographers take a stand somewhere between realism and studio.

Were the photographer to stop here his camera would be little more than a distorting, recording instrument, a kind of machine for partly remembering what was encountered. But the camera subjects the world to limiting conditions, thereby giving new shapes and new meanings to what its user aesthetically experienced. It is the characteristic mistake of amateur photographers to overlook this fact. They think that what is aesthetically satisfying will necessarily make an excellent photograph. The excellent photograph is produced only by one who sees that the aesthetically experienced will be altered somewhat by the camera.

The photographer must make himself into a kind of camera before he uses the camera in fact. He must know what it can do, realize what the aesthetically appreciated world will be like when translated into

a print. He must know not only that the camera transforms but what kind of transformations are possible by means of it. The photographer must master the technique of operating it in order to achieve the result he anticipates and desires. To do this he must frame the aesthetic experience by intent, change it into an aesthetic object held apart from the world. The aesthetic experience was enjoyed by ignoring the rest of the daily world; the aesthetic object is produced by pushing that world aside. The photographer, by making himself a camera before the fact, produces an intentionally framed, aesthetically satisfying whole, an object whose internal content has been affected by the way in which it has been made to stand over against the daily world.

A camera provides prints, not photographs. Prints are the products of craftsmanship; they presuppose skill, technique, the ability to manipulate a machine. One need not therefore be an artist to use a camera with brilliance. It is conceivable that it could be manipulated by machinery with greater accuracy and satisfaction than by a man— once granted that a man has first isolated and framed and thereby converted an experience into an aesthetic object.

The translation of prints into photographs is usually treated as a special craft. That work can also be done by a machine. But the photographer who is an artist charges the activity of translation with creativity. The results of the camera are manipulated in the dark room so as to modify its effects and values. The outcome is the world of every day, four times transformed—first by the aesthetic experience, then by the photographer's conversion of this into an aesthetic object, then by the conversion of this into another aesthetic object by means of the camera, and finally by the conversion of the camera's product into a work of art.

An artistically produced portrait of an aesthetically experienced world, the photograph is dependent in part on what the world happens to present and allows to be confronted. It stresses planes and contrasts in the way sculpture does, but it fills up space in a painterly way. It is a sculptured painting with a distinctive structure and values.

A documentary film does for time what photography does for space.

Like the photograph it isolates an aesthetically satisfying content, frames this by intent, manipulates cameras in order that the outcomes can be preserved, and then subjects the result to alterations in order to enhance the aesthetic values which the cameras were able to carry. The time it provides is a filled-up time, a time of poetry, but one whose elements are not words or phrases but incidents and events.

Although photographs may deal with artifactual objects and even with such art objects as buildings, sculpture and paintings, they are usually not so employed. Documentaries on the other hand, strive to provide accurate reports both of natural and artifactual events. It is rarely that their artistic potentialities are exploited. A splendid exception is the recent film, *New York, N. Y.* And in that subdivision of documentaries which we have come to call "recordings" there is promise for a radical development of documentaries as an art. Documentaries live in a poetic time, but one which has been made to carry a story. They are compounds of two arts, but possessing a characteristic flavor of their own.

Most recordings offer skillful reports of such artifactual events as instrumental and vocal music. The value of this enterprise has made men overlook the possibilities of creative recording not only of natural events but of artifactual ones. With an increase in the use of tapes, stereophonic devices, splicings, the deliberate distortion of old sounds and the introduction of new sounds, there will undoubtedly be a greater and greater readiness to record even great music in a creative spirit. And the development of an art of audible documentation will undoubtedly have repercussions on visual documentation, so that one may expect in the not too distant future an artistic use of visible natural and artifactual situations, montages, splicings, and sounds, resulting in an art object which has not lost contact with actual experience. It will be difficult at times to distinguish such documentaries from movies. But the two are quite distinct. The one is concerned with creating a time; the other is concerned with the creation of a becoming.

The movies make use of cameras. But they do not thereby become a branch or form of photography. Movie and photographic cameras are quite different in nature and use. The movie cameras move back

and forth, up and down; they yield a sequence of happenings and not a spatial area. A photograph is always static; the movies move. "Movement on the screen is not real movement," we will be told. "It is only the apparent movement of a moving picture, the result of passing a number of stills so rapidly before the eye that they cannot be distinguished. What is seen is only a semblance of a movement, an illusory motion, something imagined, not motion in fact." It is of course true that we do not see an actual man then and there move; we see a portrayal of this. Just as the man we report in biology is not a real man, so the man and the movement which we see on the screen are not ultimate realities. Biology and the movies, however, offer different kinds of portrayals. Biology characterizes a man under conditions which make his vital functions intelligible. These characterizations are not similar to, imitative of what actually takes place. But the movement seen on the screen is the perceivable movement of a common-sense object subjected first to camera distortions and then to montages, splicings, tintings, discontinuities, in the effort to make the seen movement iconic of a real existential movement. The biological account, in short, is offered as iconic of an abstraction, the portrayal on the screen is offered as iconic of a reality. Biology claims to report what is scientifically the case; the screen claims to report what is ontologically the case. The former has left ontology behind even though what it speaks of are not qualities, accidents but the essence of a man; the latter leaves appearances to a side, even when it confronts us with a picture and not with what is being pictured. The supposition that the movement on the screen is an illusion, induced by the quick presentation of a number of stills, confounds the causes or conditions for an art with what the art itself presents. To suppose that there is no movement on the screen is but to make a special use of the fallacy that all art is illusory, a mere semblance. There is movement on the screen, but it is not the movement of a physical body in physical space.

The movies are not documentaries. Documentaries relate events at different places and times. What they relate they keep distinct, and they relate these distinct items according to the logic of every day. But the movies merge incident with incident, and what is more im-

portant, relate them to one another according to necessities and demands which transcend and sometimes defy our ordinary experience of connections. An occurrence in the movies jumps over space and time to attach itself intimately to others in a single newly created ongoing. Space is used in documentaries while they create a continuous time; in the movies both space and time are produced in the course of the production of a single process of becoming.

The movies are not stories made visible and audible. No story is ever used in the movies until it has been transformed into a movie script. And the movie script offers a series of episodes to be photographed in any number of possible orders, times and places, and to be edited subsequently by the movie editor. Since the movies are not movie scripts made visible and audible, they are not stories, even twice removed. Nor do the movies provide us with a type of theatre. They sometimes employ actors who have achieved distinction in the theatre. But it is also true that there are movie stars who are not very capable on the stage. The movies, to be sure, often offer versions of plays which have been successful in the theatre. But these usually are not successful works of art; too much of the theatre is carried over into the movie, slowing the pace, restricting the movement, limiting the action, thereby making most conspicuous the difference between the theatre and the movies. Most important, an audience is not essential to the movies; it does not help constitute what is filmed or seen. But a theatre audience is an essential part of the theatre. The audience is its fourth wall, helping determine the texture and the process of becoming which the performance produces. Like the dance a movie is self-enclosed. Its audience functions only as an environment for it, but one which varies in distance, depending on how close or far the camera was from the recorded scene.

The silent movies offered a series of pantomimes. Its actors gestured, grimaced, and postured in such a way as to make speech unnecessary. Though pantomime is a branch of the theatre, the silent movies were not thereby made into a form of the theatre. The result of the activity and interplay of actors and of gestures was the production of a course of becoming which had a rhythm, speed, time, and space not possible in the theatre.

Because pantomime is not gesturing with the words omitted, but a distinct art needing no words, audible movies cannot be treated as pantomimes with sound. The introduction of sound required a radical transformation in the nature of the gestures. Thenceforth they ceased to supplant sounds and instead supplemented, emphasized and accented them.

The movies do not need actors; nor do they presuppose something which moves. They can make use of cartoons; dub in sounds; achieve motion through montages, and change the pace at will by changing the speed of the camera. When actors are used, when a script is borrowed from the theatre, or when action is confined to a limited space and so on, there is no radical change in the nature of the movies. The movies are not theatre, no matter how similar the two may be in personnel and plot.

The movies are somewhat like the dance, and this in a number of ways. The actors do not have roles; they are what they seem to be. The audience, on the other hand, has the double role of providing the movies with an environment, a realm in which it can exhibit itself, and with spectators who can move through the environment to arrive at and be with what is occurring in the movies. And as in the dance, there is an exhaustion of the realm of becoming in the movies; the becoming there is full bodied, dictating the shape of space and the pace of time. But the movies are also unlike the dance. Not only does the movie audience fail to contribute to the texture of the work, but the movements and processes in the movies hop over vast regions of space and time, stress dramatic and climactic incidents, and develop characters and plots. Perhaps it is best to say that the movies offer a new form of art, resulting from a marriage of theatre and dance —in short, a theatrical version of the dance.

Wagner envisaged a single all-inclusive art, resulting from a marriage of the various basic arts. Could this single art ever be achieved, the nature of existence would be portrayed not only as encompassing space, time, and becoming, but as having each of these in a triply intensified form. Such an all-inclusive art, like any successful combination of arts, would have its own characteristic texture, themes, structure and beauty. It would also have distinctive problems, demand

distinctive techniques, and yield a distinctive experience. It would not be superior to the arts it synthesized.

The separation of the different dimensions of existence from one another and the portrayal of them by arts which possess or fill them out, is as important as their combination. The arts taken singly make evident details we otherwise would not be able to discern; in combination they make evident how different features of existence fit together. Nothing less than all the arts, singly and in combination, can convey the whole of existence in all its dimensions.

Because each art makes a distinctive contribution, there cannot be a single all-inclusive art. A synthesis of all the arts would have over against it all the arts severally. If we synthesized these with the synthesis of all the arts, we would produce a new art, and still would have individual arts outside this second synthesis. An opera which successfully combined music and theatre would not make a separate music or theatre unnecessary. And if that separate music or theatre were combined with the opera, it would turn the opera into a different art, having over against it a separately functioning music, theatre, and opera.

The more we synthesize the arts, the more surely do we multiply them. The number of arts is endless, each teaching us something new about the import of existence for man. Each iconizes existence, exhibiting its texture and conveying its significance. None, of course, replaces existence. None is as rich as it is. All portray it, but only inside the area a man has won by creatively using his emotions to produce a self-sufficing substance. Each exhibits existence with fidelity but not exhaustively; each enables us to learn what the texture of existence is, but not with all its nuances; each makes us sensitive to the challenge and promise that existence has for man.

We cannot produce an art which will make the pursuit and enjoyment of other arts unnecessary. We cannot synthesize the arts without foregoing some of the virtues they possess by themselves. The only way in which we can have the benefit of them all is by participating in them all, severally and together. Each will then have an effect on our attitudes towards life; each will make a difference to the quality of our experience; each will have distinctive resonances through our

beings. But since we are single beings, we will be able to do in and for ourselves what we could not do by art. We will be able to bring the arts together in ourselves.

We can turn experienced pluralities into harmonious totalities of that single unity which is ourselves. At no time do we derive as much benefit from such a unification as when we make a single experience out of all our encounters with art. Each art alters our attitudes, changes our rhythms, and modifies our sense of values inside a single attitude, rhythm and sense of values produced when and as we give each art its separate status and role. As in us they have a texture which is as much our own as it is that of existence, because it is the two of us together, interlocked and interactive.

In ourselves we are somewhat like a realm of music where each tone maintains its integrity at the same time that it is part of more inclusive melodies and harmonies, interacting with other tones. Just as each tone occupies an entire musical space and yet allows room for others, so each work of art fills our entire being and yet permits an enjoyment of other works of art. Unlike music, though, which grants room at various times for only certain combinations of tones, we seem able to make room for any combination of arts. We experience certain combinations of sounds as discordant, but apparently no disharmony necessarily results in us when we combine any number or types of art.

There are many arts. All can be made part of a single world by being enjoyed by a single being. When this occurs they will together tell us of a single reality, the cosmic counterpart of finite man. The world of art shows us what it means for us to be in existence. There is much more to know, but this alone justifies a career devoted to the creating of and a living in the world of art.

INDEX